Julian Treuherz
was formerly Keeper of Fine Art at the
Manchester City Art Gallery, where he organized 'Hard
Times', an exhibition of Victorian social realism (1987–88).
He is the author of *Pre-Raphaelite Paintings from the Manchester
City Art Gallery* (1980) and is joint author of *Cheshire Country
Houses* (1988). Since 1989 he has been Keeper of Art Galleries
for the National Museums and Galleries on Merseyside,
responsible for the Walker Art Gallery, Liverpool, and
the Lady Lever Art Gallery,
Port Sunlight.

WORLD OF ART

This famous series
provides the widest available
range of illustrated books on art in all its aspects.
If you would like to receive a complete list
of titles in print please write to:
THAMES AND HUDSON
30 Bloomsbury Street, London WC1B 3QP
In the United States please write to:
THAMES AND HUDSON INC.
500 Fifth Avenue, New York, New York 10110

Printed in Singapore

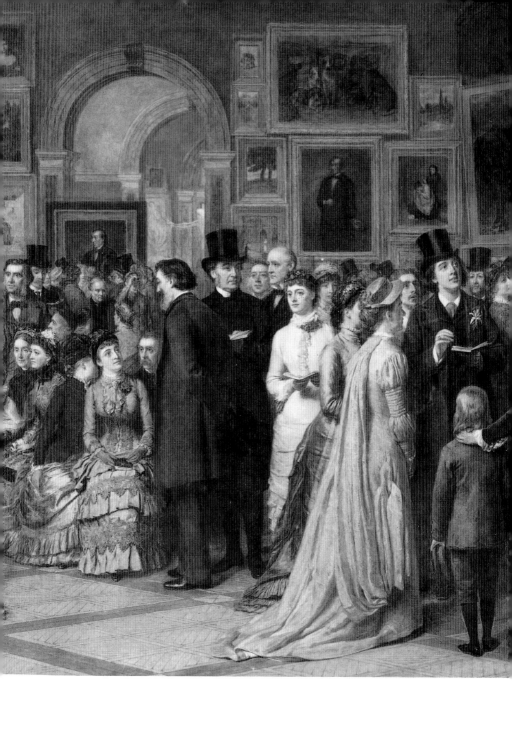

JULIAN TREUHERZ

Victorian Painting

177 illustrations, 24 in color

THAMES AND HUDSON

To my parents

I would like to thank all those scholars, curators, exhibition organizers, dealers and collectors who have contributed to the revival of the serious study of Victorian painting, and on whose work my book depends. I am particularly grateful to Judith Bronkhurst, Peter de Figueiredo and Christopher Newall for reading through my manuscript and making valuable comments.

The dates of pictures mentioned in the text are, where preceded by the letters RA or GG, dates of exhibition at the Royal Academy and the Grosvenor Gallery. Where no initials are given, the dates refer to the dates of execution. The dates of pictures in the captions and the list of illustrations are the dates of execution.

Frontispiece: William Powell Frith, *The Private View of the Royal Academy in 1881*, 1881–82 (detail)

© 1993 Thames and Hudson Ltd, London

First published in the United States in 1993 by Thames and Hudson Inc., 500 Fifth Avenue, New York, New York 10110

Library of Congress Catalog Card Number 92-61580

Printed and bound in Singapore

Contents

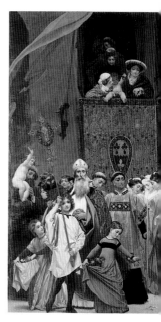

1 Frederic, Lord Leighton, *Cimabue's Celebrated Madonna is carried in Procession through the Streets of Florence*, 1853–55

Prologue

In 1855 the young Frederic Leighton, future President of the Royal
1 Academy, exhibited *Cimabue's Celebrated Madonna is carried in Procession through the Streets of Florence*. His first big success, its subject demonstrates the high status of painting in Renaissance Florence, with the artist Cimabue in the position of hero. Implicit in this picture is a comparison with Victorian Britain. Leighton's message is that art and artists should occupy a similar place of honour in contemporary society, and the remainder of his career was dedicated to realizing this ideal. It was a view shared by the Queen herself, who purchased Leighton's painting: Victoria and Albert, modelling themselves on the princely families of the Renaissance, set an example to their subjects by patronizing living British artists.

Victoria's long reign, from 1837 to 1901, was an age of expanding population and industry. There was peace at home, and middle-class prosperity and self-confidence increased, leading to conditions in which painting flourished. The period saw a huge amount of artistic production. The public flocked to exhibitions and wealthy citizens amassed large picture collections. Painters became rich; they were honoured with knighthoods and baronetcies and mixed on equal terms with aristocracy and high society. The Victorians had few doubts about their artistic achievements. Many felt that they were

6

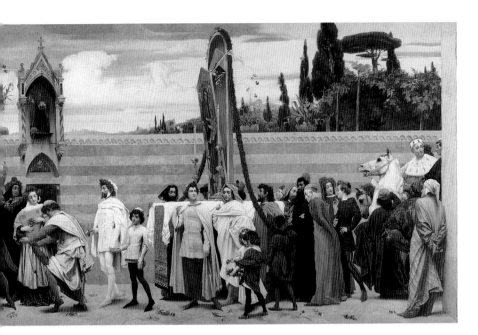

living through a great flowering of creativity which compared
favourably with any of the previous great ages of art; it was not
thought impertinent or exaggerated to rank Millais, Watts and
Leighton with Titian, Michelangelo and Raphael.

Not everyone shared this judgment. Many were worried at what
they saw as declining standards of taste. Successive groups of artists
sought to challenge accepted values; when innovation was rejected,
they set themselves up in opposition, organizing alternative exhibi-
tions and cultivating new patrons. The period saw the beginning of
the split between establishment and progressive taste which created
the modern idea of an avant-garde.

Many Victorian painters chose to speak a language that could be
understood by people of widely differing social and educational
backgrounds; they were providers of popular entertainment as well as
of cultural improvement. But some of the more advanced artists
regarded painting as a private experience, directed at a cultivated élite.
To understand the full spectrum of Victorian art, the paintings must
be seen in the context of contemporary ideas, social structure and
patronage. Interpreted in this way, Victorian paintings give vivid
expression to the aspirations, moral ideals and faults of the age.

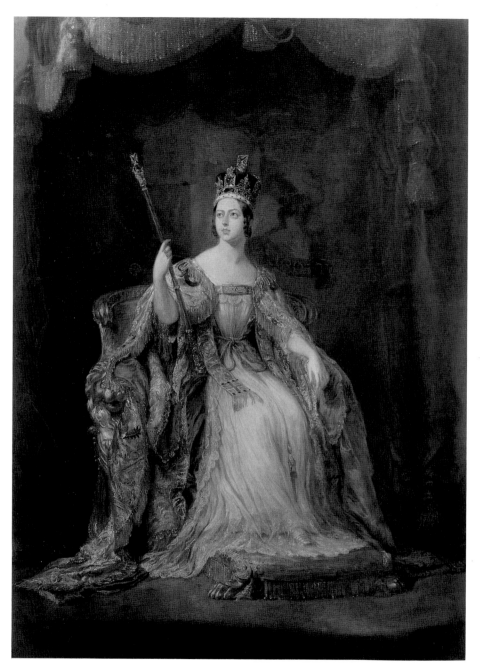

2 Sir George Hayter, *State portrait of Queen Victoria*, 1837–38

The Rise of Genre Painting

Queen Victoria commissioned her first State portrait soon after succeeding to the throne in 1837. It shows her seated amidst the glittering draperies and tassels of formal court portraiture, but the figure of the young Queen appears to lack assurance and seems uneasy surrounded by such overblown accoutrements. The painting is the work of Sir George Hayter (1792–1871); ten years earlier the artist 2 chosen would almost certainly have been Sir Thomas Lawrence (1769–1830). Had he been alive, he would have been able to provide an image with the requisite presence; the last British portrait painter to work in the grand European tradition of Van Dyck and Reynolds, no Victorian was to equal his magical combination of bravura, authority and psychological immediacy until the arrival of the American portraitist John Singer Sargent (1856–1925) in the 1880s. Hayter's failure to endow his royal sitter with majesty and confidence corresponded to a change that was taking place in the 1830s: British painters seemed increasingly unable to paint grand or elevated subjects with conviction and many were turning to less ambitious themes. Even Lawrence's reputation plummeted soon after his death; to the early Victorians his portraits began to look facile, even meretricious.

Nevertheless, the opening years of the reign saw no abrupt changes from the art of the Romantic period. Lawrence had died in 1830 and the landscape painter John Constable (1776–1837) died in the year of Victoria's accession, but most of the chief artists of the early 19th century lived on to work in the new reign, including J.M.W. Turner (1775–1851) and William Etty (1787–1849), both masters of the grand style, and two painters of genre (scenes of everyday life), Sir David Wilkie (1785–1841) and William Mulready (1786–1863). Continuity was also provided by younger artists such as Sir Edwin Landseer (1803–73), Daniel Maclise (1806–70) and William Dyce (1806–64), all thought of as quintessentially Victorian, though their styles had been formed in the 1820s and early 30s.

The year Queen Victoria came to the throne coincided with the move of the Royal Academy from its original home in Somerset House on The Strand to a slightly larger space in a wing of the National Gallery. Otherwise the Academy's annual Summer Exhibition of 1837 presented very much the same mixture as before; large numbers of paintings of contrasting styles and subjects were closely hung, frame to frame, from floor to ceiling, creating an impression of indiscriminate variety. There were frequent complaints about poor hanging, the favouring of members' works over those of non-members and the placing of Academicians' pictures in the best positions. The Academy was an exclusive and self-perpetuating body run by its own members, all either painters, sculptors, architects or engravers. There were 20 Associate Members and 40 full Royal Academicians (42 after 1853). It was the latter, the RAs, who ran the affairs of the institution, chose new members and sat on the committees which selected and hung the exhibitions.

The Royal Academy was of central importance to the Victorian art world and was far more influential than it is today. Founded in 1768, it provided training for young artists at its own schools and organized annual public exhibitions. The establishment of the annual Summer Exhibition, which first opened in 1769, as the most important event of the artistic year, had led to major changes in the pattern of British patronage. Previously most paintings were the result of individual commissions arising from the introduction of artist to patron, a meeting in which chance, fashion and social connection might each play a part. Once it was possible to see a large body of pictures together, the Summer Exhibitions became the principal means of bringing together paintings and buyers. The Exhibitions also gave artists greater freedom to paint what they liked or what they thought would sell, thus broadening the scope of subject matter from the restricted range of types, mainly portraits and landscapes, arising from commissions.

By 1837 public exhibitions had become more common, with the foundation of further exhibition societies both in provincial centres, which emulated London, and in the capital, where the new bodies were motivated by dissatisfaction with the Academy. In London annual exhibitions were held by the British Institution (founded 1805) and the Society of British Artists (founded 1824). There were also two societies for watercolourists, the Old Water-Colour Society (founded

1805) and the New (founded 1831). But the Academy retained the foremost position: many of the paintings reproduced in this book were shown there and most artists aspired to membership. In the early Victorian period each Summer Exhibition attracted about a quarter of a million visitors, the income from admissions supporting the schools and guaranteeing independence from the State. Acceptance at the Summer Exhibition could bring reputation, prestige and sometimes election to membership.

The principal founder and first President of the Academy, Sir Joshua Reynolds (1723–92), had sought to establish the intellectual status of painting as a liberal art. In his *Discourses* (1769–90), the speeches he made at the annual prizegivings of the Royal Academy Schools, he promoted the superior values of 'history painting', by which was meant not simply subjects taken from the past, but stories of an ennobling character from literature, myth or history expressed in an artistic language based on the work of those painters then considered to be the greatest masters, a canon which included Raphael, Michelangelo, Titian, Guido Reni, Poussin and Rubens. History painting, which portrayed events of timeless significance, was held to be superior to landscape, portrait or genre painting, all of which dealt with the momentary and the particular. The combination of an idealized, monumental style with heroic subject matter was often referred to as 'high art'.

History painting proper never really caught on in Britain, however. Few private collectors cared for it: the paintings were too large for most houses, so there was little demand. 'Historical painter! why yee'll starve, with a bundle of straw under your head', was the prophetic warning given to Benjamin Robert Haydon (1786–1846) at the outset of his career. The situation was not helped by the personalities of the two principal exponents of history painting, Haydon in England and the much younger David Scott (1806–49) in Scotland. Both were doggedly convinced of the important mission of high art; both bore the artistic establishment a grudge for failing to appreciate their work; yet neither had the ability to convey the great truths they aimed to express.

Scott and Haydon painted large figure compositions on ambitious subjects from antiquity, history and recent times, from Orestes and Philoctetes to Mary Queen of Scots, Napoleon and Wellington. Both artists were admirers of the great fresco cycles of the past and Haydon

vehemently criticized the government for failing to provide similar opportunities for contemporary artists. When Haydon's ideas were taken up and murals were commissioned for the new Houses of Parliament, Haydon and Scott felt it a deep injustice that they had been passed over in favour of younger painters. It was ironic that Haydon's most successful pictures, *The Mock Election* (1827) and *Punch or May Day* (1829), were animated and crowded genre scenes in modern dress; for he failed to breathe life into the high-flown and dramatic subjects he believed were his true métier. Haydon's vivid personality is conveyed not through his art but in his brilliantly written diaries, which record increasing desperation at his failure to receive public recognition. In 1846 he showed his work in premises adjacent to an exhibition featuring General Tom Thumb, the American midget: 'Tom Thumb had 12,000 people last week; B.R. Haydon, 133 $\frac{1}{2}$ (the $\frac{1}{2}$ a little girl). Exquisite taste of the English people! O God! bless me through the evils of this day.' Shortly afterwards he committed suicide.

Haydon's almost exact contemporary, William Etty (1787–1849), met with greater artistic and financial success. At best his pictures have a robust energy and a richness of colour similar to that of French romantic painting but his subjects, mainly classical, are often less than convincing for their main point was not narrative plausibility so much as a display of the artist's knowledge of the Old Masters and his command of the human figure. Etty was an assiduous attender of the Life Class at the Academy long after he ceased to be a student, and he became famous as a painter of the nude, another major element in his success with patrons. His pictures were frequently accused of indecency, despite their supposed moral purpose: the artist defended the vast naked figures in his colossal *The Sirens and Ulysses* (RA 1837) on the grounds that the painting illustrated 'the importance of resisting sensual delights'. Pictures of such large size were often difficult to sell. *The Sirens* was bought unseen by a Manchester textile merchant, Daniel Grant, who gave it to his brother but, being unsuitable for the drawing room of a private house it was soon presented to the Royal Manchester Institution (now the Manchester City Art Gallery).

Many of the paintings of Haydon, Scott and Etty might have been described as 'pieces of canvas from twelve to thirty feet long, representing for the most part personages who never existed . . .

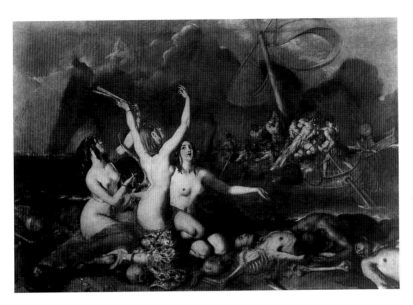

3 William Etty, *The Sirens and Ulysses*, 1837

performing actions that never occurred, and dressed in costumes they never could have worn'. This was however an impression of the Paris Salon written by the British novelist William Makepeace Thackeray (1811–63) who in the 30s and 40s published a good deal of art criticism. Large-scale history painting was indeed prevalent in France, more so than in Britain. The French government gave out commissions for the decoration of public buildings, an example often cited by Haydon and other British advocates of State support for artists. But in Britain the fashion was moving away from high art, as a rising tide of anecdotal genre paintings came to dominate the exhibitions. The shift in taste was exemplified by the difficulties of the young Victoria in finding a suitable court painter. On her accession she nominated Hayter as her 'Painter of History and Portrait' and he produced large but dull canvases of her coronation, her marriage and the christening of her eldest son. Other State occasions were recorded by C.R. Leslie (1794–1859) and Wilkie but as genre painters they were uneasy with the demands of royal portraiture (Victoria was to describe Wilkie's painting of her First Council as 'one of the worst pictures I have ever seen').

The Queen also patronized Sir Francis Grant (1803–78), obtaining
4 from him a dashing equestrian group portrait of herself and her court
gentlemen, and several more formal portraits. Grant was a younger
son of the gentry who, having run through his fortune, took up art to
support his passion for foxhunting. Largely self-taught, he neverthe-
less became an able painter of relaxed country house and sporting
portraits in the tradition of Lawrence, though he never quite equalled
Lawrence's panache. Grant became the most fashionable early
Victorian portraitist but, lacking in learning or earnestness, he was
atypical of Victorian painters; when he later became President of the
Royal Academy (1865–78) he earned the Queen's disapproval by
boasting of never having visited Italy or studying the Old Masters.
The miniaturist Sir William Charles Ross (1794–1860) also received
royal patronage but by the time he died, miniature painting had been
killed off by the invention of photography, and the daguerreotype,
later followed by the carte-de-visite, had replaced the portrait

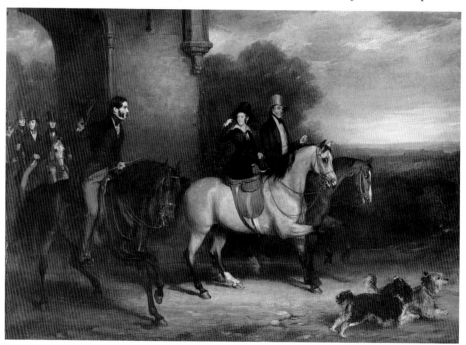

4 Sir Francis Grant, *Queen Victoria riding out with Lord Melbourne*, 1839–40

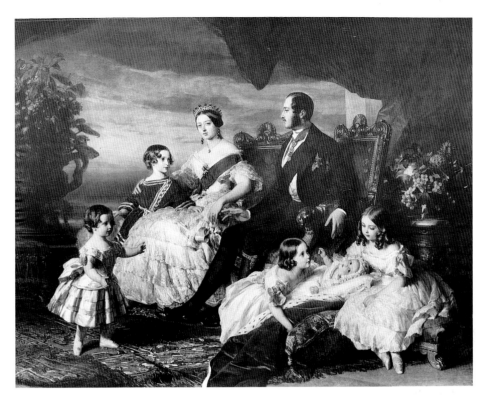

5 Franz Xaver Winterhalter, *The Royal Family*, 1846

miniature as an inexpensive and more reliable means of obtaining a likeness.

For large formal portraits, the Queen turned not to an Englishman but to a German, Franz Xaver Winterhalter (1806–73), thus reviving the Tudor and Stuart tradition of royal patronage of European portraitists like Holbein and Van Dyck. Winterhalter was recommended to the Queen in 1838 by her uncle Leopold I of Belgium and she first sat for him in 1842. He was extensively patronized by Victoria and Albert and ran a studio which produced the numerous replicas required to furnish palaces and embassies, again in a tradition going back to the Tudors and Stuarts. Winterhalter could produce strikingly intimate studies, but his main role was to paint grand State portraits and formal groups such as that of the Royal Family in 1846, 5 its treatment of the children deliberately echoing that of Van Dyck.

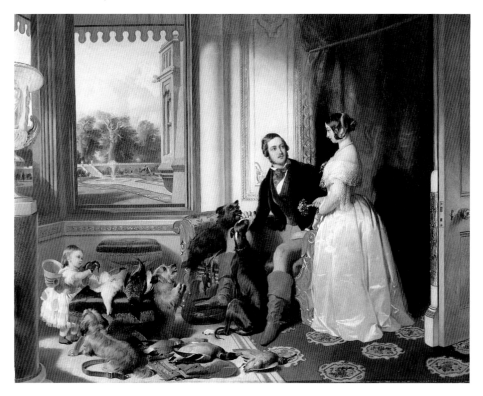

6 Sir Edwin Landseer, *Windsor Castle in Modern Times*, 1841–45

Winterhalter was immensely professional and reliable, unfailing in capturing a likeness; his style was flattering and expensive-looking, with a highly coloured, enamel-like surface corresponding to a new taste for detail and finish which was manifesting itself in the 1840s. He achieved great success both with Queen Victoria and with European high society.

The one British painter who succeeded in creating memorable portraits of the Queen and her court was Landseer, not primarily a portraitist but a painter of animals and genre. Though he had to struggle to obtain a likeness, Landseer's portraits have wit and originality. He painted Victoria and Albert in medieval costume at a fancy-dress ball held at Buckingham Palace in 1842, but it is *Windsor Castle in Modern Times* (1841–45) that seems to sum up the happy mood of their early married life. The picture is in the English tradition

of informal, country-house conversation pieces, depicting the sitters in natural attitudes. This is a richly furnished palace not an ordinary house, yet the portrait expresses the bourgeois rather than courtly ideal of domestic bliss, a common theme of Victorian art and literature.

Similar homely sentiments were the frequent theme of the genre paintings, scenes of familiar incidents mostly on a small scale and painted with humour, homespun philosophy and an eye for incidental detail, which became the dominant type of art in the 1830s. At every exhibition could be seen pictures of country markets, fairs, cottages, young lovers, mothers with babies, children at play. This was not a new fashion but its popularity increased in response to demand from collectors and lasted until the 1870s. The vogue had been created in the first two decades of the century by Sir David Wilkie and William Mulready. Both were deeply influenced by Dutch and Flemish peasant subjects of the 16th and 17th centuries, but they introduced to their work a degree of psychological penetration and narrative complexity unknown to David Teniers or Jan Steen. Through the subtly detailed observation of movement, gesture and facial expression, Wilkie could create the impression of rounded characters in real situations, suggesting events that had happened beforehand and inviting speculation as to what was to come next. His Scottish peasant subjects, such as *The Blind Fiddler* (RA 1807) or 7 *Distraining for Rent* (RA 1815) could be understood without knowledge of traditional mythological or religious stories and in his *Chelsea Pensioners reading the Waterloo Dispatch* of 1822 he applied his methods to a different kind of scene, imaginary, but constructed around an important real event from recent history, the announcement of the victory of Waterloo; he thereby created an informal modern-dress equivalent to history painting. Towards the end of his life Wilkie visited Spain, where he was greatly struck by the paintings of Velázquez, and he adopted a looser style which he applied to historical as well as genre subjects. He also travelled to the Middle East, anticipating a trend amongst Victorian artists. Yet his later work, some of it painted in the first years of Victoria's reign, was less significant for the development of Victorian genre painting than the rustic Scottish scenes of his youth. These were of incalculable influence on Victorian narrative painting and indeed on European art, for engravings of them were widely circulated.

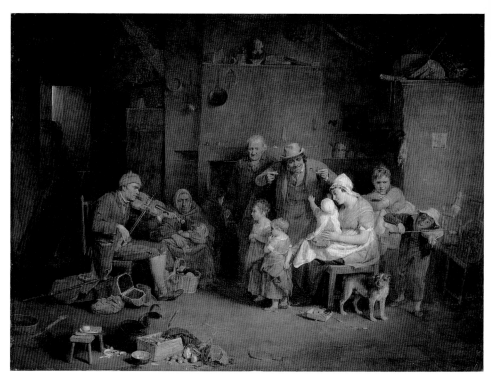

7 Sir David Wilkie, *The Blind Fiddler*, 1806

8 Thomas Webster, *The Boy with many Friends*, 1841

9 Thomas Faed, *The Mitherless Bairn*, 1855

Wilkie's major genre paintings fall into two often-imitated categories. First was the crowd scene, a busy composition packed with many figures engaged in some group activity such as a celebration at an inn or festival. This type was descended from the 16th-century Flemish *kermesse* or fair and it was the model for the panoramic crowd paintings of William Powell Frith (1819–1909). Second came the box-like cottage interior, usually lit from one side by a window and with fewer figures enacting a dramatic situation, as if on a stage. This compositional type lay behind countless Victorian interior scenes. Examples are *The Boy with many Friends* (RA 1841), a schoolboy 8 subject by Thomas Webster (1800–86) and *The Mitherless Bairn* (RA 9 1855) by Thomas Faed (1826–1900), like Wilkie, a Scot. Webster specialized in comical pictures of children at play whilst the theme of Faed's work, often with titles taken from Scottish vernacular poetry or folk wisdom, was the life of the poor, treated sometimes with humour, sometimes with pathos. Even right at the end of their careers both artists could still use settings and costumes that harked back to the remote and reassuringly old-fashioned rural world depicted by Wilkie earlier in the century.

10 William Mulready, *The Sonnet*, 1839

The boys in Webster's pictures lack the subtle observation of human behaviour seen in the genre paintings of William Mulready. Like Wilkie, Mulready drew his inspiration from Dutch art; he depicted his characters with sympathy and humour, but also with remarkable insight, creating out of everyday incidents situations of some ambiguity, so that the denouement is never obvious. The expressive range he gave to individual faces came from an interest in the science of physiognomy; he was also a devotee of boxing, often painting the fights and quarrels of schoolboys and conveying latent cruelty as well as humour. His school subjects date mostly from before Victoria's accession; those genre paintings he produced during her reign (he lived until 1863) were happier, often depicting children or young lovers with an almost throwaway gracefulness as in *The Sonnet* 10 (RA 1839). Only sometimes is there an explicit moral lesson such as the exhortation to almsgiving in *Train up a Child in the Way he should go* (RA 1841). Mulready's palette became lighter, warmer and more glowing as he pioneered the technique, later used by the Pre-Raphaelites, of applying colour over a white ground. He was also a brilliant draughtsman in chalk, particularly of the nude, a facility unusual in a genre painter. Mulready recorded his aims as 'Story Character Expression Beauty' and noted, perhaps in response to criticism of his subjects as trivial compared to those of history painting, 'Confirmed also [by experiment May 1844] that in the present state of the art, almost any subject matter may be raised into importance by truth and beauty of light and shade and colour with an unostentatious mastery of execution.'

Mulready also excelled at another type of picture common in the 1830s and 40s which, in the hands of painters lacking his powers, could be wooden and repetitive. This was the literary genre painting, which took a scene from a well-known play or novel and depicted it in an anecdotal manner, often with a humorous slant. In contrast to the artists of the Romantic period, who had favoured tragedy or high drama, the early Victorians excluded anything savage or disturbing. Shakespeare now meant for the most part Autolycus and Malvolio rather than Lear or Macbeth. The Victorians liked, in Thackeray's words, 'a gentle sentiment, an agreeable, quiet incident, a tea-table tragedy or a bread-and-butter idyll'.

One of the favourite sources for literary genre was Goldsmith's novel of 1766, *The Vicar of Wakefield*, so often seen on the Academy's

11 C.R. Leslie, *Dulcinea del Toboso, the Peasant
Mistress of Don Quixote*, 1839

walls that Thackeray at one stage refused to mention another in his
reviews. He was forced to recant on seeing Mulready's *Choosing the*
12 *Wedding Gown* (RA 1846), the brilliant colour of which he compared
to a blaze of fireworks. It shows the Vicar in the draper's shop: 'I chose
my wife as she did her wedding gown, not for a fine glossy surface,
but such qualities as would wear well.' Mulready's love of high finish
is evident in the lustrous textures of the details.

The 17th and 18th centuries were particularly favoured by the
painters of literary subjects, and Molière, Pepys, Addison, Boswell
and Defoe were often raided for ideas. The American-born Charles
Robert Leslie (1794–1859), friend and biographer of John Constable,
painted a notable series of comic subjects from Molière, Shakespeare
11 and Cervantes. His *Dulcinea del Toboso, the Peasant Mistress of Don
Quixote* (RA 1839) is a slightly different type of picture, a fancy
portrait in the so-called Keepsake style. This was named after *The
Keepsake*, a series of annual volumes published between the 1820s and
40s, containing light verse and sentimental stories illustrated with steel
engravings, often of ladies in elegant costume, with fashionable
ringlets and come-hither expressions, a formula often employed in
cabinet pictures (intended for small rooms) and portraits.

12 William Mulready, *Choosing the Wedding Gown*, 1846

Allied to the taste for literary genre painting was the immense popularity of the historical anecdote, painted in the same style and making the same appeal to be read in terms of humour, moral, incidental detail, character and period costume. Anecdotal historical subjects, as distinct from elevated history paintings, were one of the most important elements in Victorian art and up to about 1870 almost every artist of note painted them. They corresponded to a growing public interest in the past, fed by the popularity of such books as Macaulay's *History of England* (1849–61) and the historical novels of Scott, Harrison Ainsworth and Edward Bulwer Lytton. Late 18th- and early 19th-century historical subjects had concentrated on great men and momentous events, treated with the grandiose rhetoric of high art and often lacking in convincing dramatic or period sense. In the 1820s Richard Parkes Bonington (1802–28), an Englishman working mainly in France, began to paint more informal subjects, showing intimate glimpses into the private lives of well-known historical figures, the kind of scenes described in diaries and historical novels. Still more influential on British art was the French painter Paul Delaroche (1797–1856) who, exploiting the Anglomania current in Paris in the 1830s, exhibited at the Salon a series of paintings from British history including *The Children of Edward IV* (1830), *Cromwell gazing at the body of Charles I* (1831) and *The Execution of Lady Jane Grey* (1834). These were remarkable for their air of veracity, which came from the artist's feeling for the dramatic moment, from his insight into character and from his painstaking research into costume, setting and likeness. The success of these works prompted British historical painters to spend many hours consulting costume experts, history books and portrait engravings and equipping their studios with antique furniture, wigs and old costumes to give their pictures the appearance of period authenticity. Today Victorian historical paintings may seem unconvincing, but for their contemporaries they had vitality and immediacy, bringing the past to life by clothing it in colour and drama. Many famous events were fixed into the national consciousness by painted reconstructions, later reproduced in encyclopaedias and school textbooks until the images took on lives of their own.

In their choice of subjects, painters mirrored the Victorian conception of history and the prevailing Whig ethos of progress towards constitutional monarchy and the defence of parliamentary

13 Edward Matthew Ward, *The South Sea Bubble, a scene in Change Alley in 1720*, 1847

liberties. History was pictured in terms of national pride and of moral and political exemplars for the modern age, but also of romantic heroes and heroines and nostalgia for a glamorous past. Subjects connected with Henry VIII, Elizabeth I, Mary Queen of Scots and above all Charles I, Cromwell and the Civil War were especially popular.

Literary and artistic figures, particularly of the Restoration period, were also frequently depicted. Edward Matthew Ward (1816–79), who first made his name with scenes from the life of Dr Johnson, had one of his greatest successes with *The South Sea Bubble, a scene in* 13 *Change Alley in 1720* (RA 1847), based on a description of the disastrous financial speculation taken from a popular history book. Ward's interest in the early Georgian period reflected a new self-consciousness amongst Victorian artists that they were heirs to a native tradition. William Hogarth (1697–1764) was at the height of his reputation and regarded as the founder of the British School of painting. At the Academy of 1860 Ward showed a picture of Hogarth

25

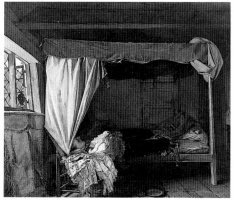

14, 15 Augustus Leopold Egg, *The Life of Buckingham. The Death of Buckingham*, c. 1854

in his studio, and W.P. Frith was later to paint two series inspired by Hogarth's *The Rake's Progress: The Road to Ruin* (RA 1878) and *The Race for Wealth* (1880). Ward and Frith took up Hogarth's strong moral stance in warning against gambling, for the dangers of debauchery were a frequent theme in Victorian art. Ward, Frith and Augustus Egg (1816–63) all depicted the court of Charles II as the seat
14,15 of dissipation and vice, as in Egg's dramatic *The Life* and *The Death of Buckingham* (RA 1855). But in keeping with Victorian propriety, Hogarth's coarse humour and satire were absent from the work of his Victorian followers.

In the 1830s and 40s there was a fashion for subjects of the so-called 'olden time' set variously in the later Middle Ages or the 16th century and depicting a golden age of Merrie England, of maypole dancing and joints of beef distributed to the tenantry. The powerful attraction of this myth was also seen in the beginnings of the Gothic Revival in architecture and in events like the Eglinton Tournament, an extraordinary medieval pageant held at Eglinton Castle in Scotland in 1839 and attended by the fashionable world, clad expensively in fancy dress and suits of armour. Such pictures as *Bolton Abbey in the Olden*
16 *Time* (RA 1834) by Landseer, *Merry Christmas in the Baron's Hall* (RA 1838) by Maclise, and *Coming of Age in the Olden Time* (RA 1849) by Frith echoed the political mood of the 40s, represented by Disraeli's Young England party with its nostalgia for a hierarchical, pre-industrial society, also found in books like Thomas Carlyle's *Past and Present* (1843).

26

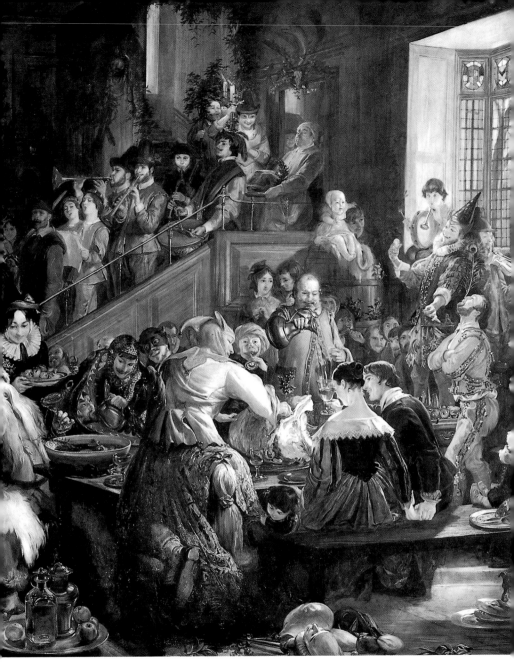

16 Daniel Maclise, *Merry Christmas in the Baron's Hall*, 1838 (detail)

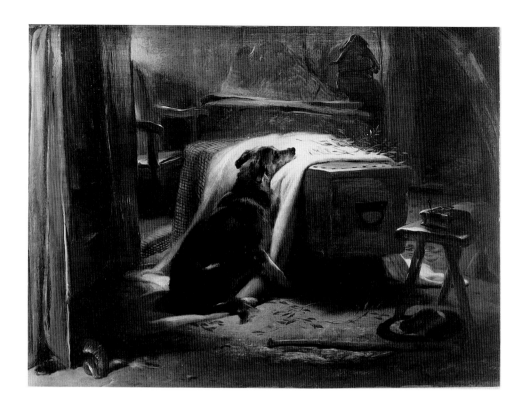

The continuing popularity of Sir Walter Scott's novels contributed greatly to the interest in the past and to the Victorian fascination with Scottish history and landscape, encouraged also by Queen Victoria's love of Scotland. The paintings of Sir Edwin Landseer were fundamental to the Victorian vision of the Highlands. He first visited Scotland in 1824 and returned regularly. In the 20s and 30s he painted a series of Highland interiors influenced by Wilkie, in which animals feature as prominently as humans. At the same time, Landseer gained a reputation with the aristocracy, for whom he produced grand sporting paintings in the tradition of Snyders and Rubens, but set in the Highlands where his patrons went deerstalking. Landseer also painted portraits of their favourite horses and dogs, most notably Prince Albert's greyhound Eos and Victoria's spaniel Dash. Landseer, like his artistic forebear George Stubbs, studied animal anatomy,

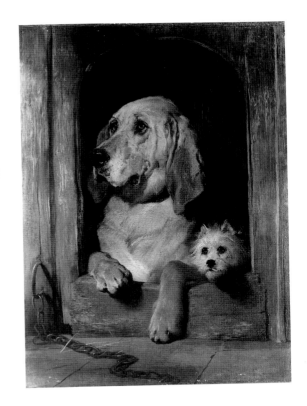

17 Sir Edwin Landseer, *The Old Shepherd's Chief Mourner*, 1837

18 Sir Edwin Landseer, *Dignity and Impudence*, 1839

developing an uncanny facility in depicting the sleek and glossy textures of fur and feather, and the quivering moistness of eye and nostril. Unlike Stubbs, he expressed the character of his animal sitters in anthropomorphic terms. This could be heavy-handed, as in elaborate canine charades like *Laying down the Law* (RA 1840) where the dogs all assume legal personalities, the fluffy hair of a poodle, for instance, being made to resemble a judge's wig. But in *Dignity and* 18 *Impudence* (1839) an apt and witty contrast is made between a magnificently impassive bloodhound and a cheeky little Scotch terrier, both dogs belonging to the artist's friend and business manager Jacob Bell.

Landseer was a natural storyteller and developed a novel kind of genre painting employing Wilkie's narrative techniques but with animals as the principal players. This had parallels in animal fables and

in contemporary literature, for Scott and Dickens both describe dogs as individuals with their own feelings. Landseer's *The Old Shepherd's*
17 *Chief Mourner* (RA 1837) depicts a tearful collie pathetically pressing his head on the draped coffin of his master, whose life and habits are suggested by the objects in the humble interior. Each detail was described at length in a famous purple passage by John Ruskin (1819–1900), who concluded that the care and thought displayed in the painting stamped the artist 'not as the neat imitator of the texture of a skin, or the fold of a drapery, but as the Man of Mind'.

Landseer's art is not now associated with intellectual qualities, yet his achievement as a 'Man of Mind' was powerfully realized, not so much in his dog pictures as in his series of deer and stags of the 1840s. These show the animals at various stages of their existence: fighting, challenged by each other, reaching safety across a lake, hunted or shot dead; their bodies are painted with incomparable accuracy and the landscapes are superbly handled. But their real significance is on a higher plane, for they bring to animal painting the epic and heroic qualities of high art. Placed in sublimely poetic, solitary Highland settings the stags seem to represent the forces of nature, free yet doomed, as in *The Stag at Bay* (RA 1846). The culmination of the
19 series is *The Monarch of the Glen* (RA 1851), commissioned to hang in the Refreshment Rooms of the House of Lords, though never installed there as the expenditure was turned down by the Commons. It was Landseer's contribution to the scheme to decorate the Palace of Westminster with paintings, a project born out of a desire to raise the level of seriousness of British art. Against this background, Landseer created one of his most powerful conceptions, in which the stag is seen proud and untamed, rearing up against spectacularly misty peaks, the low viewpoint emphasizing the animal's triumphant freedom. Though couched in animal terms, it has the timelessness and universality intended of history painting.

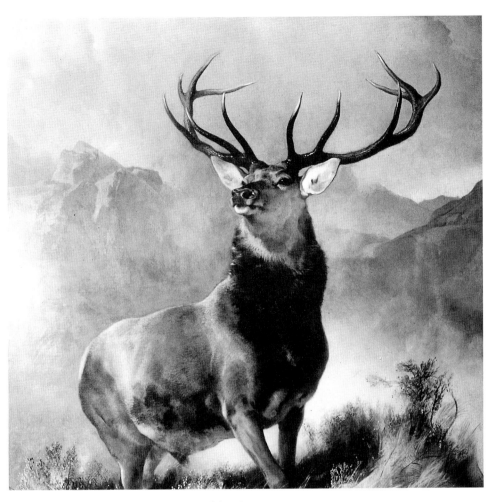

19 Sir Edwin Landseer, *The Monarch of the Glen*, 1851

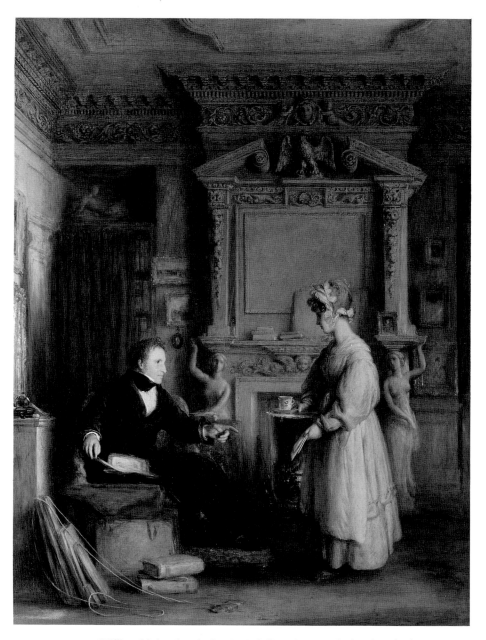

20 William Mulready, *An Interior including a Portrait of John Sheepshanks at his Residence in Old Bond Street*, 1832

Early Victorian Taste and Patronage

The popularity of genre painting was largely due to the tastes and buying power of a new class of collectors which emerged in the early Victorian period; by 1851 C.R. Leslie could write to his sister, 'The increase of the private patronage of Art in this country is surprising. Almost every day I hear of some man of fortune, whose name is unknown to me who is forming a collection of the works of living painters; and they are all either men of business or who have made fortunes in business and retired.'

Earliest and most important of these new patrons was John Sheepshanks (1784–1863), the subject of Mulready's portrait which 20 shows him in his London house with his servant. On the wall hang a few framed drawings, part of Sheepshanks' large collection which survives in its entirety, for in 1857 he presented it to what is now the Victoria and Albert Museum. Sheepshanks was a Leeds woollen manufacturer who made a fortune from supplying uniforms for the British army in the Peninsular War. In the 1830s he settled in London where he began to buy the work of contemporary painters, coming to know them as friends, sometimes commissioning pictures directly from them and also buying at the Summer Exhibitions. He owned 30 oils by Mulready, 24 by Leslie and 16 by Landseer, as well as many 10, 11, 12, 17 others. Most of them are of cabinet size, and genre and literary subjects predominate, although there are some marine and landscape paintings, including five Turners and six Constables. Sheepshanks also bought Dutch and Flemish prints which he presented to the British Museum.

A number of other collectors were active at the same time as Sheepshanks, including William Wells of Redleaf, shipbuilder and brewer, Robert Vernon, supplier of horses for the British army during the Napoleonic Wars (his collection is in the Tate Gallery), Elhanan Bicknell, whose money came from sperm-whale fishing and engineering, Samuel Ashton, owner of a Manchester cotton mill, and Charles Meigh, a Staffordshire pottery manufacturer. The sources of

33

their wealth indicate a transformation in the British art market during the 1830s and 40s. The initiative in art collecting passed from the aristocracy to the rising middle class of manufacturers, merchants and entrepreneurs, newly enriched by the Industrial Revolution, enfranchised by the 1832 Reform Act and endowed with the shrewdness and independence of judgment that had brought them success in business. They invested some of the large amounts of liquid capital they had amassed from industry and commerce not in Old Masters but in the work of living artists. They were not the first to collect contemporary British painting, for the lead had been set in the early 19th century by aristocrats like Lord Egremont (Turner's patron at Petworth) and Lord de Tabley. But now the economic power lay elsewhere, with the middle classes. Not for them a classical education, the Grand Tour and the 18th-century virtuoso's connoisseurship of Guido or Raphael. These patrons liked recognizable subjects rather than remote allegory and they preferred signed modern paintings whose authenticity could be proved to dubious Old Masters, which were extensively faked at this period.

The taste of the new collectors embodied the middle-class values of propriety and respectability, hard work, the sanctity of family life, piety and self-improvement. These values were expressed in the many domestic subjects representing home and family, the innocence of children or the virtues of obedience and charity, for it was a commonplace of Victorian art criticism that painting was a moral teacher. The utilitarian and evangelical bias of middle-class education encouraged a distrust of the purely sensual. There was deep suspicion of the enjoyment of art for its own sake; it had to have a purpose, to profit the mind. Work benefited the soul and led to personal salvation, leisure time had to be spent in improving pursuits, hence the preoccupation with subject, narrative and moral over artistic form, with learning from a picture and reading its details as closely as a book.

The Victorian period was the great age of the novel, and Scott, Dickens and Thackeray, for example, were published in large editions. The growth in education and literacy expanded a reading public avid for self-improvement: many people were brought up with the custom of regular family gatherings to hear passages read aloud from the Bible or from popular novels and history books. Genre paintings occupied a similar territory; as in domestic recitations, the incidents chosen by artists were often amusing vignettes

21 William Edward Frost, *Sabrina*, 1845

and memorable set pieces rather than passages that summed up the essence of a play or book. In the same way, detail and characterization were admired in pictures more than the general effect. This led to a certain philistinism: Lady Eastlake, a noted writer on art, complained in 1863 that the British 'had scarcely advanced beyond the lowest step of the aesthetic ladder, the estimate of a subject'. Paintings were also admired for their workmanship. The middle-class work ethic can be discerned in the appreciation of technical skill in a picture, evidence both of the artist's labour and of value for money for the purchaser. John Gibbons, an Edgbaston ironmaster and patron of many early Victorian artists, wrote in 1843, 'I love finish – even to the minutest details. I know the time it takes and that it must be paid for but this I do not object to.'

Paintings were regarded as essentially domestic in function. Writing in 1866, Richard and Samuel Redgrave noted that 'pictures to suit the English taste must be pictures to live by; pictures to hang on the walls of that home in which the Englishman spends more of his time than do the men of other nations, and loves to see cheerful and decorative. His rooms are comparatively small and he cannot spare much wall-space for a single picture.' The dominant form of the period was not the public mural or large gallery picture, but the portable easel painting, intended to be hung at home and which could be bought and sold as an article of private property.

35

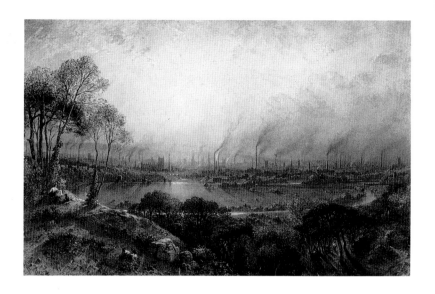

Just as Victorian social relations were governed by a strict code of acceptable behaviour, so Victorian painters avoided subjects that offended middle-class propriety. The nude figure had no part in genre painting. It was acceptable for fairy subjects and also in the context of high art where it was sanctioned by classical myth, by the precedent of the Old Masters, and by the moral lessons inherent in history painting. But it is significant that the Rubensian gusto of Etty's nudes was, in the work of his most successful follower William Edward Frost (1810–77), softened to what an obituarist described as an 'enervating correctness . . . "chaste" and proper for the eyes of the British matron in her dining room'.

Frost's patrons included the Queen, who was not the prude she is sometimes made out to be. At an exhibition of the work of William Mulready in 1853 she made a point of admiring his nude drawings despite the attempts of nervous officials to prevent her from seeing them. Mulready himself wrote somewhat cynically in his personal notebook, 'Female beauty and innocence will be much talked about and sell well. Let it be covertly exciting, its material flesh and blood approaching a sensual existence and it will be talked about more and sell much better . . . but let excitement appear to be the object and the hypocrites will shout and scream and scare away the sensuality.' But with the decline from favour of high art, paintings of the nude became less common until the classical revival of the late Victorians.

21

36

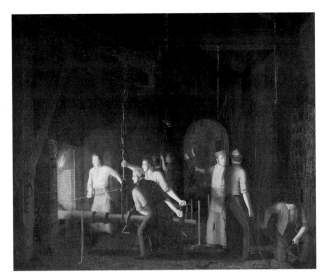

22 William Wyld, *Manchester in 1851*, 1851

23 James Sharples, *The Forge*, 1844–47 (detail)

A similar reticence operated with subjects showing the poverty, homelessness and unemployment that were features of the age. In the 'hungry forties', which received such powerful literary expression in the novels of Disraeli, Dickens and Mrs Gaskell, the problems caused by industrialization and the growth of towns and cities made little appearance in painting. The poor were visible everywhere, endlessly discussed and analysed in newspapers, books, parliamentary debates and reports, but they were not felt to be fit subjects for art. Views of factories and cities were rare, the province of the magazine illustrator or topographer but not of the fine artist. When William Wyld (1806–89) painted Manchester in 1851 he depicted the city from a distance, 22 set in a conventional rural landscape with the mass of factory chimneys seen only in the background.

One of the very few Victorian paintings showing workers in a factory is by the highly atypical James Sharples (1825–92), a Lancashire foundry worker. The story of Sharples the blacksmith artist was included as one of Samuel Smiles' exemplars in the later editions of *Self-Help*. Sharples attended evening classes at the local Mechanics' Institute, but was otherwise self-taught. His painting of *The Forge* (1844–47), and the engraving he made of it, was done in his 23 spare time. Unlike the industrial novels, *The Forge* was not meant as a critique of the factory system; on the contrary, it shows the artist's pride in the technical processes of industry.

Two contemporary professional artists, Richard Redgrave (1804–88) and George Frederic Watts (1817–1904), responded to the problems of the 1840s with a small number of pictures explicity condemning social ills. Their subjects were highly selective, however, featuring mainly female protagonists who could be shown as passive icons of suffering; these pictures owed as much to artistic convention and literary inspiration as to first-hand observation. Even so, they were remarkable for their date.

24 Redgrave, painter of *The Sempstress* (first version RA 1844), did not confine himself to the fine arts. He designed ceramics, glass, silver and wallpaper for Felix Summerly's Art Manufactures, a concern set up by the civil servant Henry Cole in 1847 to improve British design. Redgrave was also active as an art educationalist, as curator of the Sheepshanks collection at South Kensington and later, of the Royal Collection. In the 1840s he was a genre painter who distinguished himself from his contemporaries by his stated aim of 'calling attention to the trials and struggles of the poor and oppressed'. He painted a series of pictures of unhappy women including a governess, a country girl forced to leave her family for domestic service and a girl with an illegitimate child thrown out of home. But it was *The Sempstress* that caught the imagination of the public and moved another artist, Paul Falconer Poole (1807–79), to write, 'Who can help exclaiming "Poor Soul! God help her"?' The exploitation of sweated labour in the clothing trade was a notorious abuse, familiar to contemporaries from newspaper reports, but Redgrave was prompted to paint the subject not from direct experience but after reading Thomas Hood's celebrated poem *The Song of the Shirt* published in *Punch* in 1843:

> With fingers weary and worn,
> With eyelids heavy and red,
> A woman sat in unwomanly rags,
> Plying her needle and thread –
> Stitch! Stitch! Stitch!
> In poverty, hunger and dirt,
> And still with a voice of dolorous pitch
> She sang 'The Song of the Shirt.'

The details of the interior were devised to suggest the needle-woman's desperate situation, but by showing her not in a crowded sweatshop but as a solitary figure, with eyes turned up to heaven like a

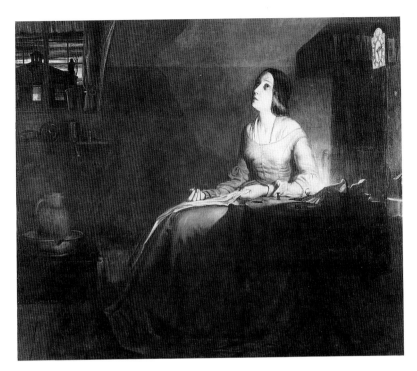

24 Richard Redgrave, *The Sempstress*, 1846

baroque saint, Redgrave was able to contrive an image of pathos which moved viewers without offending them with too great a degree of realism.

Around 1850 the young G.F. Watts painted a series of social-realist canvases including a female suicide, a beggar, another sempstress and a family evicted from home during the recent potato famine in Ireland. Watts had lately returned from Italy where he had steeped himself in the monumental art of the Renaissance, particularly the sculpture of Michelangelo. Though his paintings were inspired by contemporary issues, the form they took was unlike genre painting: they were larger in scale, broader in treatment and eliminated the use of costume and setting as narrative devices, on which Redgrave still depended. Watts had never been to Ireland when he painted *The Irish Famine*; visually, it depends on the traditional scheme of a *Rest on the Flight into Egypt*.

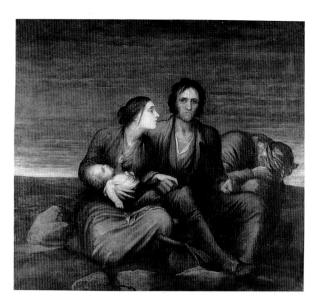

25 George Frederic Watts,
The Irish Famine, c. 1850

25 Like *The Sempstress*, *The Irish Famine* is an emblem of suffering rather than a realistic description of it.

Watts did not exhibit his social-realist subjects at the time they were painted, presumably because he thought that the public, accustomed to genre and anecdote, would not understand them. The improvement of public taste was widely debated in the art world of the 1830s and 40s. Many people felt that the new patrons had lowered standards by encouraging the production of endless trivial genre scenes. B.R. Haydon and others constantly attacked the Academy and successive governments for their failure to provide the kind of State education and public commissions for artists that were available in France and Germany. There was a powerful economic argument for State intervention, for Britain was losing ground to foreign competition in manufactured goods and would become wealthier if taste could be improved.

Art education in Britain was certainly lagging behind that of Europe: in the early 19th century there was no system in the way British artists were trained. Some learned by working as studio assistants to professional painters; others were apprenticed to house painters or to theatrical scene painters. It was possible to study at a private academy or with a drawing master but these both taught art as

a genteel accomplishment for amateurs. Art classes were held at the new Mechanics' Institutes in the industrial towns but they gave only rudimentary instruction for artisans. The most prestigious art training was provided by the Royal Academy Schools in London, but in the early Victorian period these were at a very low ebb. Academicians taught in rotation on the 'Visitor' system, changing each month; the theory was that students would avoid being dominated by any one style, but in practice it meant a directionless training. Most Visitors blatantly neglected their teaching duties, 'sitting with us the prescribed two hours, rarely drawing, oftener reading. In those days scarcely ever *teaching*', according to Frith, a student there in the 30s. The lectures were a mockery and the system of study was stultifyingly archaic, beginning with drawing from the antique, and followed only after a long time by drawing from the head and the draped model. Painting was not permitted until much later in the student's career. Equally constricting were the the methods of the private art schools, set up in the 30s and 40s mainly to prepare students for the Academy Schools. At Sass's (later called Carey's) Frith was set to copying interminable outlines from the antique, after which he laboured for six long weeks drawing a huge plaster ball to study light and shade. The British system encouraged miniaturistic skills and fine detail, but at the expense of breadth and large-scale design. British painters who had studied in Paris, such as Charles Lucy (1814–73) or Edward Armitage (1817–96), were deeply critical of the mechanical execution of artists trained in England. More fortunate were the students at the Trustees' Academy in Edinburgh, particularly in the 50s under Robert Scott Lauder (1803–69), who encouraged his students to paint at an early stage in their studies and insisted on the importance of grouping figures rather than studying them in isolation. The results were apparent in the sophistication of the Scottish painters who came to maturity in the 60s and 70s.

Partly as a result of Haydon's campaigning, a Select Committee set up in 1836 led to the establishment of a Government School of Design in London followed by others in provincial cities. The painter William Dyce (1806–64), who became the second headmaster of the London School of Design, was sent to Europe to study art education and introduced German methods. The Schools of Design were reorganized in the 50s by Henry Cole and Richard Redgrave into a more coherent national system of schools, examinations and teaching

certificates. The schools were set up under the aegis of the Board of Trade; their purpose was solely to train ornamental artists in order to improve the standard of manufactured goods; and they used rigid methods of instruction favouring mechanical exercises in geometry and ornament, rather than the traditional academic discipline based on the study of the human figure advocated by Haydon. Schools with enlightened teachers escaped the narrowness encouraged by the system, but the general result was to perpetuate the division between fine and applied art which was to be so much criticized by John Ruskin and William Morris.

The most important fruit of the campaign for State intervention in the arts was the scheme to decorate the Palace of Westminster with mural paintings. In 1834 the old Houses of Parliament had been destroyed by fire. By 1840 the new building, by the architects Sir Charles Barry (1795–1860) and A.W.N. Pugin (1812–52), was nearing completion, and the question of its decoration was being publicly discussed. Comparisons were made with public commissions in Europe, such as Louis-Philippe's Gallery of Battles at Versailles, painted by Theodor Gudin (1802–80), and more significantly with the frescoes of Peter Cornelius (1783–1867) and his school at Munich which, under the direction of Ludwig I, had recently been transformed into a city of grand public buildings enriched with mural decorations on poetic and historical subjects. In 1841 a Select Committee met to consider the question, taking evidence from experts including Barry and the painters Charles Eastlake (1793–1865) and William Dyce. Later that year a Royal Commission was set up by the Prime Minister Sir Robert Peel, who defined its purpose as 'Investigation whether the Construction of the New Houses of Parliament can be taken advantage of for the encouragement of British Art'. Peel appointed as chairman the young Prince Albert, as yet hardly known in public life, and Eastlake as secretary. And so began a most ambitious attempt to raise the level of British art and to make the Houses of Parliament into a kind of national shrine, decorated with paintings illustrative of British history and literature.

After prolonged consultation with artists and connoisseurs, the Commission decided that both Houses should be decorated with murals of historical and allegorical scenes in fresco and a series of open competitions was held, beginning in 1842; the first entries were shown the following year in a highly successful exhibition held at

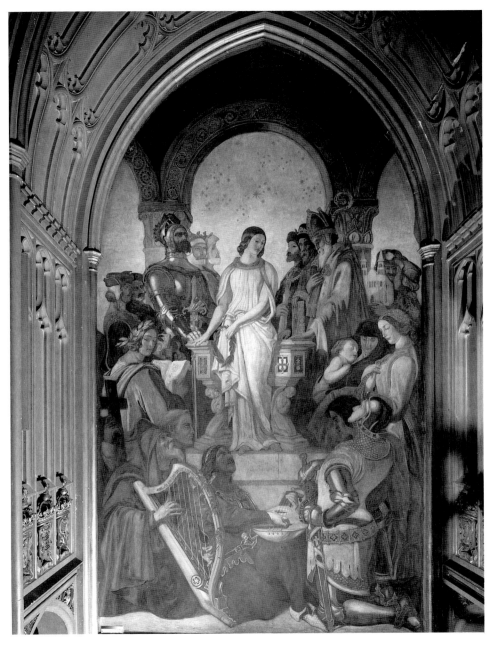

26 Daniel Maclise, *The Spirit of Chivalry*, 1847

Westminster Hall. In the competitions that followed, artists had to provide specimens of fresco as well as designs, a wise precaution in view of British unfamiliarity with the medium. It was also intended to complement the murals by hanging easel paintings in certain rooms; 19 Landseer's *The Monarch of the Glen* was commissioned as part of this initiative.

Over the next few years artists began their work. They included William Dyce, Daniel Maclise, Richard Redgrave, E.M. Ward, John Tenniel (1820–1914) – now chiefly famous for his *Alice in Wonderland* illustrations – Charles W. Cope (1811–90), John Callcott Horsley (1817–1903) and John Rogers Herbert (1810–90). Fresco, the technique of painting on fresh plaster, is a very demanding medium, impossible to alter once applied and highly susceptible to damp. Despite the difficulties, fresco was specified not simply because it was a revival of a classic Italian Renaissance technique, judged to be historically appropriate for architectural murals, but also as an acknowledgment that the Palace of Westminster was to be decorated on the successful German model, admired by Prince Albert and Eastlake; one of Eastlake's first acts as secretary had been to consult Cornelius about the best methods of fresco painting.

The first murals to be completed were in the Lords: *The Baptism of* 26 *Ethelbert* (1846) by Dyce and *The Spirit of Chivalry* (1847) by Maclise. Both were heavily influenced by the German frescoes, with clear bright colours, uniform lighting, smooth contours, strong wiry outlines and formal symmetry quite unlike the baroque theatricality and chiaroscuro (strong contrasts of light and shade) of Haydon or Etty. This German style had its origins in the renewed interest in the early Italian Masters pioneered earlier in the century by the group of German painters known as the Nazarenes. Led by Cornelius, 27 Friedrich Overbeck (1789–1869), Julius Schnorr von Carolsfeld (1794–1872), Franz Pforr (1788–1812) and Wilhelm Schadow (1764–1850), in 1809 they formed an association called the Brotherhood of St Luke, named after the patron saint of painting. They moved to Rome in 1810 where they lived together in an austere, semi-monastic community, inspired by pre-Reformation Christianity. For artistic inspiration they looked to late medieval and early Renaissance painting, reviving the technique of fresco and particularly admiring Durer, Fra Angelico, Perugino and the early work of Raphael. As a community, the Brotherhood lasted only a few years, but its influence

44

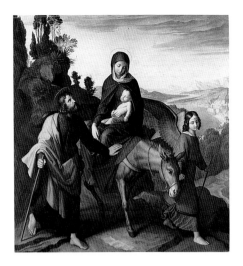

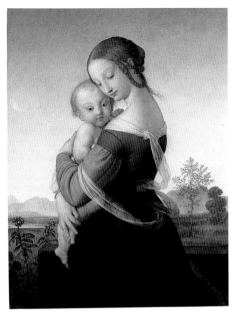

27 Julius Schnorr von Carolsfeld,
The Flight into Egypt, 1828

28 William Dyce, *Madonna and Child, c.* 1838

was widespread. Cornelius moved to Munich in 1819 and Schadow went to Düsseldorf; Overbeck remained in Rome where his studio attracted many visitors including Dyce and Ford Madox Brown (1821–93), both key figures in the transmission of the Nazarene style to Britain. Brown, an unsuccessful competitor in two of the Westminster competitions, met Overbeck in 1846 at the height of British interest in the German style, but Dyce went to Overbeck's studio in 1827, so was one of the earliest British painters to have first-hand contact with the Nazarenes.

Born in Aberdeen, William Dyce began his career as a portraitist, but the seriousness and depth of his artistic and religious impulse gave him higher ambitions. He studied in Rome in 1825 and again in 1827, and in the 30s the Nazarene influence became apparent in such works as the *Madonna and Child* of *c.* 1838. Its Raphaelesque archaism is quite 28 unlike anything else of its date in Britain. Four years previously, Nicholas (later Cardinal) Wiseman had written to Dyce from Rome to encourage him, finding the painter's interest in 'the old, symbolic, Christian manner of the ancients . . . refreshing indeed to the mind; it is like listening to a strain of Palestrina after a boisterous modern finale.' The comparison was aptly chosen, as the purity and austerity

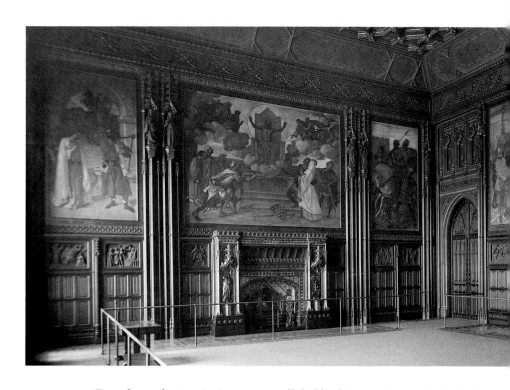

Dyce brought to painting was paralleled by his activities in the field of church music. He was a leader in the campaign to return religious music to its early simplicity and was also involved in the ecclesiological movement to restore to contemporary church architecture and decoration the dignity demanded by traditional ritual. Dyce's career as an artist was interrupted by his headmastership of the School of Design, but following his success in the 1844 Westminster competition he was able to give more time to his painting. After completing *The Baptism of Ethelbert* he was fully occupied from 1847 to 1864 with the five murals in the Royal Robing Room of the House of Lords, illustrating knightly virtues through episodes from *Morte d'Arthur*, a cycle of legends translated from the French by Malory during the 15th century, which were also the subject of an epic poem by Tennyson (1809–92). This was regarded by Albert as a British equivalent of the German epic of the *Niebelungenlied*, the subject of one of Cornelius' most famous cycles in the Royal Palace at Munich. The clarity of composition and simple action of Dyce's *Morte d'Arthur* scenes make them amongst the most successful of the Westminster murals.

29

46

29 William Dyce, Frescoes in the Royal
Robing Room, Palace of Westminster, 1848–64

30 Octagon Room, Garden Pavilion in the
grounds of Buckingham Palace. Engraving, 1846

Dyce also received important commissions from Prince Albert,
who from the time of his appointment as chairman of the Royal
Commission became one of the leading supporters of State patronage.
As a young man, Albert had, under the influence of his tutor Baron
Stockmar, received a thorough grounding in the appreciation of the
fine arts. He was familiar with the principal picture galleries of Europe
and knew at first hand the murals of Cornelius and his school in
Munich. It was due to the astute judgment of Peel, the Prime
Minister, himself a connoisseur and collector of Old Masters, that
Albert became involved in public life as an energetic promoter of the
arts, not only presiding over the Westminster murals scheme but also
over the organizing committees of the Great Exhibition of 1851 and
the Manchester Art Treasures Exhibition of 1857; the former was
devoted to manufactured goods, while the latter was a huge
exhibition of the fine arts, including an astonishing array of Old
Master paintings borrowed from private collections and a large group
of British paintings, both historical and contemporary.

In addition, Albert and Victoria, whose taste he guided, set a public

47

example by their personal patronage. For their new house at Osborne on the Isle of Wight they bought the work of living painters from the Royal Academy. Albert also helped foster the fresco movement: in 1843, as a kind of trial run for the Westminster murals, he had asked a number of Academicians to decorate a small garden pavilion in the 30 grounds of Buckingham Palace with scenes from Milton's *Comus* in one room, subjects taken from the work of Sir Walter Scott in another and Pompeian grotesques in a third. The enterprise was as much inspired by Raphael's famous decorations for the Villa Farnesina as by the murals of the Nazarenes at the Casa Bartholdy in Rome. The pavilion fell into disrepair and was demolished in 1928, but a second royal fresco commission, Dyce's Raphaelesque *Neptune resigning to Britannia the Empire of the Sea* (1847), remains *in situ* at Osborne.

Albert was also an important collector of Old Masters. The leading personalities behind the revival of the early Renaissance style in Victorian painting, the Prince Consort, Dyce and Eastlake, were pioneers in the contemporaneous change in taste from the Carracci, Reni and the Baroque to artists of the age before Raphael, such as Duccio, Fra Angelico and Gentile da Fabriano, examples of whose work were bought by Albert in the late 1840s; at this time Italian 'primitives' were still regarded with suspicion by most British collectors.

Eastlake, Albert's chief ally in the field of connoisseurship, first made his reputation as a painter with scenes of Italian peasants and banditti in the Roman Campagna. He also attained celebrity for his 31 religious works, notably *Christ blessing little Children* (RA 1839), inspired by Overbeck's painting of the same subject but, typically for Eastlake, lacking the vigour of its model. Eastlake's graceful and restrained treatment, obeying the academic rules of harmonious composition and balance between lights and darks, is a pointer to his personality and to his subsequent career as a scholarly connoisseur and a tactful and meticulous art administrator. He exemplified a new type, the painter-turned-public-servant, of which the Victorian age was to furnish further examples in Richard Redgrave, Sir Edward Poynter (1836–1919) and Thomas Armstrong (1832–1911). Eastlake was secretary to the Royal Commission from 1841, Keeper of the National Gallery from 1843–47, and President of the Royal Academy from 1850, when he also received a knighthood; as Director of the

31 Sir Charles Lock Eastlake, *Christ Blessing Little Children*, 1839

National Gallery from 1855 until his death in 1865 he transformed the young institution into a collection of world stature, and his career as a painter was quite overshadowed.

The later history of the Westminster murals was unworthy of the hopes that lay behind the original scheme. From the start there had been complaints about irregularities. Many of the competition prizewinners had not been given commissions; the designs of some who had were rejected and other artists were invited to replace them. The historical authenticity of several subjects had been doubted. There were bureaucratic delays, complaints about mounting expenditure and unforeseen technical problems such as the time it took for fresh plaster to dry. There was little co-ordination between decorative work and painting, for Barry, the architect, who took charge of the carvers and gilders, would have nothing to do with the artists, with the result that Maclise, for instance, was driven to distraction because of the coloured reflections on his panels caused by the stained glass in the Royal Gallery. Some of the murals were justly criticized by the

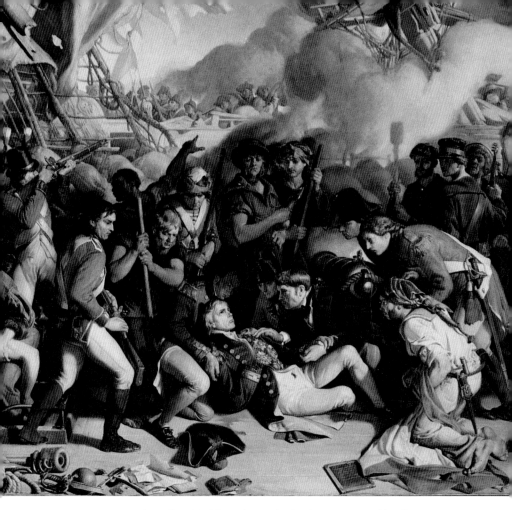

32 Daniel Maclise, *Trafalgar: the Death of Nelson*, 1863–65, (detail),
finished study for House of Lords mural

press as uninspired, but the principal failure, which made a public
mockery of the whole affair, was the disastrous use of fresco. As early
as 1854, blistering was noted in some of the paintings; in the early 60s
many of the murals were cracking and darkening, but all attempts at
restoration failed. By this time the Munich style appeared artificial
and old-fashioned, and once the chief movers of the scheme had died
(Albert in 1861 and Eastlake in 1865), the impetus to complete was

lost. C.W. Cope laboured on in the Peers' Corridor until 1866 at his series of scenes from the Civil War, but all other outstanding commissions were cancelled and the scheme, much reduced from its original scope, came to an ignominious end.

Because of the early problems with fresco, several artists had changed to the waterglass technique, a watercolour process fixed to the wall with silica, which unlike fresco allowed for retouching and alteration. Even this proved problematic. Amongst the last of the murals to be commenced were Maclise's two frieze-like battle scenes in the Royal Gallery, both carried out in waterglass, *The Meeting of Wellington and Blücher* (1858–61) and *Trafalgar: the Death of Nelson* 32 (1863–65). Tragically, Maclise could see the colour of the first disappearing as he worked away at the second. But even in their present, near-monochrome state, they are the most powerful of all the Westminster murals and the culmination of his career. Born in Ireland, Maclise had first made a name for himself as a talented portrait draughtsman and caricaturist, and from the 30s became a successful painter of flamboyantly colourful and crowded literary and historical set-pieces in a hard German style, such as *The Play Scene from Hamlet* (RA 1842), *Caxton's Printing Office* (RA 1851) and *Peter the Great at Deptford* (RA 1857). Maclise does not appear to have visited Munich until 1859 and must have learned from the many German books and prints circulating in Britain. In the two battle scenes, Maclise assimilated the more obvious German mannerisms into his own style. The paintings are packed with realistic incident, but the overall impression is one of convincing heroism and grandeur, a partial vindication at least of the attempt to foster a new school of British history painting.

Behind the Munich fresco revival, so influential on the Westminster scheme, lay the growth of German national consciousness manifested in the study of German legend and history. This had a perhaps surprising influence on another aspect of British art, the painting of fairies, which reached its apogee in the 1840s and early 50s. In the late 18th and early 19th centuries German writers such as the brothers Grimm had explored romantic legends, some of which were taken up by British illustrators and painters like George Cruikshank (1792–1878) and Maclise, whose weird *Scene from Undine* (RA 1844), from the German writer La Motte Fouqué, was bought by Queen Victoria as a birthday present for Albert. But the British also used

native sources; the Irish-born Maclise illustrated two books of Irish fairy stories and poems, and Shakespeare's *A Midsummer Night's Dream* and *The Tempest* provided the subjects for many fairy paintings, such as *The Quarrel* and *The Reconciliation of Oberon and Titania* (1850 and 1847) by Joseph Noel Paton (1821–1901). Though Blake and Fuseli provided some stylistic precedents, the hard, wiry outlines and naturalistic foliage writhing with monstrous sprites and elves owed much to the German illustrators Moritz Retzsch (1779– 1857), Moritz von Schwind (1804–71) and Ludwig Richter (1803–84). 34

One of the most promising early Victorian fairy painters was Richard Dadd (1819–87), who in the early 40s exhibited subjects from *A Midsummer Night's Dream* and *The Tempest*, noteworthy for their delicacy of touch and supernatural lighting effects, probably influenced by the theatre. In 1842–43 he travelled in the Middle East as companion to a wealthy lawyer who wanted a record of his journey and it was at this time that Dadd first experienced the delusions and nervous depression which signalled his approaching insanity. In 1843 he murdered his father and escaped to France where he was later arrested and extradited, spending the rest of his life first in Bethlem Hospital, London and from 1864 until his death in 1887, in Broadmoor prison for the criminally insane. Dadd was extremely fortunate in being attended by sympathetic doctors who encouraged him to paint. Isolated from the world outside and from new developments in art, he fell back upon the themes of his sane period, historical and literary subjects, recollections of the Middle East, portraits and fairies. The body of work he produced after he went mad is often bizarre and puzzling, but even in his disturbed state he painted with a clarity of form which reflects Nazarene influence: on his way back from the Middle East he had visited Overbeck in Rome. Dadd's most extraordinary achievement is the enigmatic *The Fairy Feller's Master-Stroke* (1855–64), a hallucinatory vision of fantastic creatures, seen as if with a magnifying glass through a delicate network of grasses and flowers. All are watching the fairy woodman (or 'feller') aiming his axe at a hazelnut, a moment pregnant with never-to-be-explained significance.

33

33 Richard Dadd, *The Fairy Feller's Master-Stroke*, 1855–64

34 Sir Joseph Noel Paton, *The Reconciliation of Oberon and Titania*, 1847

Dadd's work was never shown or appreciated until the 20th century, but in any case fairy painting soon went out of fashion at the public exhibitions, though it lived on in the book illustrations of Richard Doyle (1824–83) and later Arthur Rackham (1867–1939). The German influence on British painting waned rapidly. The piety and simplicity of the Nazarene style were seen in the 50s and 60s in the biblical scenes of W.C.T. Dobson (1817–98), in the portraits and subject pictures of Herbert and Cope, and in the 70s in the religious work of Paton. But mural painting as a State-sponsored public

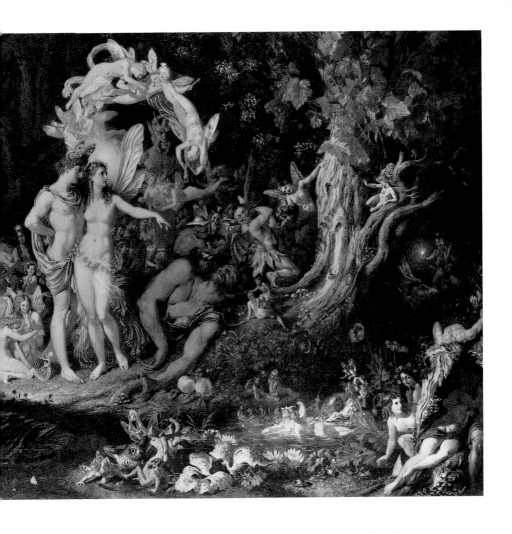

medium for the communication of national ideals was essentially alien
to British taste and was discredited by the Westminster experience.
The German-inspired Westminster style was repeated in a Raphael-
esque fresco of *The School of the Lawgivers* (1853–59) by G.F. Watts at
Lincoln's Inn, but apart from this and the ill–fated Pre-Raphaelite wall
decorations at the Oxford Union (1857), mural painting became a
domestic, decorative art until its revival in late Victorian public
buildings.

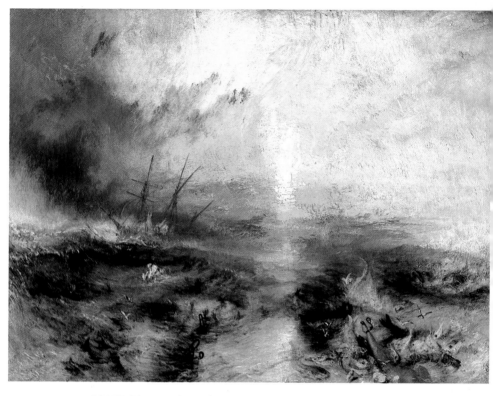

35 J.M.W. Turner, *Slavers throwing overboard the Dead and Dying. Typhon coming on*, 1840

The Post-Romantic Landscape

In the first three decades of the 19th century, British landscape painting was transformed from a fairly humble branch of art, based on topography, to one that was rich and vitally creative. Of all the artists who had contributed to this development, the greatest was J.M.W. Turner. Between 1837 and his death in 1851 his art deepened in its expressive range and was dominated by three themes: the sea, Italy (especially Venice), and the Alps. Through all these he conveyed the immensity of nature compared with the smallness of man, often uniting the sky with mountains or tempestuous seas in a tremendous vortex of movement, dwarfing the tiny figures. Turner regularly summered in Switzerland in the early 40s and from these visits came the late Swiss watercolours, which combine a sense of the vast scale of the Alpine landscape with brilliantly luminous colour effects. His last two visits to Venice, in 1836 and 1840, produced a succession of watercolours and finished oils steeped in gorgeous colour and light-filled atmosphere; in the verses which accompanied the exhibited paintings Turner made it clear he saw Venice as a decadent facade, a doomed city living on its past.

From the 30s the sea, always a preoccupation, came to represent the most powerful embodiment of the forces of nature, whether calm or, more frequently, stormy, as in *Slavers throwing overboard the Dead and* 35 *Dying. Typhon coming on* (RA 1840), a gruesome subject based on the story of a slave ship in which slaves dying of an epidemic were thrown to sea so that insurance, available for loss at sea but not from disease, could be claimed. 'Is the picture sublime or ridiculous? Indeed I don't know which', wrote Thackeray. 'Rocks of gamboge are marked down upon the canvas; flakes of white laid on with a trowel; bladders of vermilion madly spirited here and there . . . The sun blows down upon a horrible sea of emerald and purple.' 'Who will not grieve at the talent wasted upon the gross outrage in nature?' wrote the critic of the Art Union. This sort of puzzled or hostile reaction regularly greeted Turner's exhibited oils towards the end of his life; his most

vaporous late work was wisely kept from public view. But though taste was moving towards a greater tightness of handling and a more literal-minded attitude to representation, a circle of avid Turner collectors continued to appreciate his work, and many lesser artists drew inspiration from it, such as the Bristol painter James Baker Pyne (1800–70) whose expansive Continental views, often bathed in golden light, resemble Turner's landscapes in composition and palette, though not in subtlety or range.

Turner's use of landscape to convey heightened emotional states was developed by John Martin (1789–1854) and Francis Danby (1793–1861), who had come to prominence as rivals in the production of spectacularly dramatic pictures of cataclysmic events. Examples are Martin's *The Fall of Babylon* (1819), and Danby's *The Delivery of Israel out of Egypt* (RA 1825) and *The Opening of the Sixth Seal* (RA 1828). The large size, lurid lighting effects and generally sensational treatment of these pictures can be related to contemporary dioramas and panoramas, popular entertainments at which large painted cloths were displayed, animated by the manipulation of artificial light.

The careers of both artists continued into the reign of Victoria. Martin employed many of Turner's compositional tricks, such as vortex-like forms and sheets of radiant light, but his drawing was mechanical compared to Turner's and he exaggerated his effects, imagining fantastic craggy rocks dwarfing multitudes of small figures or opening up impossibly dizzying architectural perspectives. The mezzotints he published of his work, including his illustrations to *Paradise Lost* and the Bible, were widely circulated, bringing him a European reputation as a master of the sublime. Martin may have been influenced by the fantasies of Piranesi or his English follower J.M. Gandy (1771–1843). The sweeping walls of granite and massive colonnades in Martin's visions also owed much to his interest in engineering, for he was an inventor of visionary schemes, drawing up ambitious projects for lighthouses, mine safety, the improvement of London's water supply and sewage disposal and the construction of the Thames embankment. None were executed. Early in his career he quarrelled with the Academy, and became one of its most constant critics. Believing that his pictures were badly hung there, he often arranged for them to be shown elsewhere. The climax of his work was
36 a trilogy of huge canvases, *The Great Day of His Wrath*, *The Last Judgement* and *The Plains of Heaven*, completed in 1853 shortly before

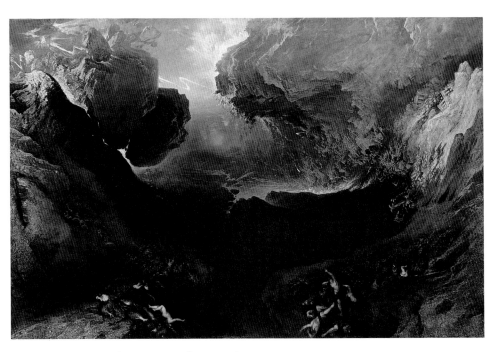

36 John Martin, *The Great Day of His Wrath*, 1851–53

his death. The paintings toured Britain and America, exhibited in booths and public halls to a large popular audience. But though the engraved versions sold, the pictures themselves appeared theatrical and outmoded to contemporary collectors and failed to find buyers.

Danby's early work consisted of Bristol views, painted with quiet clarity. He also visited Norway to study its remote and desolate landscape. But his reputation was made in the 20s with dramatic subjects similar to those of Martin. In 1829 his career was interrupted when his wife deserted him for the painter P.F. Poole, and Danby quickly left England with his children and their governess, living in Geneva and Paris, where several more children were born. He reappeared in London in 1840 when his vast *The Deluge* was shown on its own in a dealer's gallery and from 1841 until his death twenty years later he exhibited annually at the Royal Academy, although he never became a member. Danby loved to paint moonlight, sunset or sunrise. *The Deluge* was the last of his epic subjects; his later work often evokes a mood of concentrated and dreamlike tranquillity.

Sometimes this was expressed through imaginary visions such as *The Woodnymph's Hymn to the Rising Sun* (RA 1845); but more often he reverted to the pure landscapes of his younger days, as in *The Evening Gun* (first version RA 1848), which was praised for its deep solemnity by the French critic Théophile Gautier.

The limpid calm of this work recalls the paintings produced by Samuel Palmer (1805–81) and John Linnell (1792–1882) at Shoreham, Kent in the 20s and early 30s. Though now chiefly remembered for their youthful landscapes, both artists passed the majority of their working lives as Victorians. Their later work carried with it many echoes of the earlier pastoral vision, but the demands of family and career, and the pressure to sell led to a distinct loss of intensity. In his Shoreham landscapes Palmer had created an idyllic world of pastoral contentment, expressive of a mystical relationship with nature. At

37 Samuel Palmer, *The Lonely Tower*, 1864

38 Francis Danby, *The Evening Gun*, 1857

Shoreham he was sustained by a small private income, but when he left he was forced to make his style more commercial. In 1837 he married Linnell's daughter and they travelled to Italy, where he painted vividly coloured views of Rome and Tivoli. Returning to England in 1839, he began to exhibit regularly at the Old Water-Colour Society and later took up etching. He produced a large body of sensitive and accomplished work rooted in the study of nature and frequently revived the pastoral themes of harvest and shepherds, but he had to struggle to make a living, often relying for his income on teaching. Towards the end of his life he received a commission from L.R. Valpy, Ruskin's solicitor, for subjects that affected the artist's 'inner sympathies'. Palmer responded with a series of large, richly handled watercolours illustrating Milton's poems. Palmer's *The Bellman* (1864) and *The Lonely Tower* (1864) show that he had 37 not lost the power to convey the intensity of his Shoreham period, though on a less intimate scale than before.

39 John Linnell, *The Last Load*, 1874–75

John Linnell was far more successful in a material sense, becoming the most prosperous and prolific painter of landscape since Turner. Yet it was only after 1848 that he was able to concentrate wholeheartedly on landscape. In 1812 he had set out to become a painter of 'poetical landscape' but was forced to make a living from portraits and copying Old Masters. His biblical scenes of the 30s and 40s met with little success with dealers or patrons, until his reputation was made with *Noah: The Eve of the Deluge* (RA 1848). This was sold for £1000, three times the price of any of his earlier works. He subsequently developed landscape as a vehicle for religious expression, using the symbolic associations of sheep, harvest and storm. Linnell referred to his pictures as 'aspects of nature' or 'spiritual artistic facts'. Though his paintings are vaguely based on the scenery around Redhill, Surrey where he moved from London in 1851, he deliberately conveyed unspecific effects, re-using sketches done earlier rather than recording what he saw in front of him: 'Madam, I

am not a topographer', he is said to have replied to an enquiry as to the location shown in one of his paintings. At a time when the Pre-Raphaelites were setting a fashion for precision, he employed a loosely dappled texture and generalized richness of colour. Of a miserly disposition, Linnell made agreements with dealers to produce large quantities of pictures; his work is repetitive but at its best conveys a powerful, epic mood. 39

An alternative to the romantic interpretation of landscape was the more prosaic, Dutch-inspired approach of the Norwich school. This, combined with the work of Constable, was taken as a model by Frederick Richard Lee (1798–1879) and Thomas Creswick (1811–69), who during the first half of Victoria's reign regularly exhibited conventionally scenic views of the British countryside, always green and smiling. The picturesque landscapes and shore scenes of William 40

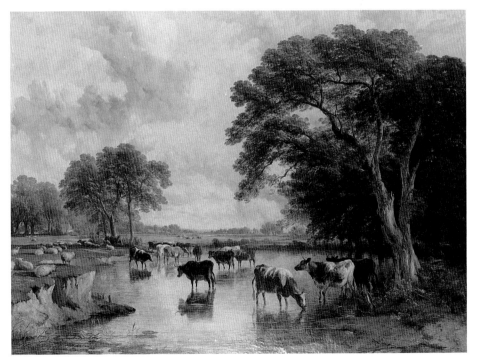

40 Frederick Richard Lee and Thomas Sidney Cooper, *Cattle on the Banks of a River*, 1855

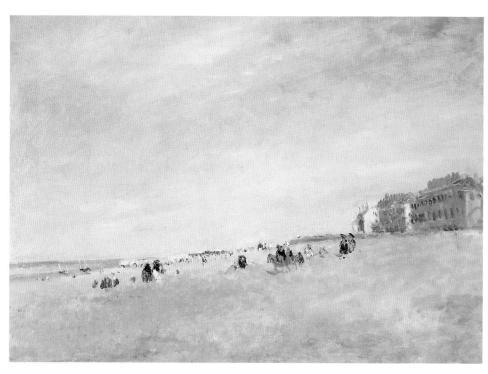

41 David Cox, *Rhyl Sands, c.* 1854

Collins (1788–1847), W.F. Witherington (1785–1865) and William
Shayer (1787–1879) were often enlivened by incidents of the kind
found in genre painting – boys fishing or birds'-nesting, horses
grazing or peasants gossiping by the cottage door – motifs harking
back to the rustic groups of the 18th-century painter George Morland
(1763–1804), the teacher of Collins. Thomas Sidney Cooper (1803–
1902) painted endless competent but unimaginative landscapes with
cattle and sheep, and Richard Ansdell (1815–85) almost rivalled
Landseer at grand sporting groups and dying stags. In the late 40s and
early 50s Ansdell and Cooper sometimes put the sheep and cattle into
the landscapes of Creswick and Lee, reviving a practice common
amongst the 17th-century Dutch school. It is easy to dismiss these
landscapes and rustic genre paintings as furnishing pictures; they
present the countryside as though it were a timeless haven of rest and
refreshment for the tired businessman and they lack the breadth or

vigour of Constable and his scientific interest in effects of weather. But these painters produced many works of great charm which had widespread appeal for Victorian picture buyers.

The practice of rapid and fluent sketching from nature had been developed in the early decades of the century by John Constable and David Cox (1783–1859). It brought a new freshness and spontaneity not only to their out-of-doors studies in oil or watercolour but also to the finished pictures derived from them, although these were painted in the studio. In the early Victorian period the careful finish demanded by collectors became the rule with most artists, especially for exhibition pictures. Nevertheless, Cox continued to paint in a freely handled style, adept at capturing passing effects of wind, weather, light and atmosphere. This breadth was preserved even in his more ambitious exhibited watercolours, for which he occasionally chose subjects of an imaginative resonance, such as the solemn procession of *The Welsh Funeral* (1848) or the lights of *The Night Train* (1849) rushing across a misty plain.

Late in life Cox took up oil painting. Around 1840, just before he retired from London to Harbourne, near his native Birmingham, he received lessons from the Bristol landscapist William Müller (1812–45), an uneven painter possessed of a fluent and energetic technique. The combination of Muller's boldness and Cox's lack of conventional experience in using oils resulted in a series of softly atmospheric paintings by Cox unparalleled in British art. His sparkling beach scene *Rhyl Sands* (*c*. 1854), one of a series based on watercolours done on the spot, anticipates Boudin and the Impressionists in its breezy, open-air freshness, achieved by loose dabs of paint and radical simplification of detail.

Cox made regular sketching trips to North Wales, where Betws-y-coed became a centre for artists largely as a result of his annual visits. Many artists painted romantic mountain views; Pyne and Samuel Bough (1822–78) often worked in the Lake District, and Bough later settled in Scotland where Horatio McCullogh (1805–67) painted grand Highland scenery in a free and vigorous style. Painters also frequently travelled abroad, for the Victorians had an inexhaustible appetite for views of unfamiliar places. During the Napoleonic Wars contact between Britain and Continental Europe ceased, but as soon as travel was possible artists began to cross the Channel, Turner in 1817, the watercolourist Samuel Prout (1783–1852) in 1818 and then

41

42

65

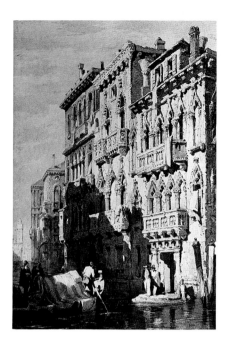

42 Samuel Prout, *The Palazzo Contarini-Fasan on the Grand Canal, Venice*, after 1841

43 Thomas Uwins, *An Italian Mother Teaching her Child the Tarantella (The Lesson)*, 1842

many others. They filled their sketchbooks with drawings of narrow medieval streets and crooked houses hung with washing, of crumbling Gothic churches, castles and Italian campaniles, or tangles of masts and rigging leading the eye into a coastal scene, with figures in folk costume to give scale and local colour. The drawings and watercolours were brought back to England and used as raw material for the exhibited paintings which became a common and enormously popular feature of the annual exhibitions in the 30s and 40s.

The vision of these topographical painters, such as James Duffield Harding (1798–1863) or William Callow (1812–1908), was coloured by the theory of the picturesque, first advanced in the 18th century, an interpretation of landscape which valued asymmetry, irregularity and uneven texture more than balance, harmony and smoothness. Often somewhat repetitive in composition, such paintings gave a prettified view of their subjects, one which was at odds with the traveller's experience of mosquitoes, dirty inns and inedible food as recorded in the artists' letters and diaries, from which emerges a xenophobic view of 'abroad'. There was little attempt to give insight into the local culture or way of life except in the most superficial touristic terms.

66

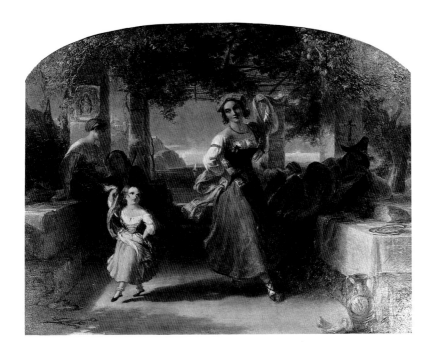

Nevertheless, these pictures served to give information about the places depicted to an audience unfamiliar with such sights.

The interest in Continental views was linked to the growing opportunities for tourism. Ruskin's parents undertook their first European tour after their curiosity had been awakened by a book of Prout's European sketches. Publishers often commissioned artists to undertake journeys to produce watercolours specifically for engraving in travel or guide books, such as the *Landscape Annuals* or *Heath's Picturesque Annuals*, series of volumes devoted to different countries and containing engravings and descriptive travelogues. Artists also made engravings of architectural antiquities or views chosen for their literary associations with writers such as Scott or Byron.

Linked to the taste for picturesque views was a kind of painting combining foreign landscape with genre. This was particularly associated with Italy, where a number of British artists active in the early Victorian years had spent extended periods in the 20s and 30s, including Eastlake, William Collins, Thomas Uwins (1782–1857) and Penry Williams (1798–1885), who settled there permanently. All exhibited romanticized Italian genre scenes of dashing brigands, pious

43

friars and pilgrims, or peasants in regional costume performing folk dances. These pictures too were popular subjects for engravings in the *Annuals* and *Books of Beauty*.

Such illustrated publications were an important source of patronage for artists, but the fashion became too popular for its own good. So many painters producing similar views of the same old places using the same tired landscape conventions – Mont-Saint-Michel, Caen, Rouen, Bruges, Venice, Naples – led to wearisome repetition, and ultimately had a deadening effect on landscape painting. Most artists went to France, the Low Countries, Germany, Switzerland and Italy but some went further, seeking unusual locations, despite the difficulties of travel in less developed countries. Wilkie was one of the first. He had been to Spain in 1825 and the Middle East in 1840. David Roberts (1796–1864) and J.F. Lewis (1805–76) followed; both went to Spain in 1832, and then between 1838 and 1842 Roberts, Lewis and Müller each independently toured Greece, Egypt and the Holy Land. Müller also visited Lycia in south-western Turkey in 1843, accompanying the expedition of the archaeologist Charles Fellowes. Müller's Lycian sketches were never published but Roberts' tour of the Middle East resulted in a remarkable series of over 200 lithographs of Egypt, Syria and the Holy Land, published between 1842 and 1850. Other artists had previously travelled to the Middle East alone or in connection with archaeological expeditions, sometimes to investigate biblical places, but the record made by Roberts was more comprehensive and more vivid than that of his predecessors, including not only all the principal ancient Egyptian monuments, temples and statues but also the mosques, which Müller had not received permission to enter, classical remains and biblical sites. Roberts was also able to use his sketches as the basis for a great many studio oil paintings.

The striking character of Roberts' views was due to his background in the theatre. After training in Edinburgh as a high-class house painter, gaining illusionistic skills in imitating marble and wood graining, he became one of the best-known scene painters for the London stage. The theatre at this period attracted a popular rather than a highbrow audience, and Roberts fed its love of spectacle, designing highly successful plays, panoramas and dioramas. He was active as an architectural perspectivist, and entered architectural

44

44 David Roberts, *The Temple of Karnak*, 1838

competitions, though without success. In his final career as a painter of architectural subjects, he depicted many of the principal buildings of Europe as well as the Middle East, showing a dramatic sense of scale and a preference for unusual viewpoints, exaggerating the height of buildings and reducing the size of figures. Roberts' watercolours could convey the excitement and drama of an on-the-spot encounter with some great monument, but his oils sometimes lack atmosphere, as if they needed stage lighting to bring them to life.

Roberts' career bore some similarity to that of Clarkson Stanfield (1793–1867), who before becoming a successful fine artist was also a famous theatrical scene painter, particularly noted for his moving dioramas in the annual pantomimes at Drury Lane; for a time the two were rivals in the theatre. Stanfield, who designed the scenery for the amateur theatricals of Dickens and his circle, painted picturesque British and Continental views, but he became especially associated with marine painting. As a boy he had run away to sea, spending several years as a sailor, and he developed a close knowledge of craft and rigging. Much of his work shows river and coastal scenes with shipping painted in some detail and he was praised for the way he depicted such things as the colour, texture and movement of the waves and his ability to convey the impression of actually being at sea.
45 His *The Day after the Wreck* (RA 1844) earned Ruskin's approval: 'It is really refreshing to turn to a surge of Stanfield's true salt, serviceable, unsentimental sea.' But though the scenic quality of Stanfield's pictures gave them immediacy, like Roberts he tended to rely on conventionally picturesque compositions and to the modern eye his work lacks a convincing sense of atmosphere. Perhaps to compensate, he introduced greater sentiment into his later work, making his landscapes settings for literary or historical narratives such as *The Battle of Roveredo* (RA 1851) or, as in his most famous late painting, *The Abandoned* (RA 1856, now untraced), introducing a melodramatic pathos. It showed a broken hulk bobbing helplessly on its side in a rough sea, all trace of human life vanished and was sufficiently well known for Augustus Egg to include a print of it in the background to his triptych *Past and Present* as a symbol of hopelessness.

Stanfield's seascapes and those of contemporary marine painters such as Edward William Cooke (1811–80) and James Wilson Carmichael (1800–68) were heavily dependent on those of Turner, not however on his contemporary work but on his earlier and more

45 W. Clarkson Stanfield, *The Day after the Wreck; A Dutch East Indiaman on shore in the Ooster Schelde – Ziericksee in the distance,* 1844

solid Dutch-inspired seascapes. In the 30s and 40s critics regularly discussed the work of Turner and Stanfield together when they exhibited at the Academy, but the comparison was almost always in Stanfield's favour. Where Turner's work seemed increasingly wild and formless, Stanfield's appeared down-to-earth, naturalistic and accessible. It is a judgment that has since been reversed.

The high reputation of Turner in the later 19th century is largely due to the writings of John Ruskin (1819–1900) who during the 1850s 62 became Britain's greatest and most influential writer on art. But in the 40s Ruskin was not yet well known. He published the first volume of *Modern Painters* in 1843 and the second in 1846. Both dealt primarily with painters of landscape and above all with Turner.

Landscape was important to Ruskin; he first came to art through a love of nature. As a young man he had been deeply moved by the beauty of natural scenery, experiencing a Wordsworthian sense of emotional communion with it. Throughout his life he was subject to

moments of revelation whilst looking at nature, particularly moun-
tains, of which he had an intimate knowledge, for his youthful interest
in collecting and classifying minerals had developed into a deep study
of geology. Brought up in the evangelical tradition of interpreting the
world as a manifestation of the divine, nature was for Ruskin an
expression of God. It followed that the art of the landscape painter was
not simply a matter of painting beautiful pictures: the truthful
representation of nature was a moral imperative. The idea of
truthfulness is central to Ruskin's thinking. 'The representation of
facts is the foundation of all art', he wrote, and concluded the first
volume of *Modern Painters* with an exhortation to young artists: 'They
... should go to Nature in all singleness of heart, and walk with her
laboriously and trustingly, having no other thoughts but how best to
penetrate her meaning, and remember her instruction, rejecting
nothing, selecting nothing, and scorning nothing; believing all things
to be right and good, and rejoicing always in the truth.' This truth was
to be attained through studying and reproducing the detail of natural
forms as accurately and minutely as possible.

Ruskin arrived at this view through his own artistic practice. A
talented watercolourist of more than amateur achievement, his
earliest work consists of picturesque views using the broken line and
asymmetrical compositions of Prout and Harding, from whom he
received lessons. But in 1842, according to his autobiography
Praeterita, he was suddenly struck by the artificiality of the picturesque
way of seeing. He drew a bit of ivy at Norwood and 'when it was
done, I saw that I had virtually lost all my time since I was twelve years
old, because no one had ever taught me to draw what was really
there'. At Fontainebleau he sketched the leaves of an aspen tree: 'With
wonder increasing every instant, I saw that they "composed"
themselves by finer laws than any laws of men!'

In Turner, Ruskin saw an artist who could represent nature as it
really was instead of imposing artificial conventions upon it. He
discussed in detail the way Turner and his contemporaries represented
different aspects of nature, and found fault with many aspects of the
work of the topographical and picturesque view painters. Ruskin
demonstrated that even Turner's breadth was based on understanding
of detail, and intimate knowledge of the effects of atmosphere and
light. *Modern Painters* also criticizes some of the great masters of
classical landscape for their inaccuracies of observation, and praises

Turner as the artist with the most truthful eye. The book is itself an extended defence of Turner and was begun in response to criticism of Turner's work. Whilst the first volume compares what Ruskin saw as Turner's 'truthfulness' with the 'falsehoods' of Claude and Poussin, the second volume is full of praise for the detail and finish of the early Italian painters, newly discovered by Ruskin after his first visit to Italy; like the most advanced connoisseurs of his day, Ruskin was beginning to appreciate the simplicity and directness of quattrocento art. But he did not want artists to copy the early Italians, rather to go to nature itself for these qualities.

Ruskin first met Turner in 1840, began to collect his work, and after Turner's death, became an executor of his will and organizer of the Turner Bequest. The third and fourth volumes of *Modern Painters* were not published until 1856, the fifth not until 1860. By this time Ruskin had become famous. He had published books on architecture, he had lectured widely and from 1855–59 he had annually issued his criticisms of currently exhibited pictures in *Academy Notes*. His view of landscape painting had changed. Like many Victorians, he lost the certainty of his Christian faith as a result of the attack made on biblical truth by science. Theories of human evolution and of the geological formation of the earth destroyed the creation myth and challenged the interpretation of nature as a manifestation of divine order. Yet Ruskin came back to a belief in God and in the possibility of man's spiritual and moral redemption through the truthfulness of art and the sanctity of the creative process. In his later writings, art criticism broadened into social commentary; he put forward the idea that great art was the expression of a spiritually healthy society, and he condemned mass production as dehumanizing, laying the foundations for the belief of the Arts and Crafts Movement in the value of individual creativity.

Modern Painters is full of extremely detailed description of the way artists depicted minutiae such as water swirling and foaming over rocks, the lines of twigs, leaves and flowers, the texture and colour of mist and reflections. Similar detail crept into the writing of other critics as they began to look harder and apply more rigorous standards. But *Modern Painters* had an even more important effect. Ruskin's conviction that art involved man's whole spiritual nature raised the level of artistic debate. It made art serious and important.

46 Dante Gabriel Rossetti, *The Girlhood of Mary Virgin*, 1848–49

The Pre-Raphaelites

The Pre-Raphaelite Brotherhood was formed in September 1848. It had seven members, of whom the three most important were John Everett Millais (1829–96), a brilliant student at the Royal Academy Schools, his fellow student William Holman Hunt (1827–1910), and Dante Gabriel Rossetti (1828–82), son of an Italian émigré and a budding poet as well as a painter. They brought into the group three friends, James Collinson (1825–81), who was in love with Rossetti's sister Christina, the sculptor and poet Thomas Woolner (1825–92), and Frederic George Stephens (1828–1907), who later gave up painting to become an art critic; the seventh member was Rossetti's brother William Michael (1829–1919), not an artist at all but a clerk in the Inland Revenue, who became the historian of the movement. The new society made no clear statement of its aims, and the paintings of its members changed in character as their personalities matured. Nevertheless, for a few years they and their associates worked closely together, sharing ideas and enthusiasms, and enough common interests emerged in their pictures to create the appearance of a coherent style.

The main factors that united the Brotherhood in 1848 were first of all their youthful idealism: Millais, the youngest, was only 19 and none was over 23. Second was their dislike of much of what they saw at the Academy, which they found frivolous, stale and repetitive. Third was their interest in Ruskin; Hunt had read *Modern Painters* in 1847, and he at once fired his friends with his enthusiasm for Ruskin's ideas, which were reflected in the naturalistic detail in the early work of the PRB. Lastly was their sympathy with the taste for early Italian painting, as implied by the title Pre-Raphaelite.

The first paintings by members of the Brotherhood included Rossetti's *The Girlhood of Mary Virgin* (1848–49), shown at the Free 46 Exhibition in London, a short-lived alternative to the Academy, and Millais' *Isabella* (RA 1849). Both bore after their signatures the letters 49 PRB, the meaning of which was not generally known. The new style

75

employed bright colour without the chiaroscuro recommended by
academic teaching. The faces were not idealized and the figures, stiff
and modelled without deep shadow, occupy a flattened picture space.
These features were derived from the Brotherhood's limited
experience of Italian art, acquired primarily at second hand. On the
night the Pre-Raphaelite Brotherhood was founded, the members
47 had examined a volume of engravings by Giovanni Lasinio (1789–
1855) reproducing the 13th- and 14th-century frescoes in the Campo
Santo at Pisa. The style of the engravings, and that of the German
outline illustrators like Retzch, was imitated in early Pre-Raphaelite
drawings such as Rossetti's *Dante drawing an Angel on the First*
48 *Anniversary of the Death of Beatrice* (1849), as if in defiance of the softly
shaded technique taught at the Academy Schools. The flatness and
linearity of the drawings, transferred to the oils, explains many of the
oddities of the early Pre-Raphaelite manner.

The subjects taken by the Pre-Raphaelites were deeply serious. *The*
46 *Girlhood of Mary Virgin* related to the Tractarian belief in the cult of
the Madonna and the ritualism associated with it, both subjects of
49 controversy in the Church of England. *Isabella*, from a poem by
Keats, then little appreciated, embodies a tale of passion, jealousy and
murder based on a story by the early Italian writer Boccaccio. Later
works depicted moments of moral crisis from Shakespeare or

76

47 Giovanni Lasinio, *The Miracles of St. Rainier, c.* 1832

48 Dante Gabriel Rossetti, *Dante drawing an Angel on the First Anniversary of the Death of Beatrice,* 1849

49 Sir John Everett Millais, *Isabella,* 1848–49

contemporary poets such as Tennyson, Browning and Patmore. The principal action in each picture was made simple and obvious in emulation of the clarity of early Italian painting, but the narrative was amplified by means of symbolic allusion, religious and colour symbolism in the Rossetti, and in the Millais details such as the falcon tearing at a feather behind the wicked brother or the passion flower near Isabella. This traditional medieval and Renaissance way of enriching a story was rediscovered by Ruskin, who in the second volume of *Modern Painters* demonstrated how each seemingly representational detail in Tintoretto's San Rocco *Annunciation* had a symbolic meaning. It was a lesson that impressed all the Pre-Raphaelites but particularly Hunt who made symbolic realism a cornerstone of his art.

The idea of forming a Brotherhood was inspired by the Nazarene example, but it was then quite common for like-minded artists to meet at each others' studios to draw and discuss their work. One of the oldest of such groups, the Sketching Society, founded in 1808, continued until 1851; its members included Uwins, Leslie and Stanfield. In the 40s Frith, Egg, Dadd, Henry Nelson O'Neil (1817–80) and John Phillip (1817–67), calling themselves The Clique, used to meet weekly for drawing and mutual criticism and the Pre-Raphaelite Brotherhood was preceded earlier in 1848 by a drawing club, the Cyclographic Society, to which most of the future members of the PRB belonged.

The Pre-Raphaelites also drew inspiration from the British advocates of the Nazarene style, from Dyce, who had encouraged Holman Hunt whilst a student, and from Ford Madox Brown. Trained in Belgium in a style derived from French romanticism, Brown's early work was dark, mannered and dramatic. On the way to Italy in 1845–46 he visited Basle where he was much struck by the work of Holbein and in Rome he visited the studio of Overbeck. The pictures he painted on his return are brightly coloured, clearly modelled and evenly lit, one showing Chaucer, part of an abandoned scheme to paint a triptych of English poets, the other Wycliffe, author of the first English translation of the Bible. Both illustrate Brown's passionate interest in English literature and language. The altarpiece-like format and symmetry of the Wycliffe painting is very Nazarene, but the figures are more natural-looking. In these pictures Brown had arrived at a kind of Pre-Raphaelitism before the style had a name. It

50

50 Ford Madox Brown, *The First Translation of the Bible into English: Wycliffe Reading his Translation of the Bible to John of Gaunt*, 1847–48

impressed the young Rossetti, who wrote to Brown and briefly took lessons from him. Though Brown, older than the others, never joined the Pre-Raphaelite Brotherhood, he was closely involved in the movement, sharing in and contributing to its evolution, and later in turn learning from its members.

In 1850 the Brotherhood brought out a journal, *The Germ*, which has the distinction of being the first little magazine to be published by an artistic group. *The Germ* included poems and articles by members of the Brotherhood and by friends such as Coventry Patmore and Rossetti's sister Christina. Though edited by William Michael Rossetti, it was chiefly the initiative of Dante Gabriel and demonstrated his belief in the close links between painting and literature. As a young man he had been undecided whether to take up poetry or art

and in his work words and images are conceived of together. He frequently wrote poems to accompany his pictures, as in the case of
46 *The Girlhood of Mary Virgin*, which has two sonnets inscribed on its frame, and he became obsessed with his namesake the poet Dante, translating his poems into English and making many paintings and drawings of Dante subjects.

The Germ ran for four numbers, sold few copies, and then folded. Nevertheless, its publication drew attention to the existence of the Brotherhood and the meaning of the initials PRB was revealed in a malicious article in the *Illustrated London News*. The earliest Pre-Raphaelite paintings had been politely received, but the critics now began to turn against the Pre-Raphaelites, condemning their figure style for 'all the objectionable peculiarities of the infancy of Art'.
51 Millais' *Christ in the House of his Parents* (RA 1850) provoked a stream of abuse. It was 'revolting', it was 'a nameless atrocity', and Charles Dickens wrote a particularly vitriolic attack in which suspicion of Roman Catholicism, aroused by the Tractarian symbolism of the sacrifice of Christ's blood, was mixed with shock at the realistic rather than divine character given by the artist to his Holy Family, with their wrinkled garments, dirty fingernails and unidealized, portrait-like faces, painted from friends and neighbours.

Ruskin had not been aware of the Pre-Raphaelites until forced to look at *Christ in the House of his Parents* by Dyce, one of the few Academicians who supported the young artists. The following year, when the Pre-Raphaelite works at the Academy received further hostile attacks, Ruskin was persuaded to intervene and wrote two letters to *The Times*, followed by a pamphlet on Pre-Raphaelitism. Though not uncritical, he supported the interest of the PRB in the early Italians, arguing that the young painters were seeking to go back to 'archaic honesty' rather than 'archaic art': 'They intend to return to early days in this one point only – that as far as in them lies, they will draw either what they see, or what they suppose might have been the actual facts of the scenes they desire to represent, irrespective of the conventional rules of picture-making; and they have chosen their unfortunate though not inaccurate name because all artists did this before Raphael's time, and after Raphael's time did not do, but sought to paint fair pictures rather than represent stern facts; of which the consequence has been that from Raphael's time to this day, historical art has been in acknowledged decadence.' Ruskin predicted a bright

51 Sir John Everett Millais, *Christ in the House of his Parents*, 1849–50

future for the new school of painting and the support of such an important critic forced people to take the Pre-Raphaelites more seriously, though their work continued to draw adverse criticism from the diehards in the art establishment.

The 1852 Summer Exhibition included *Ophelia* by Millais, taken from Shakespeare, Hunt's *The Hireling Shepherd*, an idyllic landscape which also incorporated an allegory of the Church neglecting the spiritual needs of its flock, and Brown's '*The Pretty Baa Lambs*', a pastoral in 18th-century costume. All three were painted out of doors in microscopic detail, with the paint applied over a wet white ground to produce a brilliant effect of colour. Brown's picture, the least minutely handled of the three, was the most advanced as he had considered his figures integrally with the setting, painting them all in the open, in strong sunlight and with coloured shadows, whereas the others added their figures later in the different light of the studio. Together, these paintings marked a new stage in the pursuit of truth to nature. The dazzling effect of so much highly coloured detail in equally sharp focus all over the surface of the canvas must have looked

55

54

81

particularly strident amongst the muted colour and golden varnish prevalent at the Academy.

By this time, the Pre-Raphaelites had established as their hallmarks bright colour, naturalistic detail and intensity of feeling, sometimes expressed through historical or literary subjects, sometimes modern and often combined with symbolic allusion and religious associations. Within this shared style, the differences rather than the similarities now began to become more apparent. Rossetti continued with the self-conscious archaisms of the earliest Pre-Raphaelite pictures, whereas Hunt and Millais worked in a more fully rounded, representational style. The Brotherhood began to disintegrate. Collinson had resigned in 1850 as he had become a Roman Catholic. In 1852 Woolner, despairing of commissions, emigrated to Australia to seek his fortune in the goldfields. The next year Millais was elected an Associate of the Academy, a consequence of the popularity of *The Huguenot*, shown there in 1852. For some of the Brotherhood he had now entered the opposite camp. Rossetti gave up exhibiting in public after 1850 and Brown no longer showed at the Academy after 1853. Hunt left in 1854 for the Middle East and was away for two years. But though the leaders of the Pre-Raphaelites were moving apart, the style had been taken up by a number of other artists close to the Brotherhood though not members of it, such as Arthur Hughes (1832–1915) and Robert Braithwaite Martineau (1826–69), and a wider following soon developed. The mid- and late 1850s saw the influence of the style spreading. Paintings by the Pre-Raphaelites were included in the British section of the Paris Exhibition of 1855, and the Manchester Art Treasures Exhibition of 1857. Some of the Pre-Raphaelites also arranged their own exhibition at Russell Place in London in 1857 and took part in an exhibition in America.

Quite early in the history of the Brotherhood there emerged a small number of collectors who bought their pictures, often in opposition to critical opinion. One of the first was Thomas Combe, superintendant of the Oxford University Press, and a prominent Tractarian, who acquired works by Hunt, Millais and Charles Collins (1828–73) in 1850 and 1851. Most of Combe's collection is now at the Ashmolean Museum, Oxford. Many Pre-Raphaelite paintings were purchased by the Tottenham coach-maker and Turner collector B.G. Windus, and Ruskin was himself a patron, particularly of Rossetti. Several of the early Pre-Raphaelite collectors were northern mer-

52 Ford Madox Brown, *James Leathart*, 1863
53 William Bell Scott, *Iron and Coal*, 1861

chants and manufacturers: Francis McCracken, a Belfast shipowner; Thomas Plint, a Leeds stockbroker and evangelical Christian; the Manchester industrialist Thomas Fairbairn; and in the later 50s James 52 Leathart, a Newcastle lead manufacturer, who was advised by the Pre-Raphaelite associate William Bell Scott (1811–90), brother of the painter David Scott and from 1843 headmaster of the Newcastle School of Design. Such men were independent of metropolitan taste and were able to look at new art with an unprejudiced eye: Leathart also bought pictures by advanced artists of the 60s including Whistler. Largely through the support of the Liverpool tobacco merchant John Miller, Liverpool was an early centre of support for the Pre-Raphaelites. Miller's protégé, the Liverpool artist William Lindsay Windus (1822–1907) adopted the Pre-Raphaelite style, Miller himself purchased Pre-Raphaelite works, and in the 50s the Pre-Raphaelites regularly exhibited and won prizes at the Liverpool Academy. But not all northern Pre-Raphaelite patrons were merchants or manufacturers. An important mural cycle of scenes from Northumberland history (1856–61) was commissioned from William Bell Scott by 53 Pauline, Lady Trevelyan for Wallington Hall, a country house

83

54 Ford Madox Brown, 'The Pretty Baa Lambs', 1851

outside Newcastle. She also obtained works by Rossetti, and the Pre-Raphaelite sculptors Woolner and Alexander Munro (1825–71).

The interest of the Pre-Raphaelites in contemporary problems had at first been presented through historical and religious subjects, but in 1850 *The Germ* had published several articles calling for artists to depict 'things of today'. That year the first modern-life subject by a member of the Brotherhood was shown at the Academy, *Answering the Emigrant's Letter* by James Collinson. It was prompted by the great emigration movement of the age, when large numbers of the population were driven abroad to escape poverty and overcrowding at home, but Collinson's style was more like that of Wilkie than the Pre-Raphaelites. Brown also painted an emigration picture, *The Last of England* (1855), inspired by the departure of Woolner. Millais' modern subjects included the heroism of the fire brigade (*The Rescue*, RA 1855) and the pathos of a beggar (*The Blind Girl*, RA 1856), but his strongest treatment of contemporary life is seen in a group of

55 William Holman Hunt, *The Hireling Shepherd*, 1851–52, (detail)

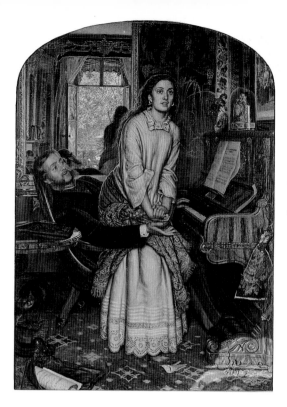

56 William Holman Hunt,
The Awakening Conscience, 1853–54

57 Ford Madox Brown, *Work*,
1852–65

unexhibited drawings on love and marriage which relate to his own
passion for Ruskin's wife and to his illustrations for contemporary
fiction. The theme of the fallen woman and the contrast between
innocence and experience were often depicted by the Pre-Raphaelites.
Rossetti's unfinished painting *Found* was to show a country drover
coming to London and recognizing his former love now turned to
56 prostitution. In Holman Hunt's *The Awakening Conscience* (RA 1854)
a kept woman in a newly and expensively furnished interior, painted
in oppressive detail, starts from the embrace of her lover as she recalls
her innocent past, symbolized by the natural world outside the
window. Subjects like these, whilst not literally autobiographical,
reflect a preoccupation in the artists' personal lives with the morality
of illicit sexual relationships. As a result, the pictures gain in intensity
of feeling; not many Victorians outside the Pre-Raphaelite circle used
such private experiences for their art.
57 In contrast, Ford Madox Brown's modern-life painting *Work*
(1852–65) is a social statement on an epic scale. Brown made a group

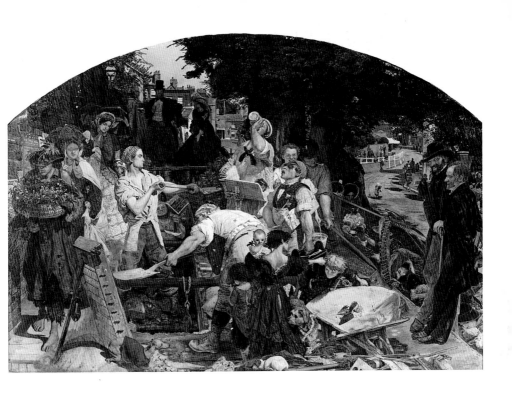

of common navvies digging for drains the heroes of his picture,
placing them at the centre of a panorama of contemporary types, rich
and poor, idle, working or unemployed and including street traders,
well-dressed ladies, beggars, ragged children and migrant farm-
workers. On the right are the 'brain workers' who provide society's
intellectual leadership, in the form of two of Brown's heroes from
public life, the Revd F.D. Maurice, Christian Socialist and pioneer of
working-class education, and Thomas Carlyle, author of *Past and
Present*, the book that stimulated many of the ideas in the painting.
Brown was also much indebted to Hogarth's modern moral pictures
with their contrasts of industry and idleness. On one level, *Work* is a
convincingly natural-looking representation of a noisy Victorian
street, bustling with brilliant colour and detail; it was painted out of
doors in bright sunlight with all the minutiae patiently studied, and
Brown's penetrating eye enabled him to portray ordinary people
without sentimentality. But *Work* is also an allegory, a modern
history painting, arising directly from the social and political ideas of

87

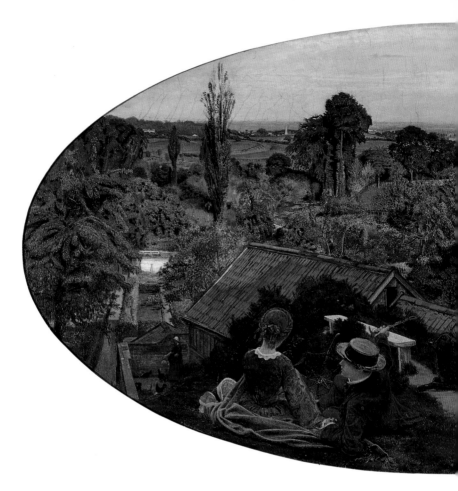

its time. The only contemporary picture like it, also an allegory in
53 realistic guise, is Bell Scott's *Iron and Coal* (1861), an amalgam of
Tyneside industry which represents the 19th century in the mural
cycle at Wallington.

Brown also painted a number of small landscapes, quite common-
place scenes which he raised out of the ordinary through subtlety of
colour and an intensity of mood sometimes lacking in the artist's more
elaborate works. His large landscape *An English Autumn Afternoon,*
58 *Hampstead – Scenery in 1853* (1852–55) shows an extensive view of
London in the clear, late afternoon sun. Besides being a beautifully
observed record of a particular place and time, it is also a modern-life

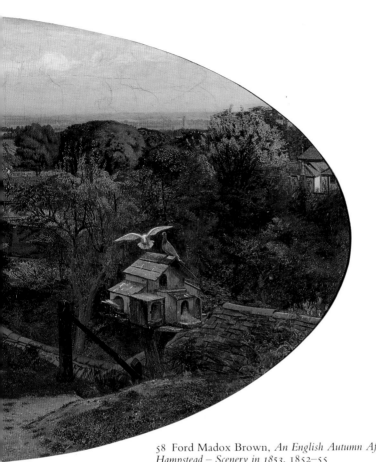

58 Ford Madox Brown, *An English Autumn Afternoon,
Hampstead – Scenery in 1853*, 1852–55

subject of a sort, for its view of back gardens, orchards and rooftops
shows the kind of everyday semi-rural landscape increasingly visible
on the fringes of the modern city, but not usually recorded by an
artist. 'What made you take such a very ugly subject?' asked Ruskin,
'It was a pity for there was some nice painting in it', to which Brown
retorted, 'Because it lay out of a back window.'

Soon after Ruskin had written in defence of the Pre-Raphaelites, he
made their acquaintance and it was not long before he was trying to
direct their practice in accordance with his ideas. He took Millais off to
Scotland to paint his portrait in the summer of 1853. It places Ruskin
in front of a meticulously painted background of rocks and waterfall, 62

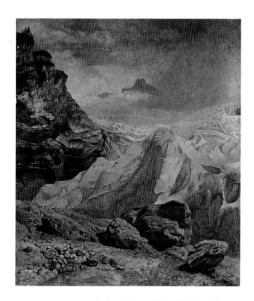

59 John Brett, *The Glacier of Rosenlaui*, 1856

60 John Ruskin, *Mer de Glace, Chamonix*, 1860

61 George Price Boyce, *At Binsey, near Oxford*, 1862

62 Sir John Everett Millais,
John Ruskin, 1853–54

a manifesto of his interest in geology and nature. But whilst working on the portrait, Millais fell in love with Ruskin's wife, leading to the couple's eventual divorce, her remarriage to Millais and a cooling of relations between artist and critic. Ruskin also attempted to influence a number of landscape painters who had become involved with Pre-Raphaelitism in the early 50s including George Price Boyce (1826–97), John William Inchbold (1830–88) and John Brett (1831–1902). Brett and Inchbold both travelled to Switzerland to paint, inspired by the passages relating to the beauty of the Alps in the fourth volume of *Modern Painters* (1856). Brett's *The Glacier of Rosenlaui* (RA 1857), an 59
austere Alpine view devoid of human presence, shows with geological precision a boulder of granite and a lump of gneiss, as described by Ruskin. But he was disappointed in both artists, whose work did not live up to his expectations and criticized Brett's *Val d'Aosta* (RA 1859) as 'wholly emotionless . . . I never saw the mirror so held up to Nature; but it is Mirror's work not Man's.' Boyce also went to Switzerland on Ruskin's advice but later made a speciality of delicate British landscape watercolours, fresh and clear in colour, 61

direct and original in composition, and often depicting the mellow textures of vernacular buildings, qualities praised by Ruskin in his writings on architecture. Ruskin also commissioned a number of painters to record Venetian architecture for the museum of the Guild of St George, an idealistic educational project founded by Ruskin in Sheffield. These artists, who include Thomas Matthews Rooke (1842–1942) and James W. Bunney (1828–82), worked under Ruskin's close supervision, in a heavy, somewhat mechanical style.

Ruskin's own watercolours are anything but mechanical. He often left them deliberately incomplete; conscious of his limitations, he treated them not as finished works of art but as explorations arising from his study of botany and geology and his interest in natural processes such as the growth of plants and the formation of rocks. His studies record minerals, mosses and leaves, a peacock's feather, or details of architectural ornament, subjects seen at close quarters as if through a microscope. His larger views of architecture and landscape often have a deeper resonance. *Mer de Glace, Chamonix* (1860) is not merely a study of nature; its fragile beauty suggests the inevitability of

60

63 William Henry Hunt, *Primroses and Bird's Nest*

64 Daniel Alexander Williamson, *Spring, Warton Crag,* 1863

growth, change and decay which began to preoccupy Ruskin in his later years.

Ruskin had taken lessons from a watercolourist of an older generation, William Henry Hunt (1790–1864), called 'Bird's Nest Hunt' after his favourite subject matter. Through Ruskin's influence Hunt's painstaking technique of applying watercolour with a fine brush over a ground of Chinese white was taken up by many artists, including Frederic Shields (1833–1911), Alfred W. Hunt (1830–96) and Henry Clarence Whaite (1828–1912). In the late 50s and the 60s the Pre-Raphaelite style influenced a great many artists working in oils as well as watercolours. Liverpool produced the Pre-Raphaelite genre painters James Campbell (1828–93) and John Lee (active 1859–67) as well as the landscapists Daniel Alexander Williamson (1823–1903) and William Davis (1812–73); from Leeds came Atkinson Grimshaw (1836–93), who was one of a number of artists who went through a youthful Pre-Raphaelite phase before establishing a

reputation for work in a different style, as was Frederic Leighton (1830–96) whose early drawing of a lemon tree (1859) earned Ruskin's admiration. The Scottish painter of fairy subjects Joseph Noel Paton was a friend of Millais and painted in a Pre-Raphaelite style in the 50s. A few outstanding Pre-Raphaelite pictures were painted by artists who otherwise remain obscure; these include *The Doubt: 'Can These*
66 *Dry Bones Live?'* (RA 1855) by H.A. Bowler (1824–1903), *The Wounded Cavalier* (RA 1856) by William Shakespeare Burton (1824–1916), and two works by Henry Wallis (1830–1916), *The Death of Chatterton* (RA 1856) and *The Stonebreaker* (RA 1858), a moving example of social realism, showing a boy killed by hard labour.

William Dyce, himself a formative influence on the original Brotherhood, also learned from the Pre-Raphaelites, adopting a minute and sharply focused style for his landscapes. In *Pegwell Bay,*
65 *Kent – a Recollection of October 5th, 1858* (RA 1860) the figures in modern dress seem oblivious to the vast forces of nature shaping the universe, represented by the geological strata of the rocks behind

94

65 William Dyce, *Pegwell Bay,
Kent: a Recollection of October 5th
1858*, 1858–60

66 Henry Alexander Bowler,
*The Doubt: 'Can these Dry Bones
Live?'*, 1854–55

them and the comet in the sky above. Dyce also painted a series of
intense devotional subjects of biblical characters in Scottish landscape
settings.

Holman Hunt became best known as a religious painter, but one
who was determined to breathe new life into Christian iconography
to give it meaning for the modern age. In *The Light of the World* (RA 68
1854) Hunt created a highly original image of Christ. It was inspired
by the passage in the Book of Revelation describing Christ knocking
at the door of the soul, but the idea of portraying him carrying a
lantern to bring light to a moonlit orchard choked with weeds was
Hunt's own invention. *The Awakening Conscience* was conceived as a 56
material counterpart to *The Light of the World*, expressing the same
theme of Christian salvation coming to a sinful world but in a modern
setting. *The Light of the World* was misunderstood when first shown
but Ruskin wrote a letter to *The Times* explaining its symbolism, and
it eventually became one of the best-known religious pictures of all
time, its fame spread by a national tour, by countless reproductions,

and by the large replica painted with the help of an assistant (1900–04), which toured the colonies and was then presented to St Paul's Cathedral.

Hunt made four journeys to the Holy Land, the first in 1854–56. He painted genre subjects and landscapes, the latter often unusual in composition and viewpoint, recording the strangely dazzling colours and unfamiliar topography of Palestine, but his main object was to
67 find authentic locations for biblical subjects. *The Scapegoat* (RA 1856) was painted on the desolate shore of the Dead Sea, and depicts the sacrificial beast annually cast out into the desert in symbolic expiation of the sins of the Israelites, as described in the book of Leviticus. Hunt, drawing a typological parallel between the Old and the New Testaments, transformed the goat into a powerful symbol of Christ taking upon himself the sins of the world. *The Finding of the Saviour in the Temple* (1854–60) and *The Shadow of Death* (1870–73) again took biblical episodes and transformed them with startlingly vivid Palestinian settings and telling symbolic references of contemporary relevance. Hunt's late work includes *The Lady of Shalott* (1886–1905),

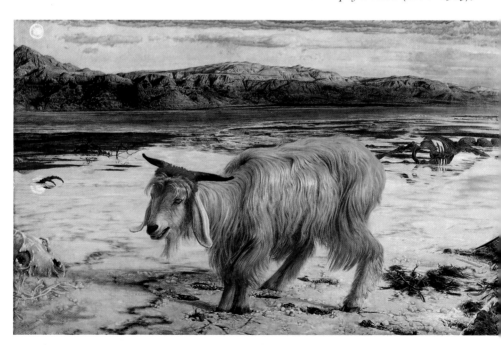

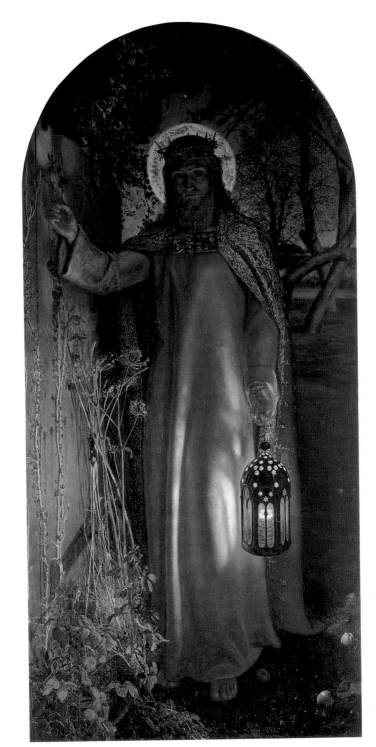

67 William Holman
Hunt, *The Scapegoat*,
1854

68 William Holman
Hunt, *The Light
of the World*, 1853

based on Tennyson's poem, and *May Morning on Magdalen Tower* (1888–90) depicting choristers ecstatically greeting the dawn in a combination of Christian ritual and pantheistic nature worship. He continued to combine a hard-won fidelity to appearance with elaborate symbolism, and to the end of his life remained the most earnest of the Pre-Raphaelites, convinced of the didactic role of art.

Millais, distanced from Ruskin by the divorce, continued to paint with Pre-Raphaelite precision until the late 50s but his subject matter began to change. He found he could achieve most success at the Academy with scenes of ill-fated lovers like *The Huguenot* (RA 1852) and *The Proscribed Royalist* (RA 1853), posed against backgrounds of
69 tangled ivy and foliage. *Autumn Leaves* (RA 1856) marked a new departure, a figure composition which evoked a mood rather than telling a story. 'I intended the picture to awaken by its solemnity, the deepest religious reflection', wrote the artist. The melancholy beauty of the girls, the end of the day and the dying year suggest human mortality. This seriousness of purpose was repeated in a few other paintings of the late 50s but they were not well understood and Millais soon returned to narrative paintings of lovers which had more immediate popular appeal, such as *The Black Brunswickers* (RA 1860). During the 60s his touch broadened and all resemblance to the early Pre-Raphaelite style was lost.

The intense feeling of Millais' best work was taken up by his most talented follower Arthur Hughes. Whilst still a student, Hughes read *The Germ*, was converted to Pre-Raphaelitism, met the members of the Brotherhood and became a friend of Millais. He exhibited a series of scenes of unhappy courtship such as *April Love* (RA 1856) and *The*
70 *Long Engagement* (RA 1859), similar to Millais' paintings of lovers but in modern dress. Also inspired by Millais were subjects showing the tender feelings of childhood, for example the triptych *Bed-time* (RA 1862) and the poignant *Home from Sea* (RA 1863), a sailor boy weeping at his mother's grave. Hughes was able to render naturalistic detail and the rough textures of clothing with a particularly delicate touch; his work was distinguished by a mood of intimate emotion heightened by glowing colour.

The minute depiction of ferns, ivy, mosses, tree trunks and rocks characteristic of many Pre-Raphaelite paintings also occurred in the
71 productions of the 'sharp' school of photography of the 1850s and 60s. The relationship between painting and photography was not one of

98

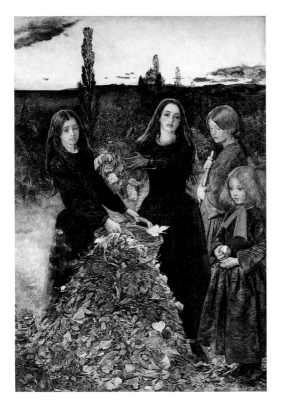
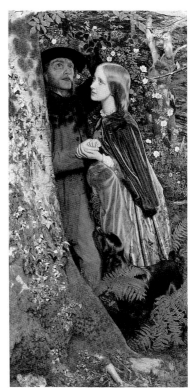

69 Sir John Everett Millais, *Autumn Leaves*, 1855–56
70 Arthur Hughes, *The Long Engagement*, c. 1854–59

simple imitation. It was common practice for painters to use photography as an *aide-mémoire*, a substitute sketchbook. This was particularly true of portraiture where sittings were time-consuming or difficult to obtain; Ford Madox Brown painted the likeness of Carlyle in *Work* from a specially taken photograph. Photographs were also used by landscape painters; in Palestine, the photographer James Graham took photographs of views that Holman Hunt and Thomas Seddon (1821–56) had begun to paint, in order to help them finish their pictures later. Brett, a keen amateur photographer, often used photographs as well as sketches made out of doors when working in the studio on his later exhibition oils. But the copying of a photograph as the basis of a landscape rather than as assistance towards

99

71 John Dillwyn Llewelyn,
Lastrea Felix Mas, c. 1854

72 Henry Peach Robinson,
A Holiday in the Wood, 1860

it was less common, though instances by Dyce and Atkinson Grimshaw are known. There was a moral imperative for artists to paint direct from nature, and in any case colour could not be studied from a photograph. Nevertheless, painters could not help but be affected by their awareness of photography and took a keen, if discreet, interest in it. Whether by conscious imitation or not, photographic traits such as the flattening of the picture space and the close-up, worm's-eye view of nature, eliminating or disguising the transition from foreground to background, are commonly seen in Pre-Raphaelite paintings. There was certainly influence in the reverse direction. Many photographers produced tableaux of figures inspired by popular paintings; the composite photographs of Henry Peach
72 Robinson (1830–1901) imitated paintings both in subject and in the practice of combining separate studies of setting and figures into one unified scene, with the same disjointed effect as is seen in some Pre-Raphaelite paintings, where the figures seem to have been cut out and pasted to an unrelated background.

Rossetti never went in for the detailed naturalistic style. He lacked the technical facility of Millais, and the planning and careful execution required for elaborate oil paintings defeated him. In the early 50s he

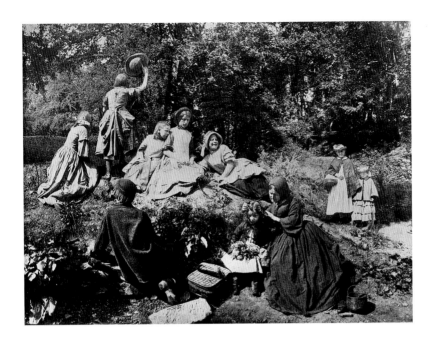

embarked on and then abandoned several such projects, but his only large oil of the 50s was the altarpiece for Llandaff Cathedral, *The Seed of David* (1858–64), commissioned by the architect J.P. Seddon (1827– 1906). Rossetti turned to the more compliant medium of water-colour, painting on a small scale and working out an unorthodox technique of his own, applying with a dryish brush layers of hatched and stippled colour to produce glowing effects similar to those of stained glass. He sold these watercolours to a narrow circle of patrons including Ruskin, who introduced him to other collectors such as Ellen Heaton of Leeds, and Charles Eliot Norton, a Harvard professor. Rossetti's subjects, mainly taken from the Bible, Dante and the *Morte d'Arthur*, concern themes of female virtue, beauty and passion, often highly charged with emotion. Scenes of guilty or illicit love such as *Paolo and Francesca* (1855) or his earliest Arthurian watercolour *Arthur's Tomb* (1855), though presented in medieval dress, reflect his own personal experience. In many of his pictures the heroine has the delicate features of his mistress Elizabeth Siddal (1829– 62) whom he married in 1860. Also a painter, she was much encouraged by Ruskin and was the subject of a series of intense portrait drawings by Rossetti.

Rossetti's finest achievement in watercolour was a group of fancifully inventive medieval subjects painted between 1855 and 73 1858, such as *The Wedding of St George and the Princess Sabra* (1857). They depict colourfully dressed knights and ladies placed in shallow claustrophobic spaces and display a delight in heraldic patterning and decorative shapes. Rossetti's distaste for conventional space and perspective may have been fostered by his great admiration for the painter-poet William Blake; Rossetti was also imitating the stylization of medieval illuminated manuscripts, which Ruskin was then collecting. Rossetti's vision of an enchanted Middle Ages was equally apparent in his woodblock engravings, which led the way towards a new flowering of book illustration in the following decade.

It was in 1856, while Rossetti was painting what he described as 'these chivalrous, Froissartian themes' (referring to the 14th-century French chronicler), that he was visited by two Oxford undergraduates who had admired his work. Edward Burne-Jones (1833–98) and William Morris (1834–96) had already discovered a romantic affinity with the Middle Ages and, encouraged by Rossetti, they gave up their planned careers in the Church in favour of art, and came to work with him. A new circle of younger artists now began to gather round Rossetti, bringing new talents and new ideas. The most important venture of the new Rossetti circle was the decoration of the debating hall of the Oxford Union Society with murals illustrating the *Morte d'Arthur* (1857). Rossetti persuaded Morris and Burne-Jones to take part, also recruiting Arthur Hughes, Val Prinsep (1838–1904), Hungerford Pollen (1820–1902) and Spencer Stanhope (1829–1908). Undertaken in the lighthearted spirit of a student jape, without any technical knowledge of mural technique or adequate preparation of the wall surfaces, the pictures darkened at once so as to be virtually invisible, but before they faded the poet Coventry Patmore described them as 'so brilliant as to make the walls look like the margin of an illuminated manuscript'.

The immediate origins of this coming together of art and architecture lay in the Gothic Revival. Progressive architects such as Benjamin Woodward (1815–61), designer of the Oxford Union, G.F. Bodley (1827–1907) and William Burges (1827–81) commissioned young artists to decorate their buildings. This trend was encouraged by Ruskin's advocacy of individual craftsmanship to combat the poor artistic standards associated with machine production.

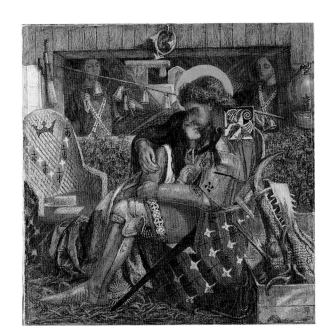

73 Dante Gabriel Rossetti,
*The Wedding of St George
and the Princess Sabra,*
1857

Morris, after working on the Oxford Union murals, abandoned painting and began his lifelong practical involvement with the decorative arts. When trying to furnish the rooms he shared with Burne-Jones in London he found himself dissatisfied with commercially available furniture and decided to design his own, enlisting Rossetti, Burne-Jones and Madox Brown to decorate it. They went on to provide furniture and painted decorations for the house designed in 1859 for the newly married Morris by the architect Philip Webb (1831–1915). This was the origin of the firm of Morris, Marshall, Faulkner & Co., founded in 1861. Soon its output expanded to include stained glass, wallpapers and textiles. But the inspiration had come from Rossetti and his intensely imaginative recreation of the Middle Ages. Just as he had stimulated the foundation of the original Brotherhood in 1848, so he acted as the catalyst which released the creativity of the younger generation of Pre-Raphaelites. With the formation of this new group Pre-Raphaelitism entered its second phase, moving away from the realistic, hard-edged and brightly coloured early manner and looking forward to the poetic and decorative bias of the Aesthetic Movement.

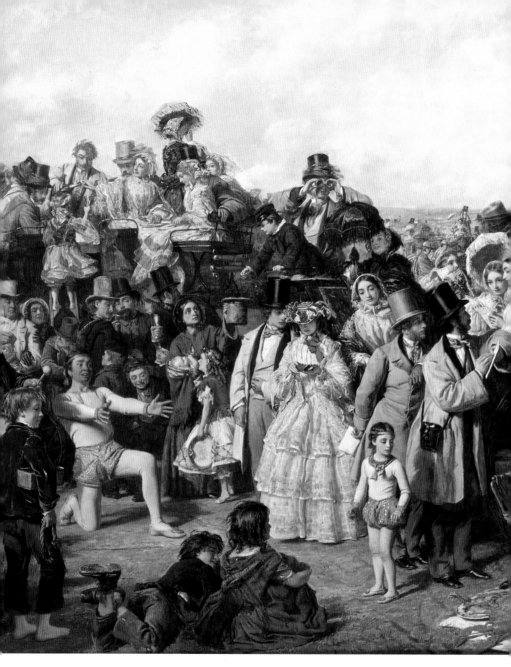

74 William Powell Frith, *The Derby Day*, 1856–58 (detail)

Mid-Victorian Realism

In 1855 Victorian artists had the opportunity to be judged against their European counterparts at the Paris International Exhibition, which included a large British section. The Parisian critics agreed that the British could not compete with their own artists in works of an elevated character, but they were surprised and impressed by the British achievement in genre and narrative painting, admiring what they saw as its originality, eccentric humour and love of detail. Not since the 'English' Salon of 1824, when the French first discovered Constable, had British art so triumphed in France. 'The best pictures of the exhibition', wrote one critic, 'are either those which have taken their subjects from actual life, or those where, although the costume of bygone times may have been adopted, passions or personifications are represented for which nature could have supplied the models.' Landseer and Mulready came in for special praise whilst the Pre-Raphaelites excited much interest; Delacroix admired the work of Millais and wrote in his journal that he was 'really astounded' by Holman Hunt.

It was because British painting was so insular that the Parisians found it refreshingly novel, so different from the universal French influence to be seen elsewhere in Europe. British artists at the Exhibition whose work showed awareness of foreign styles, Dyce for example or Armitage, lately graduated from Delaroche's studio, were criticized as 'not wholly English', whereas Mulready was commended for having absorbed Dutch and Flemish art whilst remaining true to his own British genius.

Domestic genre, rustic subjects in the Wilkie tradition and literary and historical anecdotes continued to flourish in mid-Victorian Britain, but from the early 50s, a new element entered narrative and genre painting. Many of the same artists who produced historical subjects began to paint the contemporary urban middle-class milieu, with a naive delight in the up-to-date: omnibuses and railway stations, opera boxes and parlourmaids, ladies in crinolines and men in

stove-pipe hats, scenes both from life and from modern literature. The fashion co-existed with, rather than replaced, historical subjects; it shared the same love of anecdote and lasted until the 70s when a more sophisticated treatment of modern life took over.

The arrival of contemporary subject matter at the Academy followed on closely from the Pre-Raphaelites' modern subjects of the early 50s. Brown's first ideas for *Work* dated from 1852 and Millais' drawings on marriage from 1853; the first of Frith's modern crowd 75 scenes, *Life at the Seaside*, was shown at the Academy of 1854, which 56 also included Hunt's *The Awakening Conscience*. Pre-Raphaelite influence extended to style as well as content: older painters like Faed and Frith began to brighten their palettes and to paint detail more sharply, whilst younger artists such as William Maw Egley (1826–1916) adopted insistently hard-edged detail and acid colour. The move to paint contemporary life was part of a wider repositioning of European taste. Baudelaire in his Paris Salon reviews of the mid-40s had called for artists to represent the heroism of modern life, its 'neckties and patent leather boots', and the 'thousand existences' which formed the 'floating life of a great city'. British painters, whilst remaining conservative in their attitude to narrative, detail and composition, anticipated in the 50s and early 60s the subjects that would be taken up by the Impressionists in the 70s and 80s: the races, the opera, the urban middle classes at leisure in parks, on beaches and city streets.

Life at the Seaside, showing the crowds on the sands at Ramsgate and based on sketches made there, was an instant success. Four years later 74 Frith exhibited *The Derby Day* (RA 1858) with its throng of racegoers at Epsom and four years after that *The Railway Station* (1862) showing a bustling platform at Paddington. Each painting was large, shaped like a panorama, and packed with figures. Each found a buyer without difficulty, despite the high price, due to the length of time it took to plan and execute such a complex composition. *Life at the Seaside* was initially bought by Lloyds, a firm of picture dealers, but as the Queen wished to buy it Lloyds ceded it to her for what they had paid for it, whilst astutely retaining the lucrative rights to the engraving. *The Derby Day* became the first picture shown at the Academy since Wilkie's *Chelsea Pensioners* of 1822 to have a railing and a policeman placed in front of it to protect it from the throng of admirers. The first of five such barriers for Frith's pictures, this was

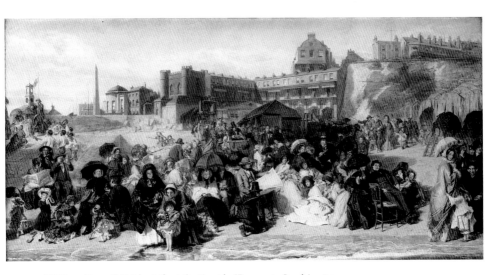

75 William Powell Frith, *Life at the Seaside (Ramsgate Sands)*, 1854

regarded as a great accolade. *The Railway Station* was not shown at the Academy but at the gallery of the dealer Louis Victor Flatow, where it attracted over 21,000 people in seven weeks. All three pictures subsequently gained a wider popularity through their publication in the form of large engravings. *The Derby Day* and *The Railway Station* became so well known that they were imitated on stage in popular melodramas when at a moment of climax the actors froze in a tableau resembling the picture. *Life at the Seaside* was lightly and delicately painted; *The Derby Day* was bolder, but Frith's later modern-dress panoramas *The Salon d'Or, Homburg* (RA 1871) and *The Private View at the Royal Academy* (RA 1883) were in comparison wooden in style 123 and never attained the same celebrity. Frith's pictures were utterly conventional in form, obeying the rules of composition and grouping he had learned at the Academy. They were painted from professional models posed in his studio, from on-the-spot sketches and in the case of *The Derby Day* and *The Railway Station* from photographs of the background settings commissioned from professional photographers.

Before *Life at the Seaside*, Frith's crowd scenes had been in historical costume and he had been nervous of what he called 'hat and trousers' pictures because of 'the drawbacks of unpicturesque dress'. Many

19th-century artists thought that modern dress was ugly. Portrait painters found it a special problem. 'Artists have to wrestle today with the horrible antagonism of modern dress; no wonder, therefore that few recent portraits look really dignified', wrote Millais, 'Just imagine Vandyck's Charles I in a pair of check trousers.' *Life at the Seaside* depicted children playing and paddling, donkey rides, Punch and Judy, a toyseller – the kind of thing that might have been in any genre painting, but because it was modern and on a scale to rival history painting the picture was damned by a critic as 'a piece of vulgar Cockney business unworthy of being represented even in an illustrated paper'.

Behind these views lay the prejudice inherited from Reynolds that art had to be elevated and generalized and not deal in the everyday. Yet as Frith knew, it was the very contemporaneity of his subjects which ensured their popularity. Here were crowds dressed in the latest fashions, the middle classes as they liked to be seen. Sea bathing and railway travel were novel and topical features of Victorian living, and though pictures of horse races were not new, Frith's picture was different from conventional sporting paintings; his real subject was not the race but the crowd of spectators, teeming with contrasts of class and character. Frith's pictures, for all their novelettish concentration on surface rather than inner moral complexities, have something of the richness of Dickens' novels with their interweaving of plot and sub-plot, and their mixture of characters from different social worlds. In *Sketches by Boz* (1835) Dickens had published a description of Ramsgate Sands remarkably similar to the scene painted by Frith nearly 20 years later. In the early 50s Frith's friend John Leech (1817–64) was publishing cartoons in *Punch* of seaside, sporting and betting types and in 1857 the magazine printed his drawing *The Great Social Evil*, showing two street-walkers in the
74 Haymarket. *The Derby Day*, shown the following year, includes figures recognizable from their dress and bearing as prostitutes, beggars and criminals mingling with the toffs, country bumpkins and gypsies, all stereotypes familiar to contemporary theatregoers and readers of popular novels. Literature, the stage and illustration, where the conventions were less strict than for painting, in this way contributed to the broadening of subject matter in the fine arts.

Frith's success led to a rash of similar paintings at the Academy on ever more ingenious variations of the crowd scene, such as *Dividend*

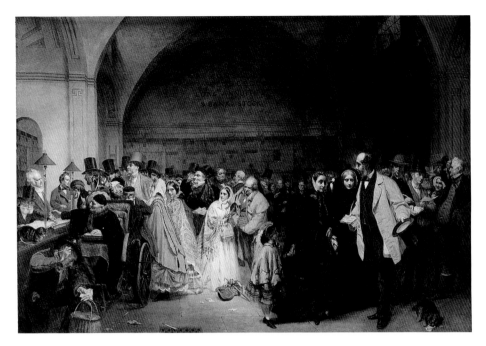

76 George Elgar Hicks, *Dividend Day at the Bank of England*, 1859

Day at the Bank of England (RA 1859), *The General Post Office at One* 76
Minute to Six (RA 1860), *Billingsgate Fish Market* (RA 1861) and the
fashionable wedding party shown in *Changing Homes* (RA 1863), all
by George Elgar Hicks (1824–1914). There were also many less
elaborate modern dress subjects such as Frith's pictures of urban types,
including a girl at the opera, a crossing sweeper and a girl smoking a 80
cigarette – a practice then regarded as highly indecorous – or Egg's
figures engaged in leisure activities such as at the theatre, on the beach,
on board a pleasure boat and inside a railway carriage (*The Travelling
Companions* of 1862). The interior of another new form of transport
provided Egley with an opportunity to paint a variety of social types
in *Omnibus Life in London* (1859). Traditional subjects were given new 77
appeal by clothing the figures in fashionable dress, as in J.C. Horsley's
scene of rustic courtship *Showing a Preference* (1860), a modern version 78
of the classical theme *The Choice of Hercules*. The act of charity for a

79 friend in need in *Old Schoolfellows* (RA 1854) by Alfred Rankley (1819–72) is a situation such as might be found in a novel by Dickens or Wilkie Collins. In pictures like these, meaning and emotion are quietly conveyed, to be read from small clues like wedding rings, letters, the language of flowers and understated gestures.

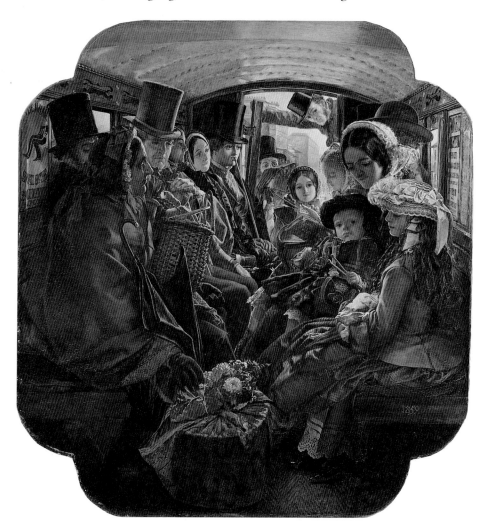

77 William Maw Egley, *Omnibus Life in London*, 1859

78 John Calcott Horsley,
Showing a Preference, 1860

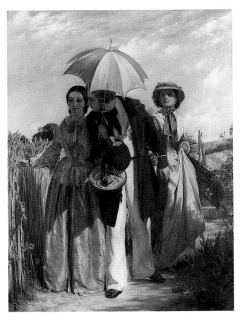

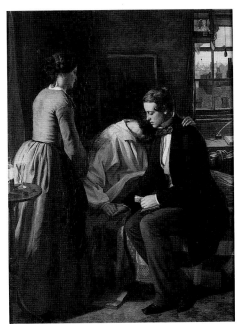

79 Alfred Rankley,
Old Schoolfellows, 1854

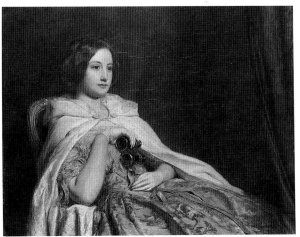

80 William Powell Frith, *The Opera Box*, 1855

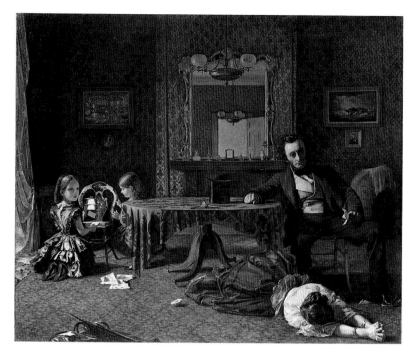

81–3 Augustus Leopold Egg, *Past and Present*, 1858

In order to extend their narratives from the confines of a single time and place, several artists employed a serial format derived from Hogarth. Abraham Solomon (1824–62) contrasted rich and poor in railway carriages in *First Class – The Meeting* and *Second Class – The Parting* (RA 1854), and painted the 'before' and 'after' courtroom scenes *Waiting for the Verdict* (RA 1857) and *Not Guilty* (RA 1859). Frith even planned a sequence inspired by Hogarth's *Times of Day*, sadly never completed, though sketches survive depicting *Morning – Covent Garden*, with drunks staggering home at dawn, *Noon – Regent Street*, crowded with carriages and shoppers and *Night – Haymarket*, in which a berouged prostitute gazes at a group of elegant theatregoers. The greatest of the serial paintings is Augustus Egg's trilogy *Past and* 81–3 *Present* (RA 1858), telling the story of a well-to-do family broken by the wife's adultery, the children reduced to poverty and the mother thrown out on to the streets with her illegitimate child. Egg, a friend of the Pre-Raphaelites, learned from Hunt the use of powerful

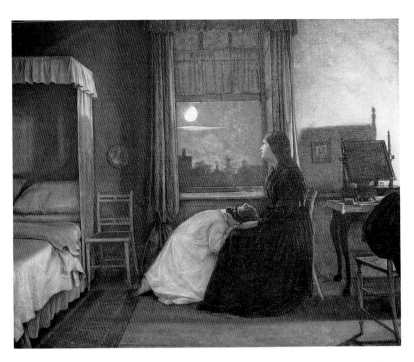

84 George Elgar Hicks,
*Woman's Mission, Companion of
Manhood*, 1863
85 Henry Nelson O'Neil, *Eastward Ho!
August 1857*, 1857–58
86 Sir Joseph Noel Paton,
In Memoriam, 1858

symbolic detail to underline his stark message, which deliberately challenged orthodox assumptions in showing sympathy for the unfortunate woman. The trilogy was criticized as 'unhealthy' and remained unsold in the artist's studio until after his death. In contrast,
84 Hicks' triptych *Woman's Mission* (RA 1863) with its three parts – *Guide of Childhood*, *Companion of Manhood* and *Comfort of Old Age* – was quickly sold; its view of woman was entirely conventional.

Artists sometimes painted modern subjects based on current events: the Royal Academy Summer Exhibition of 1858 took place at the height of the wave of British patriotism and outrage at the Indian
85 Mutiny. Exhibits included *Eastward Ho! August 1857* by Henry Nelson O'Neil, showing troops on a ship leaving for India parting from their
86 wives and families, and *In Memoriam* by Joseph Noel Paton, based on the massacre at Cawnpore, with sepoys advancing with fixed bayonets on a group of terrified English ladies and children. The threat of violence, particularly as it was directed at white women by Indian soldiers, was found by most critics to be so offensive – 'The subject is too revolting for further description. The picture is one which ought not to have been hung' – that after the exhibition Paton repainted the sepoys as Highland soldiers heroically coming to the

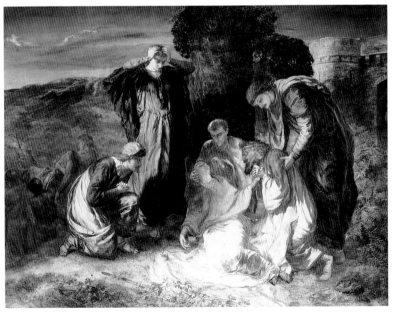

87 Paul Falconer Poole, *The Death of Cordelia*, 1858

rescue. In contrast, O'Neil's picture was greeted with acclaim; it avoided military action and idealized the soldiers as well-behaved, neatly dressed family men. Paintings that saw war in terms of domestic incident and human emotions were more acceptable to public taste than scenes of violence. When O'Neil tried to repeat his success with *Home Again* (RA 1859), showing the same soldiers returning, some with bandaged wounds, the picture was less well received for the mood of confidence had passed.

In contrast with France, where grandiose compositions of gesticulating warriors and panoramic views of fighting armies were still admired, battle paintings did not do well in Britain. In 1855 the dealer Gambart commissioned the French-trained Edward Armitage to go to the Crimea to paint two battle scenes, Inkerman and Balaclava, intended for engraving. Armitage made gruesome drawings of corpses on the battlefield but the paintings, exhibited in 1856, were never engraved and sank into obscurity. To represent the Indian Mutiny he devised not a scene of battle but a large and unconvincing allegory, *Retribution* (RA 1858), showing Britannia plunging a sword into an Indian tiger.

High Art was never quite extinguished during the 50s and 60s despite its lack of appeal to collectors. It was kept alive by Armitage and by Paul Falconer Poole, who painted richly coloured canvases with brooding and contorted figures posed against dramatically lit landscapes similar to those of his erstwhile friend Francis Danby. Despite glaring faults of anatomy and foreshortening, works like *Solomon Eagle exhorting the people to repentance during the plague of the year 1665* (RA 1843), *The Goths in Italy* (RA 1851), which impressed
87 the young Rossetti, and *The Death of Cordelia* (RA 1858) display a genuine, if idiosyncratic, power.

Poole supported himself by turning out numerous potboilers of simpering rustic maidens. The appetite of the town dweller for images of a cosy rural idyll seemed insatiable. In the pretty
88 countryside scenes of Myles Birket Foster (1825–99) the figures play an increasingly important part; originally an illustrator, he turned to watercolour in 1859, producing hundreds of highly finished landscapes in a pale and sunny range of colours, featuring milkmaids, harvesters, cottagers and children. A similar combination of genre
89 and landscape is evident in the work of James Clarke Hook (1819–1907). In the early 50s, partly through an acquaintance with Holman

116

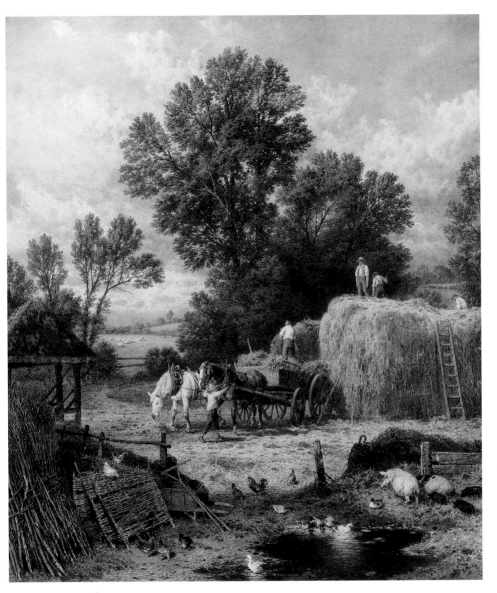

88 Myles Birket Foster, *The Hayrick*, c. 1862

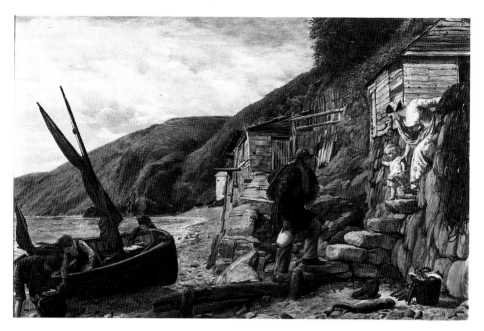

89 James Clarke Hook, '*Welcome Bonny Boat!*', 1856

Hunt, he painted sunlit English pastorals but later came to specialize in coastal scenes, making regular visits to Devon and Cornwall. Hook was preoccupied with light, building a house in Surrey with two studios, designed to bring indoors the effect of open-air light. His landscapes and seas are brightly but solidly treated, and include fishermen with their boats, nets and lobster-pots, typically accompanied by their apple-cheeked wives and children. Hook catered for the hankering of the townsman after the sea; the combination of marine painting with genre became a potent force in later Victorian art.

A number of painters were associated with foreign parts. Edward
90 Lear (1812–88) is better known today for his nonsense poetry and drawings, but he thought of himself primarily as a landscape painter. His earliest work was as a zoological and ornithological draughtsman, but in 1837 he went to Italy because of ill health, and the rest of his life consisted of a series of extended journeys, spent roaming around Italy, Greece, Turkey, Egypt, Albania and India. Epileptic, depressive, shy

118

and lonely, Lear did not fit easily into conventional society and travel was his release; his motivation was quite different from that of the earlier generation of topographical painters. Largely self-taught, and worried by his lack of training, at the age of 37 he spent a year at the Royal Academy Schools, working with students half his age. He also took lessons from Holman Hunt, from whom he learned a love of brilliant colour, though he moved away from Pre-Raphaelite minuteness of touch. On his travels, Lear made hundreds of on-the-spot pencil drawings of wild and unusual places, marked with scribbled notes about date, time of day and colour, with ink line and watercolour washes added later. Intended to be studies for finished paintings, and not works of art in themselves, they show greater freedom and originality than his studio oils and watercolours.

John Frederick Lewis also lived abroad for a time; originally an animal painter, he turned to picturesque watercolour views, visiting Switzerland, Italy and Spain. In 1837 he left England for Paris, Rome and Constantinople, probably led there out of admiration for the odalisque paintings of Ingres. In 1841 he settled in Cairo for ten years,

90 Edward Lear, *Quarries of Syracuse*, 12 June 1847

adopting the native dress and way of life; Thackeray visited him there and described him as 'like a languid lotus eater'. Whilst he was away, Lewis did not exhibit in London but in 1850 he sent back a large watercolour, *The Hhareem*. It created a sensation as much for its brilliant and intricately stippled technique as for its daring subject: a turbanned pasha, his three wives and a pet gazelle, gazing at a semi-naked African girl unveiled by a Nubian eunuch. Independently of the Pre-Raphaelites, Lewis had evolved a similar method, applying colour with a minute touch on a white ground to produce a glowing, jewel-like effect. Lewis returned to London in 1851 and painted Middle Eastern subjects based on the material he had gathered in Cairo, at first working in watercolour but then changing to oil, which was quicker and so more lucrative. Like other Orientalist painters, he saw the Middle East as a series of luxurious and sensual images, corresponding to the Western fantasy of the Orient, derived from such sources as the *Thousand and One Nights*. He painted exotic caravans and tents in the desert or indolent girls reclining on silken cushions in front of latticework screens, ignoring modern features of Oriental life and sometimes giving his harem girls Western features.

92

91 John Phillip, *La Gloria*, 1864

92 John Frederick Lewis, *The Siesta*, 1876

The romantic appeal of Spain was the subject of John Phillip, a Scot 91
whose early work was in the Wilkie mould. Following in Wilkie's
footsteps, Phillip visited Spain in 1851, living for a time in Seville, and
making two further Spanish journeys in 1856 and 1860. His art was
quite transformed. Under the influence of Velázquez, his brushwork
became more liquid and bold, and the sedate Presbyterian crofters of
his early work gave way to sunlit market scenes, guitar players,
flamenco dancers and conspiratorial peasants, a mixture which was
very successful with British collectors from the Royal Family
downwards.

A great many painters of the 50s and 60s specialized in pictures
of children, associated in the pre-Freudian age with purity and
innocence. One of the archetypal Victorian representations of

94 childhood piety is *Speak Lord, for thy servant heareth* (RA 1853), better known as *The Infant Samuel*, by James Sant (1820–1916). This was exactly the kind of vague and sentimental religious image which Holman Hunt rejected in his desire to create authentic biblical pictures, but together with its companion, *Young Timothy* (1855), it had an enormous success as an engraving.

Paintings of children in cottage interiors inspired by 17th-century Dutch art were the typical productions of a group of artists known as the Cranbrook Colony, from the Kent village where they settled in the 50s. Frederick Daniel Hardy (1826–1911) first took a house there about 1853; Thomas Webster, the follower of Wilkie and Mulready, and J.C. Horsley became frequent visitors, moving there permanently in 1857 and 1861 respectively, by which time George Bernard O'Neill (1828–1917) was renting a house there, though both O'Neill and Horsley retained London establishments. Though Cranbrook was accessible from London by rail, the village was not suburbanized and it remained an appealingly antiquated backwater. Its picturesque

93 Thomas Webster, *Roast Pig*, 1862

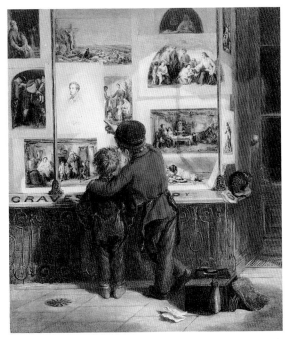

94 James Sant, *Speak Lord, for thy servant heareth (The Infant Samuel)*, 1853

95 William Macduff, *Shaftesbury, or Lost and Found*, 1862

timber-framed buildings provided the artists with settings and the villagers were willing models. The Cranbrook painters presented a rosy version of village life; the cottages were spacious and clean and the children well behaved, without the coarseness of the Dutch or the cruelty of Mulready. Webster's *Roast Pig* (RA 1862) was com- 93 missioned by the Birmingham art collector Joseph Gillot, a wealthy manufacturer of steel pens, and Cranbrook pictures were certainly popular with self-made men, whose collections were bequeathed to public galleries such as the Cartwright bequest to Wolverhampton and the Ashton gift at Tunbridge Wells.

Also associated with Cranbrook was Augustus E. Mulready (1843– 1904), no relation to William. Augustus produced a great many sentimental and repetitive pictures of pathetic barefoot waifs, beggars and flower sellers. More genuine were the spirited cockney ragamuffins seen in the paintings of Arthur Boyd Houghton (1836–75), primarily a magazine illustrator, or the two urchins in *Shaftesbury, or* 95 *Lost and Found* (RA 1863) by William Macduff (active 1844–76).

Identified by their clothing as a chimney sweep and a shoe black, they are shown gazing gratefully into a printseller's shop window at an engraved portrait of Lord Shaftesbury, the philanthropist whose social reforms benefited them both.

This apparently realistic but highly contrived scene was also designed to convey the idea of the democratizaton of art by the mass production of images through engraving. By the 1850s the audience for art was increasing. Exhibition attendances were rising and the 'picture of the year' could make a great stir, with crowds flocking 96 around it, as depicted by G.B. O'Neill in *Public Opinion* (RA 1863). The Manchester Art Treasures Exhibition of 1857 drew an attendance of 1,300,000 over six months, and on Saturday afternoons a reduced admission charge enabled working people to attend. A growing number of books, newspapers and periodicals gave plenty of coverage to the fine arts with long exhibition reviews, describing paintings in considerable detail. But above all it was the improvements in reproductive techniques that broadened the public for art. The *Illustrated London News*, founded in 1842, reached a circulation of a quarter of a million copies by 1852. A middlebrow general-interest weekly, it printed not only regular exhibition notices but also illustrations of the pictures on display. These single- or double-page wood engravings and the later coloured chromolithographic plates were fairly crude because they were produced rapidly to meet weekly deadlines at low cost. Steel engravings gave a far higher quality of reproduction than wood and these were a principal factor in the success of the *Art Journal*, issued monthly and the only specialized art magazine to last the entire length of Victoria's reign. It received permission to publish steel engravings of both the royal and the Vernon collections and reached a circulation of 20,000 in the 1850s.

Steel engraving replaced the traditional copper plate, which could produce an edition of about 500 prints before deterioration set in. During the 1820s a technique was invented for coating the copper plate in steel and not long afterwards steel plates were used to print editions of several thousand. Small-sized steel engravings were used for the views and keepsake portraits in the illustrated annuals, but by the 1840s large steel engravings were issued independently and images could then be disseminated to a wider public than formerly. Such plates, engraved by highly skilled craftsmen adept at translating the subtleties of colour and tone into black and white, took months,

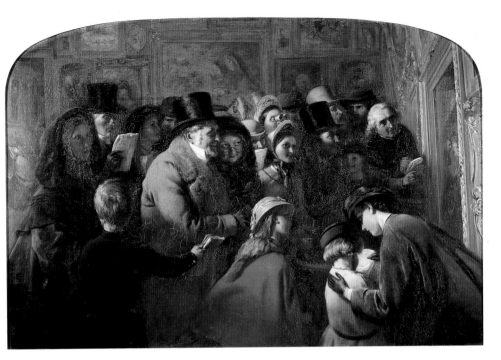

96 George Bernard O'Neill, *Public Opinion*, 1863

sometimes years, to engrave; the reluctance of collectors to do without their paintings for so long led to the practice of making reduced oil replicas from which the engraver could work.

Engravings provided additional income for the artists as well as a livelihood for engravers, printers, publishers and art dealers. Over half Landseer's income in the 1840s came from copyright fees; for *The Monarch of the Glen* he received 88 guineas for the painting and 500 guineas for the copyright on an edition of 625. Frith's *The Derby Day* was sold for £1500 but he retained the engraving rights from which he made £2250 for an edition of 5025, sold at prices ranging from five to fifteen guineas depending on the type of paper, lettering and signature. For *The Railway Station*, including sketch, picture and copyright, he was paid £4500.

These editions were limited in number; the engravings issued by the Art Unions were available in much larger quantities. Art Unions, which flourished in the early Victorian period, were bodies set up to

19
74

encourage wider circulation of works of art. They organized lotteries for members, with prizes of paintings selected from current exhibitions; they also distributed special editions of prints made not from the hand-engraved plates themselves but from electrotypes produced mechanically from the hand-engraved plates. This method enabled twenty or thirty thousand prints to be made. Only in the 80s and 90s was steel engraving superseded by fully mechanical reproductive techniques such as photogravure; even then a successful print could still bring a painter worldwide fame which the exhibition of a single painting could not hope to achieve.

The incomes of successful artists rose to great heights during this period. Landseer received about £6000 a year in the 50s and 60s, which compared well with the income of a successful man in the professions or a country gentleman. More typical was G.E. Hicks, who achieved modest but fluctuating success, earning about £400 a year in the late 50s at the start of his career, rising to £600 or £700 in the 60s and reaching a peak of £1200 in one successful year. The sums received for individual pictures varied enormously, but some idea can be obtained from the change in prices charged by the Pre-Raphaelites as their careers progressed. In 1849 Millais sold *Isabella* for £150 and Rossetti sold *The Girlhood of Mary Virgin* for £84; in 1852 *Ophelia* and *The Hireling Shepherd* were each sold for £315, though in the same year Madox Brown's *Chaucer* was sold for a derisory £50; by 1860 Millais was charging £1000 for *The Black Brunswickers* whilst Hunt sold *The Finding of the Saviour in the Temple* to the dealer Ernest Gambart for the exceptional sum of £5500 including copyright. In the same year Hicks was selling small genre paintings for £40 each and a large crowd scene for £380.

The money to be made from art enabled painters to take their place in the middle classes as respectable professionals with their own career structure, its progress marked at various points by official honours and rituals, and ending in the same kind of wealth and status associated with the top of other professions: first picture shown at the Academy, first work sold to a well-known collector or dealer, election to Associateship and eventually to full Membership of the Academy, royal patronage, exhibitions and medals at European Academies and so on in some cases to a knighthood or baronetcy. The rising status of Victorian painters is also indicated by the changing location and type of their houses. In the early 19th century the artists' quarter of London

49
46
55

was Soho and Tottenham Court Road, areas long associated with artisans and tradesmen. From the 1850s successful painters moved to new middle-class residential areas such as Kensington, Bayswater and St John's Wood and, with the coming of the railways, to Surrey and Kent. They often moved out in advance of the trend, colonizing the villages of Kensington, Chelsea and Hampstead, for instance, whilst they were still cheap and unfashionable. Early in the reign, artists worked in an existing room in their homes or built on a simple painting room at the back. Landseer extended his house with a large studio, but it was gloomy and devoid of decoration. In the 50s and 60s, though younger artists cultivated bohemian lifestyles, successful painters began to fill their studios with the picturesque props of their trade, suits of armour and oak furniture for historical painters and ship models for marine artists. Artists' houses were becoming more elaborate; in the 1860s Philip Webb designed special studio houses for Prinsep (1864) and Boyce (1869), and Horsley had an older house at Cranbrook extended (1864–69) by Richard Norman Shaw (1831–1912), soon to specialize in designing artists' homes.

Many women artists worked during the Victorian period but it was more difficult for them to make a career in art than their male counterparts. There was great prejudice against those women who tried to go beyond their approved domestic role and to achieve more than amateur status for their art. Women artists often spoke of the difficulties in combining a career with married life and some, like Emily Osborn (1834–after 1913), never married. Osborn had a long and successful career but she was one of the exceptions. Many women painters were part of the dynasties or circles of artists that were such a feature of the art world: Henrietta Ward (1832–94), wife of E.M. Ward; Jessie (1807–80) and Emma Landseer (active 1845–60), daughters of John Landseer the engraver and sisters of Edwin; Rosa Brett (1829–82), sister of John; Elizabeth Siddal, wife of Rossetti. Their work tended to be overshadowed by that of their menfolk and it was often hard for them to gain an independent style, let alone recognition as artists in their own right.

Osborn's *Nameless and Friendless* (1857), inspired by a now 97 forgotten novel, *Self Control* by Mary Brunton (1810), shows the difficulties met by women artists; a woman painter trying to sell her paintings to an art dealer is greeted with disdain. Women could exhibit at the Academy but were excluded from membership, and as

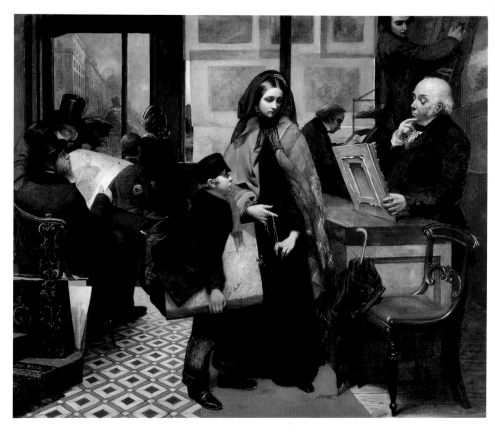

97 Emily Mary Osborn, *Nameless and Friendless*, 1857

the selection favoured members' over non-members' work they were doubly discouraged. Obstacles such as these led a group of women to found the Society of Female Painters in 1857. Study from the nude model was thought to pose moral danger to female students, and women were excluded from the Academy Schools until 1860 when Laura Herford (active 1859–d.1871) gained admission by the legitimate ruse of submitting an application in the name of L. Herford. Even so the Academy Schools banned women again from 1864 to 1867 and women were not allowed to become members until 1881, though in the meantime other art schools, notably the Slade (founded in 1871), had opened their doors to women students.

 Nameless and Friendless is one of the few paintings of a Victorian

picture dealer's shop; the growth in importance of the art dealer paralleled the rise in status and wealth of the artist. Sheepshanks and his contemporaries and the early Pre-Raphaelite collectors had befriended artists and often bought direct from them. With the rising demand for pictures from less discerning buyers, dealers increasingly came to act as intermediaries. In the 40s and 50s, Thomas Agnew, whose firm was then based in Liverpool and Manchester, turned the taste of a whole generation of Lancashire industrialists from the Old Masters to the moderns. Agnew's opened a London branch in 1860; in the meantime foreign dealers such as the eccentric Prussian L.V. Flatow and the Belgian Ernest Gambart had settled in England and began to rival the older-established London dealers.

Seeing an opportunity in the long gap between the Summer Exhibitions, art dealers mounted Winter Exhibitions, usually of cabinet-sized pictures. Beginning sporadically in the late 40s and early 50s they gradually became an established part of the art year. Dealers increasingly influenced an artist's work: in 1848 Agnew's commissioned J.B. Pyne to paint views of the Lake District and in 1851 for the same dealer Pyne undertook a three-year tour of Italy. They also actively intervened in an artist's style, as is revealed by an agreement between Gambart and John Linnell which specified 'good & well defined foreground . . . What is called sketchy to be avoided'. Sometimes dealers organized one-picture exhibitions, often linked to the promotion of engravings: Gambart showed Holman Hunt's *The Finding of the Saviour in the Temple* in 1860 and Flatow showed Frith's *The Railway Station* in 1862. Not unnaturally, these were frowned on by the Academy. A further factor in the rise of the dealer was the increase in auction prices which encouraged the collecting of modern British art for investment, particularly after the high prices fetched at the Northwick and Bicknell sales at Christie's in 1859 and 1863. Encouraged by record prices, get-rich-quick businessmen such as the Manchester textile merchant Sam Mendel or the shady financier Albert Grant formed collections of conventionally fashionable pictures for financial as much as aesthetic reasons and when their fortunes failed, hurriedly sold them again. By 1871 the *Art Journal* could remark that 'the influence of the dealer is one of the chief characteristics of modern art. He has taken the place of the patron, and to him has been owing to a great extent, the immense increase in the prices of modern pictures.'

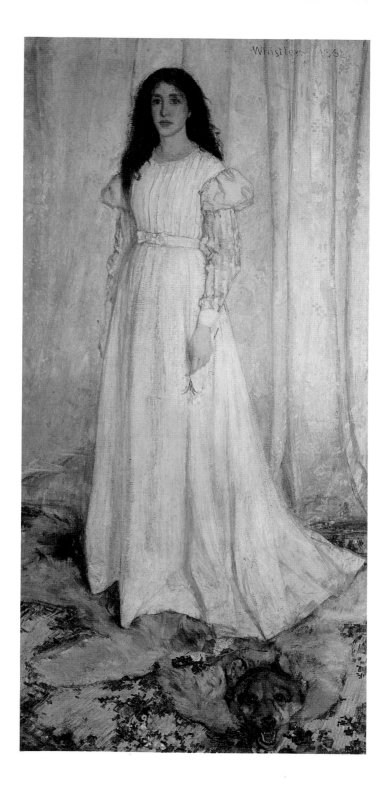

The Aesthetic Movement

In 1859 James Abbot McNeill Whistler (1834–1903) and Frederic
Leighton (1830–96) both independently settled in London after long
periods abroad: Leighton had been a student in Frankfurt of the
Nazarene painter Edward von Steinle (1810–86), and then worked in
Rome and in Paris. After the success of *Cimabue's Celebrated Madonna
is carried in Procession through the Streets of Florence* (RA 1855), his I
dramatic historical and biblical scenes of the early 60s were not so well
received. Whistler, born in Lowell, Massachusetts, had studied in
Paris at the atelier of the Neo-Classical painter Charles Gleyre (1808–
74), along with a number of English students, but only Whistler
aligned himself with the Parisian avant-garde. His enigmatic *The
White Girl* of 1861–62, rejected by both the Royal Academy and the 98
Salon, was shown in the famous Salon des Refusés of 1863. The
working-class subjects of Gustave Courbet (1819–77) and the
intimate realism of Henri Fantin-Latour (1836–1904) were important
elements in Whistler's earliest London works, showing dark interiors
and Thames-side shipping and low life. Whistler admired the
beautiful, melancholy young girls in Millais' pictures and became a
friend of Rossetti, whose decorative abstraction and rejection of
narrative aligned him with the theory of aestheticism which Whistler
had encountered in France.

This originated in the writings of the philosopher Victor Cousin
(1792–1867), who first coined the phrase *l'art pour l'art* (art for art's
sake), and in the poetry of Théophile Gautier, whose minutely
polished style demonstrated his belief in the perfection of form as an
end in itself. Aestheticism rejected both the mimetic and the didactic
roles of art and placed supreme emphasis on the intrinsic worth of
formal values such as colour, line, tone and pattern. It thus discarded
the genre, humour, narrative and anecdote of the early Victorians,
and also ran counter to Ruskin's interpretation of art as an imitator of
nature and a means to convey moral and spiritual truths. Whereas
Ruskin preferred 'stern facts' to 'fair pictures', the poet Algernon

131

98 James Abbot McNeill Whistler, *The White Girl*
(later renamed *Symphony in White No. 1*), 1861–62

Charles Swinburne (1837–1901), the most important English follower of Gautier and Baudelaire, wrote approvingly of a painting by Albert Moore (1841–93), 'Its meaning is beauty; and its reason for being is to be.' The theory of aestheticism reached its clearest literary formulation in the essays of Walter Pater (1839–94). 'All art constantly aspires towards the condition of music', he wrote in *The School of Giorgione* (1877); the analogy with music as an abstract form of artistic expression lay at the heart of many paintings of the period. In the same essay he also put forward two key ideas, first that the essence of painting was its physical form, not its subject or meaning, and second that art was superior to nature: 'In its primary aspect, a great picture has no more definite message for us than an accidental play of sunlight and shadow for a few moments on the wall or floor: is itself, in truth, a space of such fallen light, caught as the colours are in an Eastern carpet, but refined upon and dealt with more subtly and exquisitely than nature itself.'

An extension of the idea that art was independent of moral teaching was the belief that the artist stood outside conventional society. In reaction to the growing respectability of the artistic profession, some of the leaders of the Aesthetic Movement pursued a studied amorality in their lives as well as in their art. They cultivated unorthodox lifestyles – Whistler the waspish dandy, Pater the fastidious aesthete, Swinburne and the painter Simeon Solomon (1840–1905) the sexual outsiders. A strong erotic content is present in much of their work, seen particularly in the frequent portrayal of languid and world-weary female, and occasionally male, beauty.

Rossetti in 1859 had begun a series of fanciful head-and-shoulders portraits of women. The earliest were small, intimate and intense, such as *Bocca Baciata* ('the mouth that has been kissed', 1859). Some depicted the delicate beauty of Elizabeth Siddal, but they also featured more voluptuous models such as Fanny Cornforth and Alexa Wilding. Nevertheless they were not portraits of individuals but expressions of female sexual allure; by the mid-60s they had become larger and more overtly sensual. Often provocatively *en déshabillé* or at their toilet, gazing into mirrors or combing their long, flowing hair, these women recall the half-length portrayals of Renaissance courtesans by Titian and Veronese. Rossetti included luxurious accessories such as flowers, jewels, silken fabrics and musical instruments and the sense of physical beauty was enhanced by the

99

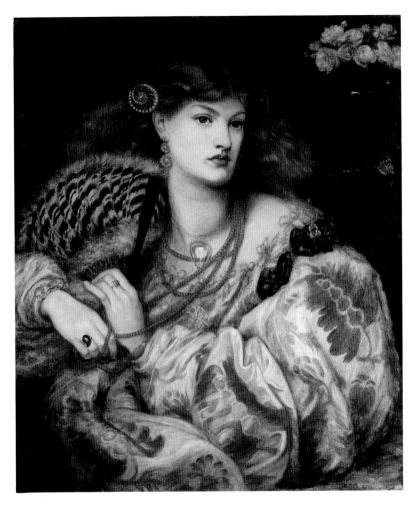

99 Dante Gabriel Rossetti, *Monna Vanna*, 1866

distinctive gilt frames he designed himself, often inscribed with lines of his poetry.

During the early and mid-60s Leighton, Burne-Jones, Whistler and Albert Moore all painted decoratively arranged pictures of female models as vehicles to convey beauty for its own sake. For Rossetti's richly coloured display of sensual pleasure they substituted paler colour harmonies and dreamy langour. References to music are evident in Leighton's charming representations of women or

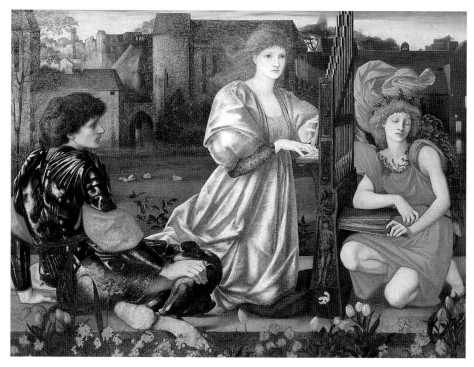

100 Sir Edward Coley Burne-Jones, *Le Chant d'amour*, 1869–77

101 James Abbot McNeill Whistler, *Symphony in White No. 3*, 1865–67

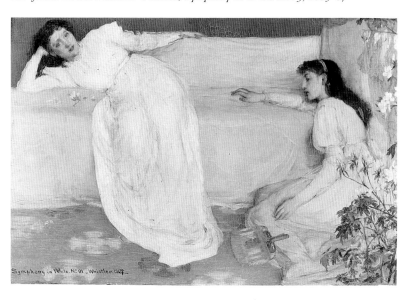

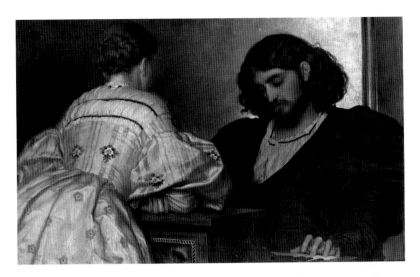

102 Frederic, Lord Leighton, *Golden Hours*, 1864

romantic lovers such as *Golden Hours* (RA 1864) which, like Rossetti's 102
pictures, recreates the sensuous ambience of 16th-century Venetian
art. A similar feeling for mood and musicality is seen in the dreamlike
idylls of Burne-Jones, deriving from the *fêtes champêtres* of Giorgione. 100
 Whistler, in his pictures of beautiful women, turned not to Italy but
to Japan. The discovery of Japanese art and the craze for collecting
blue-and-white porcelain and woodblock prints swept through the
Parisian avant-garde around 1860 and Whistler played an important
part in bringing it to London. Japanese art was collected by leaders of
taste such as Rossetti and the architects William Burges and Edward
William Godwin (1833–86), also a designer of furniture in the
Japanese style, and was introduced to a wider public at the Inter-
national Exhibition held in London in 1862. In 1864 Whistler made
several pictures of women in colourful embroidered kimonos with
Japanese screens, fans and pots; these were succeeded by paintings of
girls clad in simple white dresses, without such an obvious display of
japonisme, but showing an understanding of the underlying principles
of Japanese design, its flatness, its boldness of placing and outline, and
the subordination of detail to overall effect.
 Whistler's Symphony in White No. 3 (1865–67) shows the influence 101
of Albert Moore, whom Whistler met in 1865. After Pre-Raphaelite

beginnings, Moore developed a purely decorative type of painting depicting figures in classical draperies without subject or narrative. His first picture of this kind, *The Marble Seat* (RA 1865, untraced), showed four Grecian figures with idealized, expressionless faces, posed against a background of foliage and flowers. It was much admired by Whistler, and during the late 60s the two artists became close friends. Moore's palette lightened and like Whistler he introduced into his work not only Japanese vases, fans and sprays of blossom, but also a more pronounced sense of design in the flat. In turn, Whistler's figures became more idealized and classical and he planned, but never realized, a unified decorative scheme for a room, to be painted with storyless groups of life-sized figures dressed in fluttering pastel-coloured draperies, a synthesis of Grecian and Japanese art. Around 1866–67 both artists changed their conventional signatures to decorative monograms, Moore a honeysuckle device and Whistler a butterfly. Whistler's musical titles, Moore's figures playing instruments and the increasing interest in the placing of the figures on the canvas, often in frieze-like series, displayed a shared concern in finding a visual equivalent to musical rhythm and interval.

The figure compositions of Moore and Whistler are part of a general revival of interest in the classical ideal current in the 1860s, also seen in the work of Leighton, Watts, Burne-Jones and, in France, Puvis de Chavannes (1824–98). This was not the austere Neo-Classicism of the early 19th century with its tense linearity; it was based on a new interpretation of Greek art as the expression of a harmonious, luxurious ideal of beauty in repose. In 1865 the Elgin Marbles were restored and re-displayed at the British Museum and received renewed attention. Watts and Leighton had casts of the marbles in their studios and acknowledged their importance to them by including parts of the friezes in the backgrounds to self-portraits. The forms of drapery found in Greek sculpture and in Tanagra figurines were imitated by Moore, Watts and Leighton, and in work by the latter the cascading folds took on a decorative life of their own. Leighton made his first visit to Greece in 1867; after this his borrowings from Renaissance Italy grew scarcer and Greek art became more important for his work. He took the form of the carved frieze and recreated it in paint with sumptuous colour in *The Syracusan Bride* (RA 1866), a procession of classical figures artfully arranged in a shallow stage-like space. Another characteristic form of

136

103 Albert Joseph Moore,
A Venus, 1861

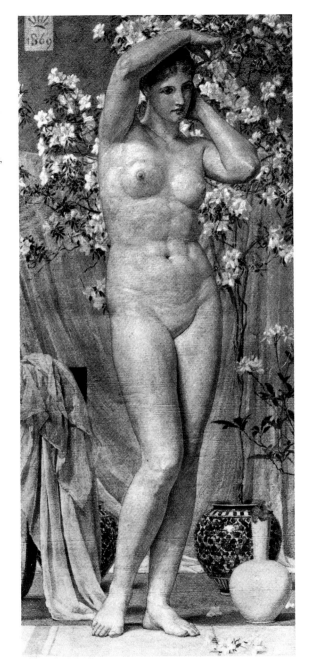

Greek sculpture, the full-length nude, was also revived in paintings by Moore, Watts and Leighton of the late 60s. The torso of Moore's *A Venus* (RA 1869) is copied from the Venus de Milo whilst Leighton's Icarus in *Daedalus and Icarus* (RA 1869) is based on the Apollo Belvedere.

The classical ideal proved to be the most fruitful and enduring influence on Leighton and Watts; Moore's art continued to represent a mixture of Greece and Japan, and Burne-Jones was deeply affected by the High Renaissance and Mannerism, but looked again to the Middle Ages at the end of his life. Whistler alone returned to contemporary subject matter. In the early 70s he turned his attention back to London, painting views of the Thames by night, which, at the suggestion of his patron, F.R. Leyland, he called Nocturnes, a word suggesting music as well as night. The first picture exhibited with this title, shown in 1872, was *Nocturne in Blue and Silver: Cremorne Lights*. He also began a series of spare but elegant portraits, showing at the Academy of 1872 *Arrangement in Grey and Black No. 1: the Artist's Mother*. These titles indicate Whistler's attitude to representation, for though he was returning to nature for inspiration, he stressed artifice rather than realism or personal feeling, employing deliberately restricted, sometimes almost monochromatic colour schemes and simplified shapes, aiming to capture the essence but not the details of a scene. Nevertheless, for all Whistler's emphasis on pure form, on fastidious application of paint in casual-looking but in reality carefully calculated effects, his portraits were quietly expressive of character and milieu and his river views intensely evocative of place and time of day.

Whistler's hypersensitivity extended to the framing and presentation of his work. Like Rossetti and Holman Hunt, Whistler designed his own frames, rectilinear in outline in contrast to the complex swept designs then in fashion; Whistler sometimes painted or scumbled his frames to enhance the tone of particular pictures. He was also deeply concerned to create a sympathetic environment for his art. His own rooms were sparsely furnished and decorated with straw matting on the floor and pale-coloured walls, quite unlike the cluttered appearance of most Victorian interiors; the White House, Chelsea, designed for him by Godwin in 1877, was in an unornamented style so plain that it came into conflict with the Metropolitan authorities. Whistler later also devised the settings for his own

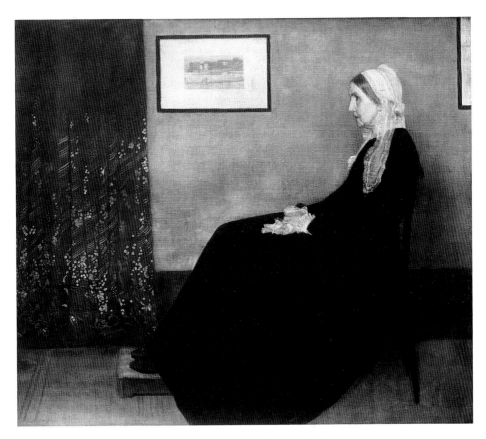

104 James Abbot McNeill Whistler, *Arrangement in Grey and Black No. 1: the Artist's Mother*, 1872

exhibitions, hanging his pictures spaciously against olive green or pale yellow walls and even specifying the colours worn by the attendants and the typography and brown-paper covers of the catalogues. Most famously, in 1876–77 he collaborated with the architect Thomas Jeckyll (1827–81) on the Peacock Room, the dining room of 105 F.R. Leyland's London house. To Jeckyll's interior, designed to display Spanish leather hangings and a collection of blue-and-white china as well as Whistler's own painting *The Princess from the Land of Porcelain* (1864), Whistler added stylized peacocks and gilded peacock-feather motifs, transforming the room into a shimmering *Harmony in Blue and Gold*.

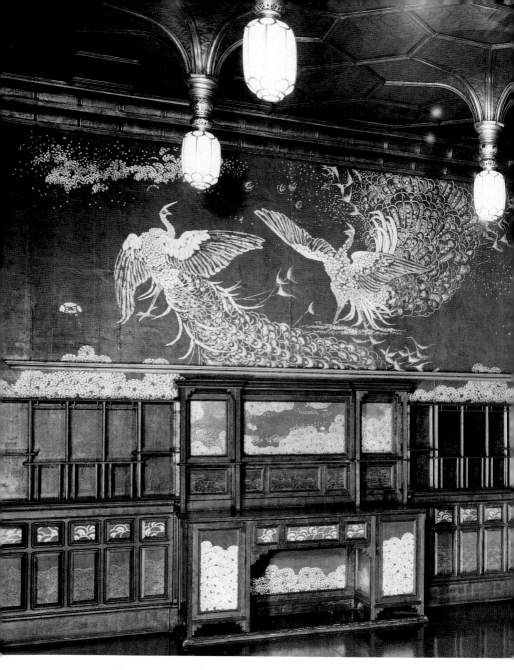

105 Reconstruction of The Peacock Room, designed by Thomas Jeckyll and James Abbot McNeill Whistler, 1876

Only Moore remained faithful to the pure decorative ideal of the late 60s. The rest of his work consists of ever more exquisite variations on the theme of draped female figures, painted with different colour combinations and accessories which served also to give the pictures titles: *Azaleas* (RA 1868), *Shells* (RA 1874), *Sapphires* (GG 1877), *Birds* (GG 1877). A clue to the artist's heightened aesthetic sense is given by his remark that after a walk in Kensington the only thing he had seen that was worth looking at had been some lemons laid out on blue paper on a costermonger's barrow. Towards the end of his life, perhaps because of his illness, his titles became more specific to time and place; human emotion began to affect his normally impassive figures: the direct gaze of one of the women in *Dreamers* (RA 1882) hints at a subtle eroticism, whilst *An Idyll* (RA 1893) represents a lovers' quarrel.

The paradox of the Aesthetic Movement lay in the fact that though the cult of beauty was of central importance, the need was felt for art to have a deeper meaning. With the exception of Whistler, who maintained his detachment, the artists of the Aesthetic Movement, particularly in their later works, sought an engagement with

106

106 Albert Joseph Moore, *Dreamers*, 1882

107 Dante Gabriel Rossetti, *Dante's Dream at the Time of the Death of Beatrice,*
1870–71

profound issues of the human condition. In these late paintings, the
formal perfection of aestheticism served to heighten their emotional
power, while their use of symbolic reference, myth and archetype,
often operating on a subconscious level, linked them with European
Symbolism.

Whilst Rossetti was painting portraits of beautiful women, he was
also working on more personal subjects which arose from his
obsession with Dante's unconsummated passion for Beatrice and
from his own unhappy love first for Elizabeth Siddal and then for Jane
Morris, the wife of his friend and former disciple William Morris.
Beata Beatrix (1864) is a memorial to Elizabeth Siddal, an emblematic
representation of the moment of her death. The same theme was
elaborated in *Dante's Dream at the Time of the Death of Beatrice* (1870– 107
71), this time giving Beatrice the features of Jane Morris. The painting
was based on a much earlier watercolour, now enlarged on to a huge
canvas, signifying the artist's intention to make a public statement

after many years without showing in exhibitions. But in the early 70s Rossetti became a virtual recluse and retreated into his own imaginative world. Already beset by failing eyesight, poor health and increasing dependence on chloral, he suffered a breakdown after the critic Robert Buchanan attacked his poetry as obscene in an article entitled 'The Fleshly School of Poetry' (1871). Almost all of his later chalk drawings and oils feature the brooding likeness of Jane Morris; sometimes the poses are based on photographs of her taken in 1865 by the photographer J.R. Parsons. Rossetti's late works, coarse in execution but of powerful presence, were largely concerned with themes of ill-fated passion, cruel or unhappy women and contrasts between heavenly and earthly love: *La Pia de Tolomei* (1868) from Dante's *Purgatorio*, imprisoned by her husband in a fortress, *Pandora*

108 (1871) who introduced evil into the world, *Proserpine* (1877) condemned to spend most of her life in the underworld, *The Blessed Damozel* (1875–79) in heaven separated from her earthbound lover and *Astarte Syriaca* (1877), an amalgam of love goddess and merciless queen, an archetype of female power over men. The full lips and sad eyes of Rossetti's heroines recall his belief that the mouth represents the sensual and the eyes the spiritual aspect of love; the mannered hands, profusely flowing hair and the writhing, flame-like patterns of the draperies anticipate the curves of Art Nouveau. These forms are echoed in the rhythmical cadences of Rossetti's poetry, which conveys the same mood of doomed ecstasy.

The Pre-Raphaelite circle of the late 50s and 60s was dominated by

112 Rossetti. Arthur Hughes turned to medieval themes, to musical subjects inspired by Venetian art, and to illustration, particularly for children's books. Rossetti also provided the inspiration for the *femmes*

110 *fatales* of Frederick Sandys (1829–1904), seen both in his powerful and imaginative wood engravings and in his oil paintings of cruel heroines and enchantresses, executed with the sharp focus and bright colours of the early Pre-Raphaelite style. Also a member of Rossetti's coterie was the Jewish painter Simeon Solomon, whose early work included Old

111 Testament subjects and engravings for an illustrated Bible to which many of the Pre-Raphaelites contributed. In 1863 he met Swinburne whose interest in sado-masochism prompted Solomon to be more open about his own homosexuality in his art, and stimulated a change of style. Solomon's paintings of enigmatically beautiful young men possess an erotic charge akin to that of Rossetti's fleshly portraits;

108 Dante Gabriel
Rossetti,
Proserpine, 1877

109 Sir Edward Coley Burne-Jones,
*The Annunciation (The Flower
of God)*, 1863

many mix spiritual and sensual ecstasy in a way paralleled in some of
Swinburne's poems. Solomon's own prose poem *A Vision of Love
revealed in Sleep* (1871) was the source for his later subjects, mostly
chalk drawings of androgynous youths, often weak in execution;
following his indictment for sexual offences in 1873, he was ostracized
by society and reduced to a wretched life of poverty, dying in the
workhouse.

Unlike others of the Rossetti circle, Burne-Jones was virtually self-
taught as a painter, except for informal lessons from Rossetti and some
life classes at private academies. As with Rossetti, Burne-Jones was
distinguished from his fellow artists by the power and originality of
his imagination rather than by technical ability, and in the early part
of his career, from his introduction to Rossetti in 1856 until the mid-
70s, he suffered from uncertainty and self-doubt as he tried to acquire
the means to express his ideas fully. His early work consists of dense
pen-and-ink drawings, charming but gauche, and of small water-
colours. These enshrine a fairytale vision of a chivalric and passionate
Middle Ages. Burne-Jones was taken in hand by Watts and Ruskin
who were worried by his over-reliance on Rossetti's medieval
archaism. In 1862 Ruskin went with him to Italy and made him copy

110 Frederick Sandys, *Medea*, 1868

111 Simeon Solomon, *Carrying the Scrolls of the Law*, 1867

112 Arthur Hughes, *The Knight of the Sun*, 1860

Giotto, Titian and Tintoretto, to give his style more grace, repose and
109 breadth. Even so the lyrical but idiosyncratic gouaches he exhibited in
the 60s were criticized as eccentric and lacking in naturalism.

Burne-Jones developed a brilliant decorative aptitude from his
long practice in designing for the applied arts. This was vital to his
development as a painter, just as it was for others of the Aesthetic
Movement. During the 60s artists of all kinds, not just those in the
Pre-Raphaelite circle, were involved in the decorative arts. Much of
their work consisted of figure paintings applied to furniture, but their
experience with tiles, glass and ornamental design taught them the
skills of two-dimensional pattern-making and the use of simplified
shapes and outlines, making them more conscious of formal values.

Burne-Jones' designs for Morris, Marshall, Faulkner & Co.
included painted furniture, tiles, textiles and above all stained glass.
He designed a vast number of pictorial windows and after 1875, when
the firm was re-organized as Morris & Co., Rossetti and Brown
withdrew, leaving Burne-Jones as the only stained-glass designer,
constantly making new cartoons and adapting old ones. This gave
him the confidence to work on a large scale and produced the facility
with decoratively flowing line that is a hallmark of his mature
paintings. Because of the volume of work, in 1866 he began to
employ studio assistants, who enlarged and transferred designs and
prepared his canvases. Burne-Jones often re-used the same design in
different media, returning to favourite subjects sometimes after long
intervals, developing them from small watercolours or illustrations
into paintings and murals, or using them for the tapestries that became
an increasingly important part of his work in the 1880s. Many of his
subjects came from the episodic cycle of poems *The Earthly Paradise*
by William Morris, begun in 1865, a source that also inspired murals
such as the *Cupid and Psyche* frieze (1872–87) and the *Perseus* series
(1875–98), both for the London houses of important patrons. The
murals are narrative paintings without the violent activity, focused
expressions or demonstrative gestures of the early Victorians; Burne-
Jones' stories are told through a succession of still images conveying a
measured rhythm.

In the 1870s, Burne-Jones' mature style began to emerge. He
exhibited little between 1870 and 1877, a period of personal
unhappiness, but his art grew in assurance, scale and monumentality.
After his flirtation with aesthetic classicism, he took a renewed interest

in the High Renaissance and Mannerism, visiting Florence and Rome
in 1871 and 1873, studying particularly Signorelli, Mantegna,
Botticelli, Leonardo and Michelangelo. This experience was reflected
in a number of paintings connected with an ambitious polyptych on
the story of Troy, begun in 1870 but never finished. Several major
works of the 1870s, such as *The Beguiling of Merlin* (GG 1877) and *Laus* 113
Veneris (GG 1878) depict female mastery over the passive male,
played out by elongated androgynous figures with weary, inward-
looking expressions powerfully suggestive of repressed desire. In
contrast were evocations of pure beauty in which the subject took a

subsidiary role, such as *The Mirror of Venus* (GG 1877) or *The Golden Stairs* (GG 1880). These mature paintings appear calculated, lacking in the freshness and spontaneity of his earlier work; but they gain in richness of texture, intricacy of design and depth of feeling.

In the work of the 80s and 90s Burne-Jones created a self-contained, dreamlike atmosphere with a powerfully hypnotic appeal which won him a European reputation. The theme of withdrawal from the world, expressing the characteristically late-Victorian mood of doubt and its rejection of materialistic values, is seen in the enchanted court of the Sleeping Beauty from the *Briar Rose* series (1890) installed at Buscot Park, Oxfordshire; in the myth of *King Cophetua and the Beggar Maid* (GG 1884), the king who gave up his wealth in favour of 114 poverty and beauty; and above all in *The Sleep of Arthur in Avalon*, Burne-Jones' last major painting, begun in 1881 but left unfinished at his death in 1898. It held a deep personal meaning for the artist, who identified himself and his approaching end with the vision of the sleeping king who, after his worldly quest, lay waiting to be called again, surrounded by mysterious women in an atmosphere of hushed stillness.

Burne-Jones exhibited eight paintings at the opening exhibition of the Grosvenor Gallery in 1877. This venture launched the Aesthetic school into the public eye and overnight Burne-Jones became famous as its leading artist. The Grosvenor was privately owned, financed and run with flair by the wealthy and artistic Sir Coutts Lindsay (1824–1913) and his wife. Artists showed by invitation, but once chosen they were free to exhibit what they wished without a selection committee. Works by a single artist were grouped together and in contrast to the crowded Academy hang they were well lit and spaciously arranged. The success of the Grosvenor was supported by clever publicity and by its modish aristocratic ambience, for Lady Lindsay invited the cultivated artistic élite to openings and receptions, and the public flocked to the exhibitions, avid for an elevating cultural experience. The opening of the Grosvenor challenged the dominance of the Academy and signalled the late Victorian trend towards multiplicity and fragmentation of the art scene.

If the first exhibition established the reputation of Burne-Jones, it brought notoriety to Whistler. After seeing Whistler's *Nocturne in* 115 *Black and Gold: the Falling Rocket* (*c.* 1874) at the Grosvenor, Ruskin wrote, 'I have seen, and heard, much of cockney impudence before

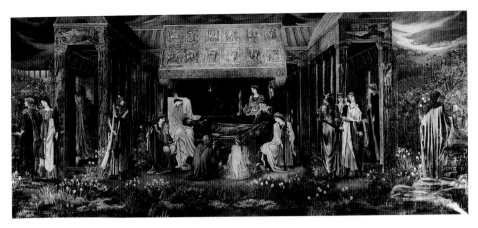

114 Sir Edward Coley Burne-Jones, *The Sleep of Arthur in Avalon*, 1881–98

now; but never expected to hear a coxcomb ask two hundred guineas for flinging a pot of paint in the public's face.' Whistler sued the critic for libel. Ruskin's words had been published in *Fors Clavigera*, a series of letters written to British workmen emphasizing the importance of nature, and of moral and spiritual values in art. These ideas had wide popular currency but for the more advanced they could be seen as the views of an intolerant, out-of-touch old man. At the trial in 1878, Whistler treated the philistinism of the lawyers with merciless sarcasm and Ruskin, on the verge of a nervous breakdown and too ill to attend in person, drafted in witnesses as unlikely as Frith and Burne-Jones to defend the traditional idea of 'finish'. Serious debate was not really possible. In the event, Whistler won the case but was awarded the insulting damages of one farthing.

 Though Whistler's influence was temporarily eclipsed and he left for Venice, the trial brought the new art out into the open and it was widely talked about. Through his lectures and journalism, Oscar Wilde (1854–1900) became the chief publicist of aestheticism, borrowing many of Whistler's ideas as well as his dandified stance, and the Aesthetes were mocked in du Maurier's *Punch* cartoons and in Gilbert and Sullivan's comic opera *Patience* (1881). The Grosvenor Gallery continued to show the Aesthetic school but after a few years the differences between the Grosvenor and the Academy became less marked, the Grosvenor was forced to become more commercial to survive and in 1887 its role was taken over by the New Gallery to which Burne-Jones and many others transferred their allegiance.

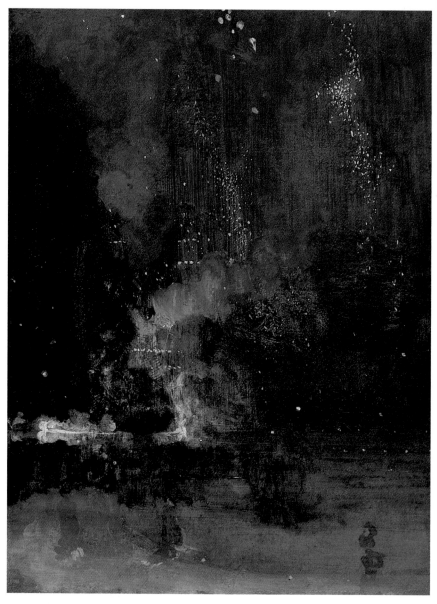

115 James Abbot McNeill Whistler, *Nocturne in Black and Gold: the Falling Rocket*, *c.* 1874

116 Ford Madox Brown, *The Opening of the Bridgewater Canal AD 1639*, 1881–83

The ideal of collaboration of artist and architect, a preoccupation of the Aesthetic Movement, was realized in a number of domestic mural schemes such as a room at Bank Hall, Derbyshire (1872–73) designed by the architect W.E. Nesfield (1835–88) and jointly decorated with draped females, urns and birds by Thomas Armstrong and the childrens' book illustrator Randolph Caldecott (1846–86). The same ideal, but with a public and didactic mission, is seen in the cycle of mural paintings by Madox Brown at Manchester Town Hall 116 which form an apt complement to the Gothic revival architecture of Alfred Waterhouse. The murals (1878–93) depict episodes from the history of the city and combine spirited Pre-Raphaelite detail and narrative ingenuity with sweeping lines and strong designs which respect the flatness of the wall. The series resuscitated the discredited Westminster ideal and was widely praised, inspiring a revival of mural paintings in late Victorian and Edwardian civic buildings.

For many artists who exhibited at the Grosvenor and the New Gallery, Rossetti and Burne-Jones were formative influences. J.R. Spencer Stanhope, who had worked on the Oxford Union murals, lived for many years in Florence. He was one of the first British painters to revive the Italian technique of tempera painting and the combined influence of Burne-Jones and Botticelli dominated his work. The cult of the quattrocento which developed amongst the followers of Burne-Jones is seen in the somewhat lurid work of Stanhope's niece Evelyn de Morgan (1855–1919), in the gently romantic fantasies of John Melhuish Strudwick (1849–1937) and in 117 the paintings and watercolours of Walter Crane (1845–1915), also a designer of wallpaper and textiles and a book illustrator; the rich field of British Art Nouveau book illustration, which also includes the startling work of Aubrey Beardsley (1872–98) and Charles Ricketts (1866–1931), sprang directly from the work of Rossetti, Burne-Jones and Morris.

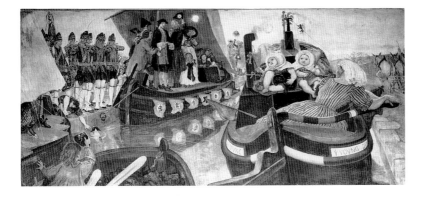

The last stage in the Pre-Raphaelite story came in the 1890s after the retrospective exhibition of Millais' paintings held at the Grosvenor Gallery in 1886 when his early works were much praised. The same year a Holman Hunt retrospective took place at The Fine Art Society. There followed a revival of the brightly coloured, sharply focused style of the original Brotherhood, particularly associated with Birmingham, where Burne-Jones, who had been born there, was of increasing influence in artistic matters. Pre-Raphaelite precision mixed with a fairy-tale mood is found in the paintings and murals in oil and tempera of Joseph Southall (1861–1944), Henry Payne (1868–1940) and others connected with the Birmingham School of Art, and in the illustrations and paintings of Eleanor Fortescue-Brickdale (1872–1945) and John Byam Shaw (1872–1919), painter of the poignant *Boer War 1900* (RA 1901).

118

Before it became generally fashionable, the art of the Aesthetic Movement was supported by a number of collectors, mainly *nouveau riche* merchants, manufacturers and financiers such as George Rae, a Birkenhead banker and one of Rossetti's most important patrons,

117 J.M. Strudwick, *Isabella*, 1879
118 John Byam Liston Shaw, *Boer War 1900*, 1900

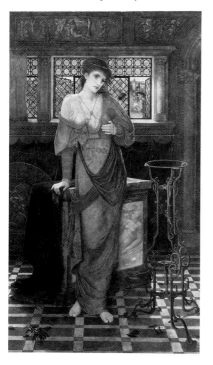

119 Julia Margaret Cameron, *The Kiss of Peace*, 1869
120 George Frederic Watts, *Tennyson*, 1863–64

William Graham, jute manufacturer and Member of Parliament for Glasgow who became a close friend of Burne-Jones, and F.R. Leyland, the Liverpool shipowner, who acquired pictures by Whistler, Rossetti, Moore and Burne-Jones. They were all educated men of refined tastes, and bought *objets d'art* and antiques of all kinds as well as pictures, creating specially designed settings for them. Perhaps the acme of the aesthetic patron was the Greek Consul-General and financier Alexander Ionides who formed a collection of Japanese prints, Tanagra figures and Old Master and modern paintings including works by Rossetti, Burne-Jones, Sandys, Whistler, and Watts. Ionides lived in London in a house designed by Philip Webb, extended by Thomas Jeckyll and decorated with furniture, textiles, friezes and tiles by Morris, William de Morgan, Burne-Jones and Crane. It became a shrine dedicated to the cult of beauty.

With the increasing secularization of late Victorian society, art was itself becoming a cult, and for many, art worship became a substitute for religion. Nowhere is this seen more clearly than in the change in the reputation of G.F. Watts. Until the 1880s he was principally known for his portraits. Besides painting his own circle, he recorded for posterity the great figures of the age, writers, statesmen,

philanthropists, artists, poets and musicians. These were not com-
missioned portraits or even conventional likenesses, for the artist's aim
was not merely to record outward appearance, but to 'capture the
120 shape and colour of a mind and life'. *Tennyson* (1863–64) is shown
against laurel leaves and *Cardinal Manning* (GG 1882) is posed like a
Raphael pope; most of his other portraits consist simply of a head and
shoulders against a dark background, and despite some unevenness,
the best convey powerful qualities of intellect and creativity.

Watts believed that art ennobled and improved the lives of
ordinary people. He promoted mural paintings in public buildings
and made public sculpture. From 1880 he gained a new reputation as a
painter of high-minded allegory through a series of one-man
exhibitions in Britain and abroad. He opened galleries of his work at
his houses in Kensington and Compton, Surrey (now a museum),
gave to public museums and lent to exhibitions, especially to those
held from the 1890s at the Whitechapel Art Gallery in the deprived
East End of London. He attracted a succession of devoted women
followers who referred to him as 'Il Signor' and promoted a cult of
Watts as the great artist and sage of his day.

Watts shared the preoccupation of the Aesthetic Movement with
ideal beauty and with antique and Italian Renaissance sources. His
work also has much in common with the photographs of his friend
119 Julia Margaret Cameron (1815–79) who shared with the painter a
liking for the suggestive power of blurred and vague effects as well as a
desire to convey spirituality both in portraits and allegorical subjects.
Watts gave his paintings a rough, granular finish, related to his
admiration for Venetian art. Just as the 'arrangements' of form and
colour by Whistler and Moore reach out unconsciously towards 20th-
century abstraction, so Watts' interest in the painterly and the
accidental was strangely prophetic: cracks and stains on a dirty plaster
wall suggested the subject *Chaos* (1873) and patterns cast on the ceiling
122 by a night light gave him the idea for *The Sower of the Systems*
(*c.* 1902), an almost formless picture of the Deity painted with
swirling brushstrokes.

For Watts, beauty for its own sake was never enough; he was
essentially a didactic painter and his bias towards allegory was present
in his early work. A visit to the Sistine Chapel in 1845 had inspired
him to devise a grandiose scheme for a mural cycle, *The House of Life*,
portraying a cosmic history of mankind and the universe through a

121 George Frederic Watts, *Hope*, 1886
122 George Frederic Watts, *The Sower of the Systems*, 1902–3

series of personal interpretations of biblical stories, including *Eve* and *Cain*, besides original allegories on themes such as *Chaos, Progress, The Court of Death* and *Time, Death and Judgement*. The overall scheme, though vague and often revised, is similar in kind to Munch's *Frieze of Life* and Rodin's *Gates of Hell* (both 1890s). Watts repeatedly returned to these subjects for individual paintings, making many versions, but he avoided any overt suggestion of creed or dogma for he was an agnostic and wished to create a language which could be widely understood. Some of his allegories were generalized references to topical issues, such as *The Good Samaritan* (RA 1850), a tribute to a prison reformer, and *The Minotaur of London* (1885), a condemnation of child prostitution. The deep currents of doubt that lay beneath the self-confidence and prosperity of late Victorian society were expressed in *Mammon* (1884–85) and *For He had Great Possessions* (RA 1894), icons of anti-materialism, whilst *Hope* (GG 121 1886), a blindfolded female seated on a globe and trying to play a broken lyre, became, in spite of its ambiguous meaning, an image of universal inspiration.

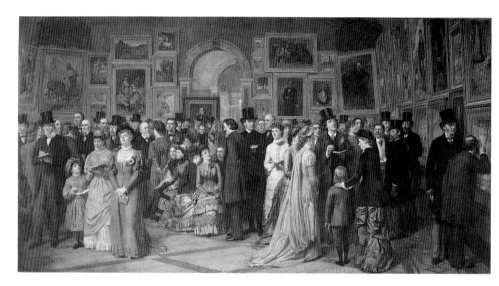

123 William Powell Frith, *The Private View of the Royal Academy in 1881*, 1881–82

124 The studio, Leighton House, London. Photograph, 1895

The Late Victorian Academy

For the Royal Academy, which moved from the National Gallery to Burlington House on Piccadilly in 1869, the last three decades of the century were palmy days. The Summer Exhibitions continued to draw crowds, notwithstanding the rise of rivals like the Grosvenor, the New and the growth of loan exhibitions of contemporary art such as those held from 1890 at the Guildhall. The Academy maintained its prestige in spite of attacks on its exclusivity, on the right of Academicians to have eight of their pictures hung each year, and on the mediocrity of many of the works in its exhibitions. From 1870 the Academy expanded its activities, holding Winter Exhibitions of Old Masters and Memorial Exhibitions of work by recently deceased British painters, but the chief attraction was the Summer Exhibition which in the 1880s drew about 350,000 visitors each year.

One of the reasons for the exhibition's continuing popularity was that it was not just an event for the art world but part of the London season. Frith's *The Private View of the Royal Academy in 1881* (RA 1883) 123 shows a gathering of prominent figures from the worlds of art, letters, politics, music, theatre, the universities, the Church and high society. The inclusion of Oscar Wilde holding forth before an audience of eager female disciples shows that art worship was not exclusive to the Grosvenor but was also pursued by the more establishment audience of the Academy. Artists were socially desirable, sought after by smart hostesses, and studio visits on 'Picture Sundays', held just before the Academy sending-in day, became a fashionable activity.

Artists' houses grew in architectural pretension. Designed for entertaining as well as for working, they were meant, like prestige business premises, to impress prospective clients. To Leighton's house, designed in 1865 by George Aitchison (1825–1910), an exotic Arab Hall lined with Persian tiles was added in 1877, adorned with a fountain and with carvings and mosaics designed by Walter Crane and Randolph Caldecott; the house was the scene of many receptions and musical soirées. Richard Norman Shaw, who designed houses for

125 Briton Rivière, *Sympathy*, 1877
126 Walter Dendy Sadler, *Thursday*, 1880

painters including Luke Fildes (1843–1927), Marcus Stone (1840–1921), Edwin Long (1829–91), and the illustrator Kate Greenaway (1846–1901), became an expert in the technical requirements of studio houses, knowing how to contrive a good light in which to paint, and providing such features as glass studios for use during the dark London winters, and separate staircases to avoid models and visitors meeting. The climax of each artist's house was an impressively large
124 studio, furnished with rugs, tapestries, easels, antique furniture, majolica and blue-and-white china. The luxurious house of the classical genre painter Sir Lawrence Alma Tadema (1836–1912) had two studios, one for himself with Pompeian decorations and the other a Dutch panelled interior for his wife, also an artist, each room reflecting the character of their paintings. The fortunes artists made to enable them to build these houses were considerable; equally so were the pressures to produce quantities of saleable pictures in order to maintain their lavish style of living.

Public interest in art was never higher, and was spread by the growth of the press and of publications devoted to art. The Academy's first Press Day was held in 1871; prior to that no special facilities had been given to journalists, but by 1894 300 critics and writers attended. Illustrated catalogues began to appear as advances in printing techniques made possible inexpensive photographic reproductions.

Art became more widely available also through the opening of municipal galleries in cities like Liverpool (1877), Manchester (1882) and Leeds (1888). Rich men such as the Wigan cotton manufacturer Thomas Taylor, or George McCulloch, who made a fortune from Australian gold mines, still collected for reasons of prestige, but the late Victorian period saw the formation of private collections intended as the nucleus of public or educational galleries. The pictures at the Royal Holloway College, Egham, for example, were assembled by the patent medicine manufacturer Thomas Holloway for the women's college he established in 1876, and the paintings given in 1894 by the sugar refiner and collector Sir Henry Tate led to the foundation of the Tate Gallery in 1897.

Popular interest in art, and the innate conservatism of the many Academicians who were content to repeat their early successes, exhibiting perfunctory variations of worn-out themes well into their old age, encouraged the simple view of art that ingenuity of subject was more important than artistic values. Despite Leighton's efforts to raise the standard of the Summer Exhibitions after he became President of the Royal Academy in 1878, much that was mediocre, banal or mechanical was still shown there. Many able technicians courted an easy popularity, aiming not to enlarge public taste but to provide mass entertainment, like today's producers of soap opera or best-selling novels. The animal painter Briton Rivière (1840–1920)

painted many ambitious allegorical and classical subjects featuring animals, but it was his pictures of quacking ducks and faithful dogs
125 such as *Sympathy* (RA 1878) that made him famous. Humour was also a popular ingredient in a painting's success. Walter Dendy Sadler
126 (1854–1923) was responsible for *Thursday* (RA 1880) with jolly monks catching fish and its sequel *Friday* (RA 1882) showing them eating it. Paintings like these were widely admired and artists were praised for their ability to transcend differences of class and education in their audience; many of the new public art galleries bought popular sentimental paintings not out of ignorance, nor to talk down to their public, but in a spirit of idealism, seeking to attract as wide an audience as possible and, having aroused their interest, to encourage them on to better things.

The later work of Millais represents the more popular side of Academy taste, a far cry from his work of the 1850s. He worked in several different modes, each widely influential on other painters. His treatment of pretty little children is exemplified in the trite but much
127 admired image of innocent piety *My First Sermon* (RA 1863). So successful was this work that the artist painted a pendant *My Second Sermon* (RA 1864), showing the same girl asleep. In the 60s and 70s Millais depicted religious stories and many historical narratives embodying patriotism, romance and pathos, such as *The Boyhood of Raleigh* (RA 1870), *A Yeoman of the Guard* (RA 1877) and *The Princes in the Tower* (RA 1878). Millais' late manner, of rich impasto and rapid, flickering brushwork, emerged in the later 60s. It is seen at its most impressive in the likenesses of great statesmen and society figures in which Millais attempted to rival Titian, Van Dyck and other masters of patrician portraiture. Homage was paid to favourite sources in *Souvenir of Velázquez* (RA 1868) and *Hearts are Trumps* (RA 1872), a tribute to Reynolds. The brilliantly free paintwork and strong
128 characterization of *Mrs Bischoffsheim* (RA 1873) astounded the French
129 at the Paris Exhibition of 1878. *Chill October* (RA 1871) was the first of an impressive series of evocative Scottish landscapes painted near his wife's family home in Perthshire. They employ drab colours and impose on the scene a mood of bleakness and melancholy which had an immense appeal both to the public and to other landscape painters; desolate landscapes, often featuring Highland cattle, mist and snow, became fashionable in the last three decades of the century.

It was his fancy portraits of children that made Millais most widely

127–129 Sir John Everett Millais,
My First Sermon, 1863,
Mrs Bischoffsheim, 1873,
Chill October, 1870

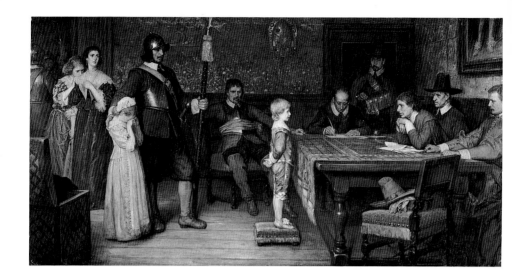

known. Many were given wide circulation through mass reproduction: *Cherry Ripe* (1879) was issued both as a steel engraving and as a colour print with the *Graphic* and sold 600,000 copies. By far his best-known picture was *Bubbles* (1886), based on a Dutch *vanitas* motif emblematic of the transience of earthly life. Reproduced first in the *Illustrated London News*, the picture, much to Millais' annoyance, was purchased by Pears, the soap manufacturer, and with the addition of a bar of soap, was used as an advertisement. It nevertheless ensured the artist's fame and he became one of the wealthiest of all Victorian painters with a grand house in Queen's Gate and an income of about £30,000 a year, making him a multi-millionaire by today's standards.

The paintings of the St John's Wood Clique typify middlebrow late Victorian taste. The group consisted of Philip Hermogenes Calderon (1833–98), John Evans Hodgson (1831–95), George Dunlop Leslie (1835–1921), son of C.R. Leslie, Henry Stacy Marks (1829–98), George Adolphus Storey (1834–1919), David Wilkie Wynfield (1837–87), Wilkie's great nephew, and William Frederick Yeames (1835–1918). The members of the Clique loved to dress up, aping the world they created in their paintings, mostly imaginary scenes of historical genre. Wynfield was also a photographer, taking portraits of his sitters in historical costume. One summer they rented Hever Castle, Kent, using it as the background for their pictures. Some of their subjects reflected a weakness for laboured jokes; Anne Boleyn's

130 William Frederick Yeames, *'And When did you last see your father?'*, 1878

131 Henry Stacy Marks, *A Select Committee*, 1891

bedroom at Hever was depicted by Yeames in *Visit to The Haunted Chamber* (RA 1870), showing fearful ladies peeping nervously round a four-poster bed, alarmed by scuttling mice. Marks' first success was entitled *Toothache in the Middle Ages* (RA 1856) and his *What is it?* (RA 1873) shows a line of figures in medieval dress seen from behind peering over a wall at some unseen object. This is a so-called problem picture, posing an open-ended question and inviting spectators to imagine the outcome. Most famous of these is *'And When did you last see your father?'* (RA 1878) by Yeames, an invented incident set in the 130 Civil War and including a common Victorian archetype, the fair-haired, blue-eyed innocent boy.

The group painted real as well as imaginary characters from history but their work was not purely historical. Hodgson was known for idealized English landscapes; Storey produced Dutch scenes in the manner of de Hooch and fancy portraits of ladies in large hats, known as 'Dorothy' pictures after *Mistress Dorothy* (RA 1873); and Leslie painted aesthetic groups of ladies with flowers in gardens or interiors. Marks came to specialize in parrots and other ornithological subjects, often with facetious anthropomorphic titles such as *Convocation* (RA 1878) and *A Select Committee* (RA 1891). 131

Figure subjects of greater sophistication were painted by three Scotsmen who came south in the 1860s; all had been trained by Robert Scott Lauder at the Trustees' Academy in Edinburgh. William

165

Quiller Orchardson (1832–1910) settled in London in 1862 with his friend John Pettie (1839–93) and the next year they were joined by Tom Graham (1840–1906). They startled the Academy with their use of thin, transparent brushwork loosely applied in muted colour schemes. The Scottish painters' early study of figure grouping and their ability to convey character, expression and movement without painstaking detail gave naturalness and credibility to their stories.

Graham never achieved the reputation of the other two, mainly because he painted few elaborate historical compositions. His work, distinguished by its subtle colour sense, includes impressionistically treated exteriors with figures, and engaging studies of girls in exotic costume. Pettie excelled at evoking the romantic and conspiratorial atmosphere of the Civil War and the Jacobite Rebellion, with duellers and swashbuckling soldiers in invented incidents like his early success *A Drumhead Court Martial* (RA 1865), real historical events including *The Duke of Monmouth's Interview with James II* (RA 1882), and 132 subjects from Sir Walter Scott, such as the *Scene from 'Peveril of the*

132 John Pettie, *Scene from 'Peveril of the Peak'*, 1887

133 William Quiller Orchardson, *Mariage de Convenance*, 1884

Peak' (RA 1887); its arresting use of empty space is characteristic of the Scottish painters. Pettie's style, often confused with that of Orchardson, tends to be richer in colour and his drawing has a nervous elegance which gives movement and dash to the figures.

At first Orchardson's subjects, like those of Pettie, were taken from historical and literary sources of the 17th century or earlier. Their faded ochre and brown colour schemes were likened by the French critic Ernest Chesneau to the wrong side of an old tapestry. In the late 70s Orchardson began to paint social comedies set in the Regency, a period also occasionally taken up by Pettie. Orchardson portrayed with wit and insight the rituals of drawing-room society, the unease of a wallflower, or a couple imprisoned in polite conversation, set in apartments decorated with Aubusson rugs and French rococo or Empire furniture, of which Orchardson was an early collector. He also painted real historical characters of the late 18th and early 19th centuries such as Voltaire, Mme Récamier and Napoleon.

134 James Tissot, *The Ball on Shipboard*, 1874

Orchardson's most original achievement was a small number of
133 modern-dress subjects. *Mariage de Convenance* (RA 1884) depicts a
disillusioned old husband and his bored young wife in a cavernous,
richly appointed dining room, and its sequel, *Mariage de Convenance –
After!* (RA 1886), shows the same shadowy interior and the same man
seated by the fireside alone, the dining table laid for one. Not all these
modern subjects depict domestic strife; in *Her Mother's Voice* (RA
1888) the memories of a widower are aroused by his daughter's
singing at the piano and the unfinished *Solitude* (begun 1897) shows a
woman alone in a barouche. With their opulent settings, these
paintings seem to represent the insecurities that lay behind the
materialistic facade of late Victorian society.

Nine years after Orchardson moved to London, the French painter
James Tissot (1836–1902) escaped from the Paris of the Commune and
settled in London. His early work consists of 15th-century Flemish
subjects and then in the late 60s paintings of flirting couples set in the
Directoire period, pre-dating Orchardson's use of Regency costume.

168

Tissot's first English works were caricatures for the periodical *Vanity Fair*, which won him portrait commissions. He then painted a series of fashionable English social occasions, beginning with *Too Early* (RA 1873), *The Ball on Shipboard* (RA 1874) and *Hush!* (RA 1875). These 134 won him success and prosperity, though their lack of clear narrative or moral was criticized; Ruskin called them 'unhappily mere colour photographs of vulgar society'. Unlike Orchardson, Tissot delighted in meticulous finish, in the detailed rendering of extravagant gowns. He loved all that was modish, adopting in turn French realism, japonisme, Whistlerian langour and the snapshot immediacy of Degas' compositions. In the mid-70s Tissot fell in love with a divorcée, Kathleen Newton, with whom he lived from 1876, isolated from society. Her likeness dominates his later paintings and etchings, which depict beautifully dressed women picnicking, lounging in gardens, strolling in elegant London streets or waiting by the Thames against a backdrop of masts and rigging (he had developed a love of ships as a boy in the French port of Nantes). After Mrs Newton's death in 1882 he returned to Paris where he painted a series of chic Parisian women and, following his religious conversion, spent the rest of his life on an ambitious but disappointing series of Bible illustrations.

Tissot's society paintings are not quite what they seem. Beneath their stylish surfaces there lies a hint of ennui and mockery of the emptiness of society; the pictures of Mrs Newton have a bittersweet sense of the transience of beauty and happiness. The ambiguity of these images was not noted at the time, but this, together with their technical superiority, gives Tissot's paintings an edge lacking in the superficially similar but essentially empty work of his English followers Marcus Stone and Atkinson Grimshaw, painters of prettily dressed women musing in gardens and cluttered interiors. Stone began his career with book illustrations and conventional historical set-pieces, but in 1876 he switched to Regency costume, exhibiting the first of numerous sentimental confections of lovers daydreaming or sulking in sunlit gardens, the men in cocked hats, the women wearing Empire dresses, picture hats and vapid facial expressions. Aware of the shallowness of his work, Stone would say, 'One sells one's birthright'; nevertheless, he made an enormous fortune from these creations with titles like *In Love* (RA 1888), *A Passing Cloud* (RA 1891) and *Two's Company, Three's None* (RA 1892). Mechanical in 135

execution, they were peculiarly well suited to reproduction in photogravure and many other artists, such as Dendy Sadler and Edmund Blair Leighton (1853–1922), found a ready market for Regency subjects.

These pictures attracted a public nostalgic for a mythical pre-industrial golden age of lost elegance and leisure. The classical period was made to exert a similar appeal by Sir Lawrence Alma Tadema, who specialized in reconstructions of everyday incidents in the lives of wealthy Romans or Pompeians, similar to the work of the French painter J.L. Gérôme (1824–1904) and his followers, known as the 'Neo-Grecs'. Tadema was born in Holland and at first produced historical scenes from Merovingian history. He also painted Egyptian and, under the influence of his teacher Hendrik Leys (1815–69), Flemish subjects, but became obsessed with classical antiquity after visiting Rome, Naples and Pompeii on his honeymoon in 1863. Shortly afterwards he met the Belgian dealer Gambart who shaped his career and in 1870, after Tadema's first wife died, he moved to London.

Alma Tadema was a brilliant technician. His exquisite touch recalls the meticulous handling of his Dutch forebears, the interior and still-life painters of the 17th century, and he too loved to paint flowers and

135 Marcus Stone, *Two's Company, Three's None*, 1892

136 Sir Lawrence Alma Tadema, *Unconscious Rivals*, 1893

precious objects. He had an effortless facility in representing the sheen of marble, both in his early rich and shadowy Pompeian interiors and in the later paintings of sunlit outdoor scenes in pale, iridescent colours. Tadema's work was marked by an interest in architecture and unusual spatial effects, steeply foreshortened vistas and views from one room to another. His fastidious care over details, and his feeling for nuances of colour and composition marked him out as an aesthete, but his paintings were different from those of the Aesthetic Movement, for his art was descriptive to the point of illusionism, and it was anecdotal; he was a genre painter, depicting trivial everyday situations, visits to the baths or the temple, or figures idling in marble villas or on terraces overlooking the sea. He also painted the 136 occasional female nude with thinly disguised erotic overtones and a number of subjects concerned with the production and collecting of art, including the Greek sculptor at work in *Phidias and the Frieze of the Parthenon* (1868) and several pictures of connoisseurs and dealers

171

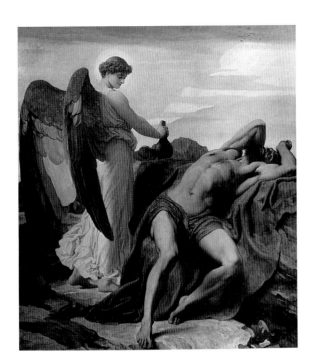

137 Sir Lawrence Alma Tadema,
*A Picture Gallery in Rome in
the time of Augustus*, 1874

138 Frederic, Lord Leighton,
Elijah in the Wilderness,
1878

in galleries, transposing the Victorian art world into ancient times:
A Picture Gallery in Rome (RA 1874) includes a likeness of Gambart 137
wearing a toga, a tribute to the importance of the dealer in Tadema's
life.

Tadema developed a wide knowledge of classical archaeology,
collecting a huge archive of photographs and measured drawings of
buildings and antiquities which he used as source material for his
work. But his paintings, though convincing-looking, were not
accurate recreations of the ancient world. They combined details
from different periods and places for aesthetic effect, and depended on
an implicit parallel between ancient and Victorian civilization which
was only a partial truth. In his glimpses into the classical world, always
pleasant, leisured and luxurious, prosperous Victorians could imagine
they saw their own lives flatteringly mirrored.

Like the classical language of architecture, classicism in painting
could be used in different ways, decorative or anecdotal, intimate or
elevated, archaeological or symbolic. Many artists used different
inflections at different times. The principal exponent of the classical

173

revival was Leighton, whose interest in the harmonious expression of beauty is seen at its purest in his decorative pictures of the 60s, and in some of his later classical subjects such as *Winding the Skein* (RA 1878). But during the 60s and 70s he painted intensely dramatic narrative paintings of confrontation and struggle from biblical and historical as well as classical sources; most powerful of these was *Elijah in*
138 *the Wilderness* (1878). Leighton also entered the field of sculpture with the muscular figure of the *Athlete struggling with a Python* (RA 1877), and the elegantly stretching *The Sluggard* (1882–85), leading the way towards the late Victorian movement known as 'The New Sculpture'.

The ideals of high art, expressed through classical myth and poetry, came to dominate Leighton's late work. He continued to paint single figures and groups in which the subject was a pretext for a decorative harmony of elegantly arranged figures, mellifluous draperies and sumptuous colour. But the themes he chose began to have increasing importance. Returning to the processional frieze, he painted two enormous pictures, *The Daphnephoria* (RA 1876), a glorious hymn to art and beauty represented by the sun god Apollo, and *Captive*
139 *Andromache* (RA 1888), a meditation on the loneliness of exile. These themes lay behind most of his later work. Tragic stories like *The Last*

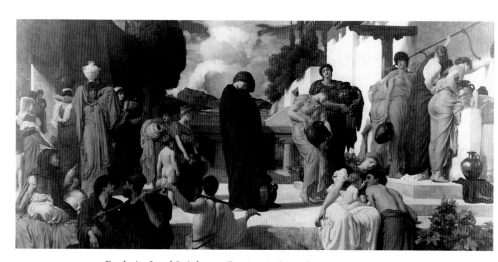

139 Frederic, Lord Leighton, *Captive Andromache*, 1888

174

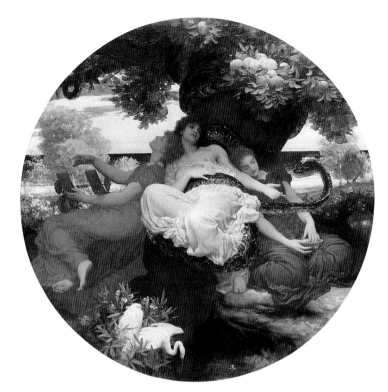

140 Frederic, Lord Leighton, *The Garden of the Hesperides*, 1892

Watch of Hero (RA 1888), and a series of emblematic single figures such as *Solitude* (RA 1890) express loss, isolation and mourning, as if the artist himself were becoming aware of old age. In contrast are the paintings where warmth and sunlight are associated with fertility and luxury, such as *The Return of Persephone* (RA 1891), an allegory of the coming of spring, and *Clytie* (RA 1892), passionately worshipping the sun. The culmination of Leighton's art came with the richly coloured *The Garden of the Hesperides* (RA 1892) and *Flaming June* (RA 1895), 140 where the heat of the sun and the beauty of the women creates a heady mood of erotic languor.

Leighton was the leading figure of the late Victorian art world and won renewed respect for the Academy. As its President, he acted as a public ambassador for the arts, mixing with patrician ease both in high society and in academic circles, and working to bring increased distinction and status to his profession. He tried to improve the Academy Schools and to open up the Exhibitions to new influences,

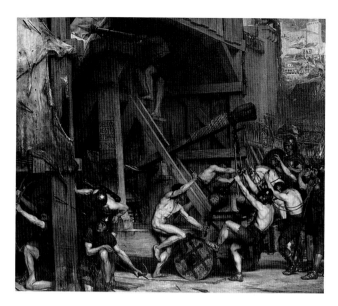

141 Sir Edward Poynter,
The Catapult, 1868

persuading a reluctant Burne-Jones to become an Associate and
privately encouraging new talent, even artists such as Aubrey
Beardsley whose work challenged all the values Leighton stood for.
His idealized and high-minded art was the perfect expression of a
cultivated and disciplined personality.

The career of Edward Poynter (1836–1919), one of Whistler's
fellow students in Paris, is also characterized by a mixture of
classicism, aestheticism and public service. He painted small classical
genre subjects and larger figure groups, draped or nude, but his
reputation came from historical narratives such as his first success
Faithful unto Death (RA 1865), a centurion grimly standing at his post
during the eruption of Vesuvius. This was followed by elaborate
compositions such as *Israel in Egypt* (RA 1867) showing labouring
141 Hebrew slaves, *The Catapult* (RA 1868), Roman soldiers with a siege
engine, and *The Queen of Sheba's Visit to King Solomon* (RA 1891).
With many figures and archaeologically detailed settings, these
appear over-studied when set against the fluency of Leighton's
classical groups or the delicate handling of Tadema. Poynter also
carried out tile designs and mural paintings. A superb draughtsman,
when in 1871 he became the first Slade Professor at University
College, London he introduced rigorous French methods of teaching

176

drawing which were continued by his successor Alphonse Legros (1837–1911) and laid the foundations for the school's reputation in draughtsmanship. Poynter became Director of the National Gallery (1894–1904) and President of the Royal Academy (1896–1918), leaving him little time for painting.

Edwin Long also produced elaborate scenes from Egyptian and classical history including the celebrated *Babylonian Marriage Market* (RA 1875), based on a scene described by Herodotus, and C.E. Perugini (1839–1919) painted statuesque women with flowers and other decorative accessories, but Leighton's most important follower was William Blake Richmond (1842–1921). An accomplished portraitist of public figures and beautiful society women, he also exhibited classical subjects including processional scenes and decorative mythologies. From 1891 he designed and supervised the execution of the mosaics in the dome of St Paul's Cathedral.

The popularity of paintings of myth and legend extended from the late Victorian period into the first decade of the 20th century. Despite the bland identical faces of the nubile female figures in the paintings of John William Waterhouse (1849–1917), he had a knack of inventing memorable images, painting classical stories such as *Hylas and the* 142 *Nymphs* (RA 1897) and reviving Pre-Raphaelite subjects like *The Lady of Shalott* (two versions, RA 1888 and 1894) and *Ophelia* (RA 1910).

142 John William Waterhouse, *Hylas and the Nymphs*, 1897

143 Edward J. Gregory, *Boulter's Lock – Sunday Afternoon*, 1897

144 Edith Hayllar, *A Summer Shower*, 1883

Frank Dicksee (1853–1928) also produced fanciful scenes featuring Pre-Raphaelite types, though his output was more varied and included portraits, historical and chivalric subjects and modern-dress dramas in the manner of Orchardson. The *femmes fatales* in these paintings, superficially like those of Burne-Jones and Rossetti, were now free of disturbingly cruel sexual overtones and therefore were acceptable at the Academy, as were the voluptuous nudes in the grandiose mythological scenes by Solomon J. Solomon (1860–1927) and Herbert Draper (1864–1920).

 In complete contrast were the unpretentious depictions of daily life
144 by many minor painters. Edith Hayllar (1860–1948) and her sister Jessica (1858–1940) were the most talented of a family of artists who painted with charm and delicacy life at their small country house in Berkshire, its interiors and its social gatherings, christenings, weddings

178

and tennis parties, a more modest social milieu than that of Tissot or Orchardson. Tissot's Thames scenes probably inspired the former illustrator Edward J. Gregory (1850–1909) to paint *Boulter's Lock –* 143 *Sunday Afternoon* (RA 1897), as crowded with incident as a Frith; a critic described it as 'a three-volume novel in art'.

Whilst detail was still an important factor in a work's public appeal, the late Victorians also liked to be moved. 'The fact that counts is the power of touching the people's heart', wrote the military painter Elizabeth Thompson, later Lady Butler (1846–1933). She and her contemporaries the social realists exemplify the importance of strong feeling, or 'sentiment' to use the contemporary term, in late Victorian painting. Lady Butler rose to fame with three paintings of the Crimean War painted some twenty years after the events depicted, but reconstructed from the accounts of survivors. *The Roll Call* (RA 145 1874), purchased by Queen Victoria, *Balaclava* (1876) and *The Return from Inkerman* (1877) were not elevated or heroic treatments of war, and avoided depicting violence; instead they showed the horrific experience of the ordinary British soldier in the aftermath of battle. Lady Butler's new approach reflected the contemporary climate of military reform and sympathy for the common soldier and evoked a strong response in the public.

145 Elizabeth Thompson, later Lady Butler, *The Roll Call*, 1874

The rise of late Victorian social realism was associated with the *Graphic*, a weekly news magazine set up in 1869 to challenge the domination of the *Illustrated London News*. In the days before cheap photographic reproduction, topical events were illustrated with wood engravings, mostly provided by jobbing engravers for whom speed was more important than quality. The founder of the *Graphic*, William Luson Thomas (1830–1900) commissioned work from the new generation of artists, encouraging them to look for material from ordinary life. The *Graphic* was a general-interest magazine, covering events of all kinds, from wars and political meetings to garden parties and concerts, but the most memorable illustrations of its early years were full-page engravings of scenes of working-class life including street markets, gin palaces, factories, field workers, soup kitchens and workhouses. Amongst the artists employed were Luke Fildes, Hubert von Herkomer (1849–1914), Frank Holl (1845–88), Arthur Boyd Houghton, George J. Pinwell (1842–75) and Charles Green (1840–98). The *Graphic* illustrations look soberly realistic but inevitably, because of the artists' training, their realism was coloured by a leaning

146 Sir (Samuel) Luke Fildes, *Applicants for Admission to a Casual Ward*, 1874

147 Sir Hubert von Herkomer, *Hard Times 1885*, 1885
148 Frank Holl, *Her Firstborn*, 1876

149 Sir (Samuel) Luke Fildes,
An Al Fresco Toilette,
1889

towards drama and pathos and a desire to elicit sympathy from the largely middle-class readership; the more threatening aspects of poverty, such as violence and disease, were avoided.

Three of the *Graphic* artists, Fildes, Herkomer and Holl, later worked up their black-and-white illustrations into oil paintings which were shown in the very different context of the Royal Academy Summer Exhibitions. The paintings were at first criticized as ugly and inartistic, but the shock value of their subjects commanded attention and their prior appearance in the magazine had prepared the way for public acceptance.

The first issue of the *Graphic* included *Houseless and Hungry* by Fildes, an engraving of homeless people queueing outside an overnight refuge. In 1874 he exhibited an oil version at the Academy, 146 retitling it *Applicants for Admission to a Casual Ward*. The tiny 16-inch-long illustration became an 8-foot oil, its emotionalism intensified by dingy colour and by alterations which gave the figures more space, weight and grandeur. In this way Fildes transformed his image from

genre to epic, creating a modern-dress equivalent of high art. The picture created a sensation at the Academy and opened up a debate about whether such subjects were suitable for the fine arts in the face of the view of many critics that 'there is little in a theme of such grovelling misery to recommend it to a painter whose purpose is beauty'. None of Fildes' later attempts at social realism made such an impact, and though his famous *The Doctor* (RA 1891) became one of the best loved of all Victorian paintings, it was as much about the devotion of the professional man as about social injustice.

Even before being taken on by the *Graphic*, Frank Holl had attracted attention with *The Lord giveth and the Lord hath taken away* (RA 1869), showing a family in mourning for its father. It was admired by the widowed Queen Victoria who commissioned Holl's next picture showing a fisherman's wife weeping for the fate of her husband. Death and mourning amongst the poor were Holl's main themes. Like the Dutch painter Jozef Israels (1824–1911), whom he much admired, he liked sombre subjects, and painted country funerals 148 and mothers grieving over dying children in bare cottage interiors, using softly handled, drab colours. His work for the *Graphic* led him to paint scenes of urban poverty including a third-class railway waiting room, a pawnbroker's shop, an abandoned illegitimate baby picked up by police and his most famous work, the monumentally scaled *Newgate: Committed for Trial* (RA 1878), showing women visiting their criminal husbands in prison.

Herkomer was the most original of the three principal *Graphic* artists. For many of his early illustrations he depicted minority communities, such as gypsies, Jews and Italian immigrants, reflecting his childhood as a poor German émigré first in the USA and then in Britain, an experience also recalled in *Pressing to the West* (RA 1884) showing immigrants arriving in New York. His first two major paintings were, like Fildes' *Casual Ward*, enlarged and heightened versions of *Graphic* engravings. Both represented charitable institutions for the old and poor: the Chelsea Hospital for war veterans in *The Last Muster* (RA 1875) and a workhouse for female paupers in *Eventide – a scene in the Westminster Union* (RA 1878). His later social-realist subjects were independent of his *Graphic* work; *Hard Times 1885* 147 (RA 1885), painted after a harsh winter, is an arresting image of an unemployed labourer and his family modelled on a *Rest on the Flight into Egypt*; and the over-life-sized *On Strike* (RA 1891) shows the

striker not as a glorious hero but torn between duty to support his wife and solidarity with his comrades. All these images gain in power from Herkomer's painterly technique and his expressive distortion of perspective.

Whilst the successes of Holl, Fildes and Herkomer made social realism more acceptable, such subjects were always in a minority at the exhibitions and indeed were only a small part of the three painters' output. Herkomer also painted English and Bavarian rural narratives, experimented with enamels, opened an art school at Bushey, and became a pioneer of film-making. Fildes alternated his few social realist subjects with pictures of flirting lovers, idealized village scenes and later, sunlit Venetian views with flower girls and boatmen. All three innovators in the field of social realism, Holl, Herkomer and Fildes, took to portraiture in the latter part of their careers, and the fame of their social-realist work was eclipsed.

149

All the major social-realist pictures had found buyers readily, some in rich collectors and others in the newly founded public galleries. But narrative painting, whether social-realist or otherwise, represented for artists an enormous investment in ingenuity, time and research. Portrait painting was quicker, less demanding and more profitable and in the last decades of the Victorian age demand seemed limitless. Almost all figure painters executed portraits and some practically gave up other subjects altogether. But the demands of portraiture deadened the artistic impulse; late Victorian portraits by specialist portraitists tend towards dullness, as is evident from the dreary rows of dignitaries in many town halls and clubs. From 1879 Holl switched entirely to portraits, working in a simple style with forceful modelling and strong chiaroscuro; he was overwhelmed by the relentless pressure of portrait commissions, producing about twenty a year until his death in 1888 from overwork. Fildes also painted portraits and Herkomer made them his principal source of income, earning from them about a quarter of a million pounds. Towards the end of his life he painted six ambitious group portraits of town councillors, Royal Academicians and businessmen, including the directors of the arms manufacturers Krupp (1912). It is ironic that the artist who made his name with images of the underprivileged should end his career portraying the wealthy, but he maintained they were complementary aspects of his ambition to record all levels of society 'for future generations to dream over and wonder'.

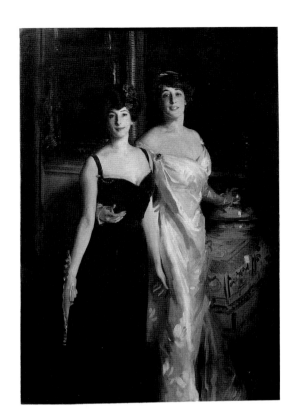

150 John Singer Sargent,
*Ena and Betty, Daughters of
Asher and Mrs Wertheimer*,
1901

In the 90s British portraiture was suddenly made to look static and old-fashioned by the new style of John Singer Sargent, an expatriate American trained in Paris. There he had studied with Carolus-Duran, who insisted that his students paint direct with a fully loaded brush and no reworking. This rigorous discipline gave Sargent the ability to record appearances in a few swift and fluid strokes. His early London exhibits such as *The Misses Vickers* (RA 1886) were condemned by the critics as 'clever', but by the early 90s the new style was accepted. Despite his unnerving ability to seize a likeness with vivid and unflattering frankness, he was much in demand from plutocrats, bankers and art dealers such as his great patron Asher Wertheimer 150 (1844–1918), as well as the aristocracy who were his main clients after 1900. Sargent dazzlingly captured the vitality of his sitters and the opulence of their surroundings; he restored to portraiture the glamour it had lacked since the death of Lawrence.

151 George Heming Mason, *The Gander*, 1865

152 Frederick Walker, *The Harbour of Refuge*, 1872

Late Victorian Landscape

In 1859 the landscape painter George Heming Mason (1818–72) returned to England after living in Italy since 1843, and began to paint landscapes of his native Staffordshire. They were distinguished by a mood of poetic reverie and featured graceful girls and boys in country smocks and bonnets, harvesting or tending animals; some of his later works depict more explicitly Arcadian figures such as dancing maidens and a piping shepherd. Mason's gentle classicism reflects his contact with the Italian painter Giovanni Costa (1827–1903), who had taught him to make open-air oil sketches of peasants in the Roman Campagna. The young Leighton had accompanied Mason and Costa on painting expeditions and learned the art of making rapid oil studies which he practised on his later travels in Italy, North Africa, Greece and Asia Minor. Practically unknown during his lifetime, Leighton's small landscapes are brilliant and spontaneous reactions to light and atmosphere, which also served as raw material for the backgrounds of his exhibition pictures. 151

Classical allusions are also present in the landscapes of Frederick Walker (1840–75). A keen student of the Elgin Marbles, his figures possess a statuesque quality, and he was fond of giving his paintings a mythic, allegorical dimension, despite their very English settings by making contrasts of youth and age or life and death, as in *The Old Gate* (RA 1869) and his most famous work *The Harbour of Refuge* 152 (RA 1872). Here a group of old people in an almshouse quietly await their end; the presence of death is indicated by a figure with a scythe.

Walker was a superb and widely imitated watercolourist. His technique, a reaction to the dry minutiae of the Pre-Raphaelites, was to produce a suggestively veiled effect by painting in fine detail which he then partially erased. Walker, his friend John William North 153 (1842–1924) and George John Pinwell were later dubbed the Idyllists because of the dreamlike beauty they brought to their watercolours of

153 John William North, *Halsway Court*, 1865
154 Helen Allingham, *The Orchard*, 1887

gardens, mellow old buildings and forest glades, using a delicate
stipple to suggest magically shimmering atmosphere.

Most famous and prolific of the many other artists of idyllic rural
scenes, influenced by Birket Foster as well as Walker, was Helen
Allingham (1848–1926), a niece of Laura Herford who was the first
woman student at the Royal Academy Schools. Allingham specia-
154 lized in watercolours of picturesque old-fashioned cottages with
common garden flowers and little girls in sunbonnets. Even at the

155 Cecil Gordon Lawson, *The Minister's Garden*, 1878

156 Matthew Ridley Corbet, *Val d'Arno: Evening*, 1901

time, her work had a nostalgic charm; though she lived for a period in Surrey, she was essentially a town dweller, idealizing the traditional country buildings which were rapidly disappearing with the increasing suburbanization of the Home Counties.

The true heir to the Idyllists was Cecil Lawson (1851–82), painter of *The Minister's Garden* (GG 1878), a luxuriant view of an English 155 country garden in high summer, so large as to envelop the spectator in the scene. Lawson had studied the landscapes of Constable and Rubens and his admiration of the latter's *Château de Steen* in the National Gallery is evident in his combination of an extensive panorama with a detailed foreground of plants and flowers, the whole teeming with life. Lawson was fond of sunsets, mists, moonlights and unusual compositions, such as the steeply raked *The Hop Gardens of England* (RA 1876). His landscapes combine realism and poetry without recourse to idealized or symbolic figures.

Elegiac Italian landscapes by Giovanni Costa and his English followers were frequently shown at the Grosvenor and the Academy. These artists, known as the Etruscan school after Costa's nickname 'the Etruscan', included William Blake Richmond, the amateur painter George Howard, 9th Earl of Carlisle (1843–1911), and Matthew Ridley Corbet (1850–1902), an assistant to Watts who lived 156 for a time in Italy. Characteristic of the Etruscan school was a horizontal format with panoramic lines, and a preference for the poetic glow of sunset or dawn.

157 Benjamin Williams Leader, *February Fill Dyke*, 1881

Most of the established late Victorian landscapists at the Academy had been educated in the 50s and 60s when Pre-Raphaelite detail and Ruskinian earnestness were in the ascendant, but few had fully understood or absorbed them, and fashion had now moved on; by the 70s breadth, looseness of touch and heightened sentiment were the rule. Benjamin Williams Leader (1831–1923) was one of the most successful painters of large studio landscapes. His Welsh views of the 60s, like the early pastorals of his friend George Vicat Cole (1833–93), had a superficially Pre-Raphaelite brightness but his later landscapes were broader and more subdued. Leader achieved great popularity 157 with *February Fill Dyke* (RA 1881), a view of leafless trees against a sunset sky reflected in rain-filled pools. He employed the same ingredients in many later variations based on scenes of his native Worcestershire. On the few occasions when he abandoned stock picturesque compositions and chocolate-box effects he attained greater individuality, as in his paintings of the building of the Manchester Ship Canal.

The few artists who continued to work in the Pre-Raphaelite tradition, such as John Brett or Atkinson Grimshaw, settled for a somewhat mechanical version of the style. In the 70s and 80s

Grimshaw painted many repetitive moonlit quayside scenes and 158
nocturnal tree-lined suburban streets. Brett's late work consists of
coastal scenes and marine views handled with an impressive if dry
clarity. The attention given to cloud and rock formations shows
Ruskin's continuing influence, but the razor-sharp intensity of Brett's
earlier work had gone. Like Brett, Henry Moore (1831–95) painted
meticulous Pre-Raphaelite landscapes in his youth, but his mature
work consists of large, empty compositions in two horizontal bands 159
of sky and sea, devoid of figures or ships and without anecdotal or
symbolic content. Probably for this reason, he was not elected a Royal
Academician until towards the end of his career, though he exhibited
there regularly. More conventional marine painters such as William
Lionel Wyllie (1851–1931) painted detailed views of rivers and docks,
crowded with merchant and naval vessels, but Moore, like his brother
Albert, restricted his subject matter so that he could concentrate on
nuances of colour and texture.

The taste for bleak Scottish landscapes, created by Millais in the
1870s, was seen in the work of Peter Graham (1836–1921), painter of
Highland cattle and of desolate cliffs with seabirds circling above the

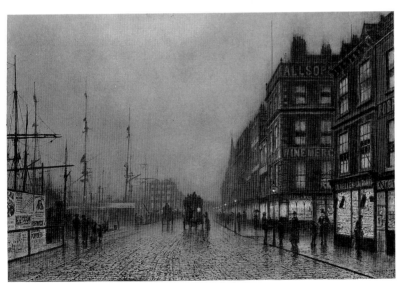

158 Atkinson Grimshaw, *Liverpool Quay by Moonlight*, 1887

spray, and in the forest scenes of John MacWhirter (1839–1911), both pupils of Lauder in Edinburgh who moved south to make their fortunes. Their work was popular but grew increasingly weak in execution. In contrast, the wintry Scottish landscapes of Joseph Farquharson (1846–1935) were of consistently high technical quality if repetitive in subject. The son of a Scottish laird with an estate in Aberdeenshire, he painted many pictures of sheep in the snow, each with varied effects of light, atmosphere and coloured shadows.

Free, painterly brushwork and bold, fresh colour was characteristic of many Scottish painters of marine and coastal views, but the most original was William McTaggart (1835–1910), another of Lauder's pupils at the Trustee's Academy. He evolved a highly personal and expressive manner out of the mainstream of Victorian painting. Impressed by the Pre-Raphaelite work of Millais shown in Edinburgh, McTaggart, in his early pictures such as *Spring* (1864), used detail and bright colour, but with regard for atmospheric unity. This became more pronounced in his later works as he lightened his palette and dissolved figures and settings into a rich, open network of swirling paint. Despite a parallel with the broken brushwork of French Impressionism, McTaggart seems to have evolved his style independently, though he must have known the work of Whistler and the Hague School. His later pictures like *The Wave* (1881) or *The* 160 *Storm* (1890) are empty of figures; the turbulent vitality of his paint becomes a powerful equivalent to the forces of nature.

159 Henry Moore, *Mount's Bay: Early Morning—Summer*, 1886

160 William McTaggart, *The Storm*, 1890

In the late 70s and 80s a whole generation of British art students flocked to Europe to complete their artistic education. They enrolled at the ateliers of Paris or at the Antwerp Academy, a cheaper and morally less distracting alternative than the French capital, and spent their summers painting in the open air in Brittany, where the villages of Quimperlé, Pont-Aven and Concarneau were overrun by artists of many nationalities. This contact with the Continent profoundly changed the kind of landscape produced in Britain by younger painters in the closing decades of the century.

European study presented a fresh and exciting alternative to the teaching methods of the Royal Academy and other British art schools. Compared with French painting, the studio landscapes of the Academicians and the idealized peasants of the Idyllists appeared thin and artificial. Appetites had been whetted by the French pictures shown in London in the 70s by dealers such as Deschamps and Durand-Ruel, who exhibited Millet, Corot, artists of the Barbizon school and even Manet, Degas and Pissarro. Interest in French artists

193

161 Jules Bastien-Lepage, *Pauvre Fauvette*, 1881
162 Stanhope Forbes, *A Street in Brittany*, 1881

who depicted peasant hardship, such as Millet and Lhermitte, was fostered by Alphonse Legros, the French émigré who became Slade Professor in 1876; his own work consisted of austere paintings and etchings of tramps and wanderers in the landscape.

Millet's archetypal images of rural labour were widely known, but the French artist most influential on the British was Jules Bastien-Lepage (1848–84) who made his name at the Paris Salon of 1878 with *Les Foins*, showing two harvesters lying exhausted in a field, coarse rustic types painted out of doors in an even, bright grey overcast light. Bastien used big square brushes, a much-copied technique which emphasized surface flatness and tonal values at the expense of local 161 colour. His *Pauvre Fauvette* (1881), a single figure of a peasant girl standing matter-of-factly in front of a high horizon, was imitated by many British painters.

One of the earliest British pictures to show the influence of Bastien 162 was *A Street in Brittany* (RA 1882) by Stanhope Forbes (1857–1947), painted in Cancale in 1881 where Forbes and Henry La Thangue

194

163 Sir George Clausen, *The Stone Pickers*, 1887
164 William Teulon Blandford Fletcher, *The Farm Garden*, 1888
165 Frank Bramley, *A Hopeless Dawn*, 1885

(1859–1929), who had both studied in Paris, went to work in the open air. Forbes returned to Brittany the next two summers but by 1884 he had settled in a Cornish fishing village. 'Newlyn is a sort of English Concarneau', he wrote, 'and is the haunt of a great many painters.' The first artist to settle in Newlyn had been Walter Langley (1852–1922) in 1882; by the mid-80s a community of artists had developed including Frank Bramley (1857–1915), and Henry Tuke (1858–1929), who lived at nearby Falmouth. A large Newlyn scene by Forbes entitled *A Fish Sale on a Cornish Beach* (RA 1885) established the style and type of subject matter of the Newlyn School and there followed many paintings of quaysides, village streets, fishing boats at sea, cottage interiors and studies of local characters.

The flight of the artists from London to a remote village where they could observe the lives of ordinary people was a deliberate rejection of the artificial studio light and studio subjects of the Academy. But Newlyn artists still produced set-pieces for the summer exhibitions, such as *The Health of the Bride* (RA 1889) and *By Order of the Court* (RA 165 1890) both by Forbes, and *A Hopeless Dawn* (RA 1888) by Bramley, story pictures full of the tragic or nostalgic sentiment avoided by Bastien-Lepage. During the 80s and 90s Newlyn painters continued to depict village scenes, but the simple ideal of sharing life with the locals was soon left behind. Artists built glass studios on to their cottages, an art school was founded, subject matter became more sophisticated and by the turn of the century many of the original settlers had left.

Whilst Newlyn was developing as an artists' colony, other British followers of Bastien-Lepage were working independently but along parallel lines in different parts of the country. Walter Osborne (1859–164 1903) and William Teulon Blandford Fletcher (1858–1936) spent the mid-80s travelling in Oxfordshire, Berkshire and Worcestershire, sometimes with Edward Stott (1859–1918), staying in cheap lodgings and painting informal, freely handled studies of figures in cottage gardens, fields or farmyards. La Thangue and George Clausen (1852–1944) followed Bastien-Lepage's technique more literally. First in Britanny, then in England, in the 80s they painted an impressive series 163 of square-brush canvases of gleaners, potato pickers, stone gatherers, ploughmen and other country labourers. In his views of wintry fields with peasants bent over or muffled up in coarse clothing, Clausen expressed the hardship of country life, though he denied he was a

166 John Singer Sargent, *Carnation, Lily, Lily, Rose*, 1885–86

social realist. Both Newlyn painters and rural naturalists were amongst the early exhibitors at the New English Art Club, founded in 1886 in order to exhibit the work of the French-influenced *plein-air* school of painters, to whom the Academy was unsympathetic.

The style of the rural naturalists changed direction around 1890 as they became more concerned with light and atmosphere. Stott ceased to paint in the open air and settled in Amberley, Sussex, where he produced nostalgic pictures of village life in a softly shimmering technique. After 1892 Osborne remained in his native Dublin

painting portraits, landscapes and evocative views of Dublin street
169 markets. Clausen and La Thangue abandoned their opposition to the
Academy and exhibited there from 1891. La Thangue painted large
symbolic works such as *The Last Furrow* (RA 1895) and *The Man with
the Scythe* (RA 1896), but in other pictures he continued to depict
167 everyday agricultural tasks using a warm palette and a formalized
Impressionist technique of dappled brushstrokes. Clausen's paintings
of the 90s, influenced by a study of Millet and Monet, showed figures
168 at work in rhythmic movement, often with striking, pale colour
schemes. These pictures convey pride in traditional country ways, a
mood also seen in the contemporaneous photographs of rural life
taken by the photographer P.H. Emerson (1856–1936).

The influence of the French Impressionists supplanted that of
Bastien-Lepage on Clausen and La Thangue but neither artist ever
achieved the degree of fluency seen in the astonishingly free and rapid
open-air oil sketches made by John Singer Sargent in the mid-80s.
Sargent painted out of doors as a private relaxation from his portrait
practice, summering at Broadway in the Cotswolds, working with
Monet at Giverny in 1887 and spending the following summers in
Britain. At the Academy of 1887 he exhibited *Carnation, Lily, Lily,* 166
Rose showing young girls lighting Japanese lanterns in a garden, the

167 Henry Herbert
La Thangue, *The Ploughboy*,
1900

168 Sir George Clausen,
The Mowers, 1897

169 Walter Osborne,
Life in the Streets,
Musicians, 1893

170 James Abbot
McNeill Whistler,
Chelsea Shops,
early 1880s

title taken from a popular song. Fundamentally a decorative
composition, akin to the aesthetic arrangements and *japonisme* of
Whistler, its free handling and luminous effect of light incorporated
the casual appearance of his oil sketches; the picture was the first public
demonstration of Impressionism in Britain.

In 1888 the NEAC split between the more conservative rural
naturalists and a progressive clique which supported Whistler, led by
Walter Sickert (1860–1942). Whistler, with his antipathy to the

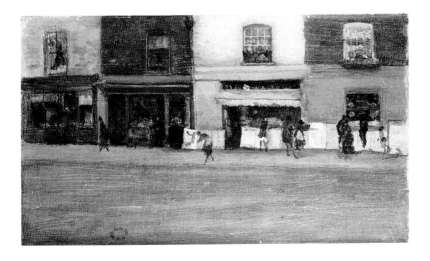

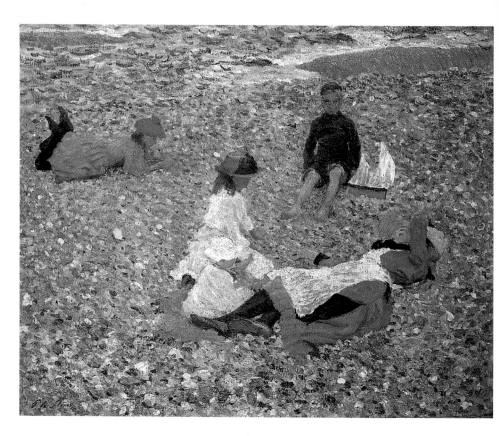

171 Philip Wilson Steer,
Knucklebones, 1888–89

172 Walter Richard Sickert,
*The Gallery of the Old Bedford
(The Boy I Love is up in
the Gallery)*, 1895

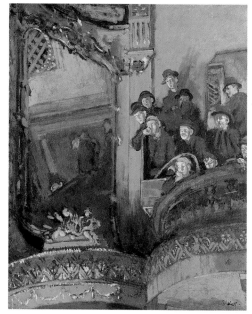

Academy and his familiarity with the French avant-garde, was a natural focus for the more advanced British artists of the 80s. After the libel trial he had renewed his contacts with Monet and Degas. A series of one-man exhibitions held in London in the 80s revealed a change in style and scale and won him new followers. Whistler's etchings and pastels of Venice and his small, thinly painted panels of seascapes, beach scenes and shop fronts recorded fleeting effects with deftness 170 and economy. In the *Ten O'clock Lecture* (1885) he set out his artistic credo with incisive wit, emphasizing the selectivity and the poetry of the artist's vision. Through his Presidency of the Society of British Artists, he offended the British by reducing the number of members, organizing a less crowded hang and introducing the work of French artists. He was forced to resign in 1888 though ten years later he became President of a new group, the International Society of Painters and Engravers and again included French art in its exhibitions.

The simplification and economy of Whistler's style bore fruit amongst younger artists. Whistler's most important British follower was Walter Sickert who in 1882 abandoned his training under Legros at the Slade to become Whistler's pupil and studio assistant. Whistler introduced him to his French friends, sending him with the portrait of his mother to the Paris Salon, giving him letters of introduction to Manet and Degas and inviting him to paint at Dieppe with Monet and Degas. Sickert's early work was derivative of Whistler and consisted of small, low-toned panels of seascapes and shops. Through his study of French art, however, particularly that of Degas, Sickert's handling became more robust and confident, and he developed a more personal vision; he began to frequent music halls, exploring the effect of the 172 footlights on the performers, the ornate interiors and the largely working-class audience. This type of urban, low-life subject matter was important to him. In 1889 Sickert assembled an exhibition of paintings by himself and his friends, styled the 'London Impressionists'. They included Sidney Starr (1857–1925), Paul Maitland (1863–1909), Theodore Roussel (1847–1926) and Philip Wilson Steer (1860–1942), who had been a founding member of the NEAC. In the exhibition catalogue, Sickert called for artists to 'render the magic and the poetry which they daily see around them'. This was a call, with echoes of Whistler, for a specifically London-based subject matter, exemplified in Sickert's music-hall pictures, in Starr's painting of a

London street seen from the top of an omnibus, and in the delicate views of Chelsea and the Thames by Maitland and Roussel. Sickert lived in Dieppe from 1898 and made many visits to Venice, painting street scenes and studies of figures in interiors, using dark but subtle colours. In 1905 he returned to London; as his former teacher Whistler had died in 1903, Sickert now became the principal focus of advanced French trends.

The most radical exponent of French ideas was the Paris–trained Steer. His atmospheric Walberswick paintings of 1888–89 of girls on the beach are bold experiments with colour and technique; the surface of *Knucklebones* (1888–89), shown in the London Impressionists exhibition, consists of tiny, vibrantly coloured dabs of paint, like the divisionism of Seurat. Steer also made numerous oil studies of young girls musing in lamplit interiors, developments from Whistler's late portraits, often using the same model, Rose Pettigrew. They have a melancholy poetry and a latent sexual charge reminiscent of Rossetti.

Most of the work of the London Impressionists was on a small scale, intended not for the exhibition gallery but for the ordinary living room of the bourgeois house, 'art for the villa' as the Francophile critic George Moore (1852–1933) put it. Painting was seen as a private experience rather than a means of elevating and improving the public. This attitude is also characteristic of a number of NEAC artists who painted rural landscapes in an easy Impressionist style close to the work of Monet and Sisley. These included James Charles (1851–1906), who also painted charming *plein air* genre studies, and Frederick William Jackson (1859–1918) who lived at Staithes, a Yorkshire fishing village which became a popular artists' colony in the 90s.

Another short-lived artists' colony at the tiny village of Coburns-path, near Berwick-upon-Tweed, played a significant part in the formation of the group of Scottish painters known as the Glasgow Boys. Their style was formed in reaction to the academic subjects and finish of the previous generation of Glasgow artists, but their brief flowering in the late 80s and 90s was possible only because of the artistic climate in Glasgow, made prosperous by shipbuilding, coal and iron. Glasgow collectors bought contemporary French and Dutch pictures, and works by Whistler, Rossetti, Burne-Jones and Monticelli were shown at the Glasgow Institute exhibitions in the 80s. It was the combination of Bastien-Lepage's *plein air* style, Whistler's

171

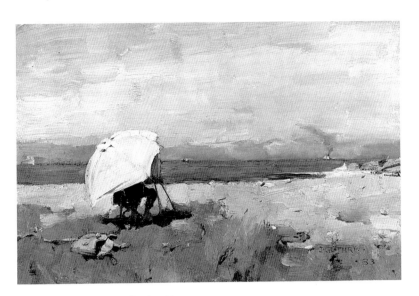

173 James Guthrie, *Hard at it*, 1883

decorative sense and Monticelli's rich textures that gave the Glasgow School its particular inspiration.

The Glasgow style evolved from several nuclei of artist friends painting out of doors in different places. In the late 70s James Paterson (1854–1932) and William Young MacGregor (1852–1923) spent the summers painting together at St Andrews; Paterson was studying in Paris, where he learned the soft, tonal style which he further developed after settling in the Dumfriesshire village of Moniaive in 1884. MacGregor, older than the others in the group, painted still life and landscape with extraordinarily bold handling. A second group of artists was centered on James Guthrie (1859–1930). Largely self-taught, he received early encouragement from John Pettie who advised him to stay in Britain rather than study abroad. Accordingly he spent the late 70s and early 80s painting out-of-doors with his friends Edwin Arthur Walton (1860–1922) and Joseph Crawhall 173 (1861–1913). They worked first at Rosneath outside Glasgow and then in 1880–81 at Brig o'Turk in the Trossachs, where Guthrie painted *A Funeral Service in the Highlands* (RA 1882), a large and solemn social-realist subject influenced by Courbet. Guthrie came

174 Joseph Crawhall,
The Flower Shop,
1894–1900

175 John Lavery, *The Tennis
Party,* 1886

under the influence of Bastien-Lepage; he worked in Lincolnshire in
1882 and from 1883–85 he lived in Coburnspath, where many of the
Glasgow painters congregated each summer to paint in the open air.
Guthrie returned to Glasgow in 1885 to paint Whistlerian pastels of
domestic interiors and became a successful portraitist to the Glasgow
establishment. Walton settled in the prosperous Glasgow suburb of
Helensburgh, depicted in his later watercolours with the clarity and
decorative placing characteristic of the Glasgow school.

This turning from rural to urban, middle-class subjects is typical of
the development of the Glasgow Boys. A similar progression took
place in the career of the Dublin-born John Lavery (1856–1941)
around whom the third group of Glasgow painters formed. After
studying in Paris in the early 80s and painting out of doors at Grez-
sur-Loing in northern France, Lavery settled in Glasgow in 1885 and
175 produced the extraordinary painting *The Tennis Party* (RA 1886). It
may have been done with the aid of photographs, for Lavery had
earlier worked as a photographer's assistant. The figures are caught in
movement with a Whistlerian delicacy; in Glasgow Whistler became
the prime influence on Lavery, particularly in the series of deceptively
casual low-toned oil sketches of the Glasgow International Exhibition
of 1888. Following the commission to paint a huge group portrait of
the State visit of Queen Victoria to the exhibition, Lavery became a
fashionable portrait painter, and his later work is in a more fluid style
influenced by Manet, Velázquez and Sargent.

Joseph Crawhall and Arthur Melville (1855–1904) had both been
involved with the *plein air* phase of the Glasgow school but they later

204

176 Arthur Melville, *The Little Bullfight. Bravo Toro!*, 1899

moved in different directions, each evolving his own unorthodox watercolour style, but both marked by the Glasgow flair for stylized composition. Much of Crawhall's work of the later 80s and 90s

174 depicts animals and birds painted with a painstaking but seemingly effortless virtuoso technique and composed with a startling economy derived from a knowledge of Japanese prints. Crawhall and Melville painted often in North Africa and Melville worked in Spain,

176 depicting the sunlit exoticism of bullfights, processions and Moorish architecture. Melville handled oil painting with vigour and was an important influence on Frank Brangwyn (1867–1956), whom he accompanied to Spain, but Melville's chief importance lay in his watercolour technique, working on damp paper in bold patterns of blobs and patches to achieve highly original effects.

A final phase of the Glasgow school was the so-called 'Persian carpet' style of George Henry (1858–1943) and Edward Atkinson Hornel (1864–1933). Henry had painted in the *plein air* manner but after meeting Hornel in 1885 a new boldness and strength emerged in their work. The vibrant colour and sweeping lines of their Kircudbrightshire landscapes were akin to Gauguin, whilst the

177 tapestry-like *The Druids: Bringing in the Mistletoe* (1890), painted jointly by both artists, evoked a magic world of Celtic myth quite different from the realism of the earlier Glasgow school landscapes. This patterned, richly textured manner, making extensive use of the palette knife, was continued when in 1893–94 they worked in Japan, their visit financed by the Glasgow dealer Alexander Reid and the collector William Burrell, but the pictures they produced after their return are disappointing.

The Glasgow Boys were first noticed by the London public at the NEAC in 1887. In 1890 the Grosvenor Gallery devoted a section to the Glasgow artists, which made an enormous impact. It was seen by visitors from Germany and there followed an invitation to show at the Munich Exhibition of that year, leading to exposure in other European cities. But after the mid-90s the work of the Glasgow Boys ceased to be innovative.

Clausen and La Thangue showed at the Academy, where some of the younger artists were influenced by the decorative stylization of the Glasgow Boys. But in general, the type of landscape painting that dominated the Summer Exhibitions around the turn of the century was bland and unadventurous. The Royal Academy had lost

177 George Henry and
Edward Atkinson Hornel,
The Druids: Bringing in the Mistletoe,
1890

credibility as an artistic leader. It had survived because of its social prestige and because of the success of Leighton in improving its standards, associated with the revival of high art. But by 1918, when Poynter, the last eminent Victorian to be President of the Academy, stepped down from office, he and the Academy were both anachronisms. In the 1830s when Martin and Haydon had attacked the Academy, they had done so wishing to change it, knowing that otherwise their careers would suffer. In the 1850s the young Pre-Raphaelites had challenged its values by showing there and the Academy had been broad-minded enough to accept their work. But major figures such as Rossetti, Brown, Hunt and Whistler, though they began their careers either in its Schools or at its exhibitions, all sooner or later deserted the Academy. The Grosvenor and the New English Art Club had shown artists that they could make their reputations without the Academy. Burne-Jones exhibited at the Academy only once; many of the younger generation simply ignored it. Victorian certainties were replaced by a more fragmented art world which encouraged experimentation, not only in the work of Sickert and the followers of Whistler, but also at the Slade School, where, taught by Steer and Henry Tonks (1862–1937), a new generation of talented students, including Harold Gilman (1876–1919), Spencer Gore (1879–1914), Gwen John (1876–1939) and her brother Augustus (1878–1961), was waiting to spread its wings.

Select Bibliography

GENERAL

Surveys and Dictionaries

BENDINER, Kenneth *An Introduction to Victorian Painting*, 1986
MAAS, Jeremy *Victorian Painters*, 1969
REDGRAVE, Richard and Samuel *A Century of British Painters*, 1866
REDGRAVE, Samuel *A Dictionary of Artists of the English School*, 2nd ed. 1878
REYNOLDS, Graham *Victorian Painting*, 1966
WOOD, Christopher *Dictionary of Victorian Painters*, 2nd ed. 1978

Catalogues

CHAPEL, Jeannie *Victorian Taste, The Complete Catalogue of Paintings at the Royal Holloway College*, 1982
CUMMINGS, Frederick and Staley, Allen *Romantic Art in Britain, Paintings and Drawings 1760–1860*, exh. cat., Detroit Institute of Arts and Philadelphia Museum of Art 1978
FORBES, Christopher *The Royal Academy Revisited, Victorian Paintings from the Forbes Magazine Collection*, exh. cat., New York 1975
MORRIS, Edward et al. *Lord Leverhulme*, exh. cat., Royal Academy, London 1980
PARKINSON, R. *Catalogue of British Paintings 1820–60*, Victoria and Albert Museum, London 1990
SPALDING, Frances and JEFFREY, Ian *Landscape in Britain*, exh. cat., Arts Council of Great Britain 1983
STALEY, Allen, ORMOND, Richard and Leonée, HEDBERG, Gregory and DORMENT, Richard *Victorian High Renaissance*, exh. cat., Manchester City Art Gallery, Minneapolis Institute of Art and Brooklyn Museum, New York 1978–79
TREBLE, Rosemary *Great Victorian Pictures: their Paths to Fame*, exh. cat., Arts Council of Great Britain 1978

Watercolours

HARDIE, Martin *Watercolour Painting in Britain, vol. 3, The Victorian Period*, 1978
NEWALL, Christopher *Victorian Watercolours*, 1987

Scottish Art

HARDIE, William *Scottish Painting 1837–1939*, 1976
IRWIN, David and Francina *Scottish Painters at Home and Abroad 1700–1900*, 1975

The Victorian Art World

GILLETT, Paula *The Victorian Painter's World*, 1990
MACLEOD, Dianne Sachko 'Art Collecting and Victorian Middle Class

Taste', *Art History*, vol. 10, no. 3, Sept. 1987
MACLEOD, Dianne Sachko et al. *Painters and Patrons in the North East*, exh. cat., Laing Art Gallery, Newcastle upon Tyne 1989–90
MORRIS, Edward 'John Naylor and other Collectors of Modern Paintings in 19th-Century Britain', *Walker Art Gallery Annual Report and Bulletin*, vol. v, 1974–75

CHAPTER ONE **The Rise of Genre Painting**

ALTICK, R. D. *Paintings from Books, Art and Literature 1760–1900*, 1985
CAMPBELL, Mungo *David Scott 1806–1849*, National Gallery of Scotland, Edinburgh 1990
ERRINGTON, Lindsay *Tribute to Wilkie*, exh. cat., National Gallery of Scotland, Edinburgh 1985
FARR, Dennis *William Etty*, 1958
GEORGE, Eric *The Life and Death of Benjamin Robert Haydon 1786–1846*, 1948
HAYDON, B.R. *Autobiography and Journals*, ed. Malcolm Ewens, 1950
HELENIAK, Kathryn Moore *William Mulready*, 1980
McKERROW, Mary *The Faeds, A Biography*, 1982
MILES, H.A.D. and BROWN, D.B. *Sir David Wilkie of Scotland*, exh. cat., North Carolina Museum of Art, Raleigh 1987
ORMOND, Richard *Sir Edwin Landseer*, exh. cat., Philadelphia Museum of Art and Tate Gallery, London 1982
— *Franz Xaver Winterhalter*, exh. cat., National Portrait Gallery, London and Petit Palais, Paris 1987–88
STRONG, Roy *And When Did You Last See Your Father? The Victorian Painter and British History*, 1978

CHAPTER TWO **Early Victorian Taste and Patronage**

ALLDERIDGE, Patricia *The Late Richard Dadd 1817–86*, exh. cat., Tate Gallery, London 1974
ANDREWS, Keith *The Nazarenes, a Brotherhood of German Painters in Rome*, 1964
CASTERAS, Susan P. and Parkinson, Ronald, eds *Richard Redgrave 1804–88*, exh. cat., Victoria and Albert Museum, London and Yale Center for British Art, New Haven 1988
KLINGENDER, Francis D. *Art and the Industrial Revolution*, 1947, revised 1968
MACDONALD, Stuart *The History and

Philosophy of Art Education, 1970
ORMOND, Richard and TURPIN, John *Daniel Maclise 1806–70*, exh. cat., National Portrait Gallery, London, Arts Council of Great Britain 1972
POINTON, Marcia *William Dyce 1806–64*, 1979
ROBERTSON, David *Sir Charles Eastlake and the Victorian Art World*, 1978
STEEGMAN, John *Consort of Taste 1830–1870*, 1950 (reprinted as *Victorian Taste* 1970)
VAUGHAN, WILLIAM *German Romanticism and English Art*, 1979

CHAPTER THREE **The Post-Romantic Landscape**

BUTLIN, Martin and JOLL, Evelyn *The Paintings of J.M.W. Turner*, 2 vols. 1977
CROUAN, Katharine *John Linnell, A Centenary Exhibition*, exh. cat., Fitzwilliam Museum, Cambridge and Yale Center for British Art, New Haven 1982–83
FEAVER, William *The Art of John Martin*, 1975
GREENACRE, Francis *Francis Danby 1793–1861*, exh. cat., Tate Gallery, London 1988
GREENACRE, Francis and STODDARD, Sheena *W.J. Müller 1812–1845*, exh. cat., Bristol Museum and Art Gallery 1991
GUITERMAN, Helen and LLEWELLYN, Briony *David Roberts*, exh. cat., Barbican Art Gallery, London 1986–87
HEWISON, Robert *John Ruskin: The Argument of the Eye*, 1976
HILTON, Timothy *John Ruskin, The Early Years*, 1985
LISTER, Raymond *Samuel Palmer and the Ancients*, exh. cat., Fitzwilliam Museum, Cambridge 1984
— *The Paintings of Samuel Palmer*, 1985
LOCKETT, Richard *Samuel Prout 1782–1852*, 1985
MERWE, Pieter van der and TOOK, Roger *Clarkson Stanfield 1793–1867*, exh. cat., Tyne and Wear Museums and Rheinisches Landesmuseum, Bonn 1979
WILDMAN, Stephen *David Cox 1783–1859*, exh. cat., Birmingham Museums and Art Gallery 1983
WILTON, Andrew *The Life and Work of J.M.W. Turner*, 1979

CHAPTER FOUR **The Pre-Raphaelites**

BANHAM, Joanna and HARRIS, Jennifer eds *William Morris and the Middle Ages*, exh. cat., Whitworth Art Gallery, Manchester 1984

BENNETT, Mary Ford Madox Brown 1821–1893, exh. cat., Walker Art Gallery, Liverpool 1964
— Millais PRB PRA, exh. cat., Walker Art Gallery, Liverpool and Royal Academy, London 1967
— William Holman Hunt, exh. cat., Walker Art Gallery, Liverpool and Victoria and Albert Museum, London 1969
— Artists of the Pre-Raphaelite Circle. The First Decade. Catalogue of works in the Walker Art Gallery, Lady Lever Art Gallery, Sudley Art Gallery, National Museums and Galleries on Merseyside 1988
ELZEA, Rowland The Samuel and Mary R. Bancroft Jr., and Related Pre-Raphaelite Collections, Delaware Art Museum 1978
FREDEMAN, W.E., ed. The P.R.B. Journal, 1975
GRIEVE, Alastair The Art of Dante Gabriel Rossetti. The Pre-Raphaelite Period 1848–50, 1973
— 1. Found, 2. The Pre-Raphaelite Modern Subject, 1976
— The Watercolours and Drawings of 1850–55, 1978
HILTON, Timothy The Pre-Raphaelites, 1970
PARRIS, Leslie, ed. The Pre-Raphaelites, exh. cat., Tate Gallery, London 1984
— Pre-Raphaelite Papers, 1984
STALEY, Allen The Pre-Raphaelite Landscape, 1973
SUMNER, Ann Ruskin and the English Watercolour From Turner to the Pre-Raphaelites, exh. cat., Whitworth Art Gallery, Manchester 1989
SURTEES, Virginia The Paintings and Drawings of Dante Gabriel Rossetti (1828–1882): A Catalogue Raisonné, 2 vols, 1971
— ed. The Diary of Ford Madox Brown, 1981
TREUHERZ, Julian Pre-Raphaelite Paintings from the Manchester City Art Gallery, 1980
WATKINSON, Raymond Pre-Raphaelite Art and Design 1970
WATKINSON, Raymond and NEWMAN, Teresa Ford Madox Brown and the Pre-Raphaelite Circle, 1991
Dante Gabriel Rossetti, Painter and Poet, exh. cat., Royal Academy, London 1973

CHAPTER FIVE Mid-Victorian Realism
AGNEW, Geoffrey Agnew's 1817–1967, 1967
ALLWOOD, Rosamund G.E. Hicks, Painter of Victorian Life, exh. cat., Geffrye Museum, London 1982–83
DANIELS, Jeffrey et al. Solomon, a Family of Painters, exh. cat., Geffrye

Museum, London 1985
DYSON, Anthony Pictures to Print. The Nineteenth-Century Engraving Trade, 1984
ERRINGTON, Lindsay Sunshine and Shadow. The David Scott Collection of Victorian Paintings, exh. cat., National Gallery of Scotland, Edinburgh 1991
FRITH, William Powell My Autobiography and Reminiscences, 2 vols, 1887
— Further Reminiscences, 1888
GREG, Andrew The Cranbrook Colony, exh. cat., Wolverhampton Art Gallery 1977
GUISE, Hilary Great Victorian Engravings. A Collector's Guide, 1980
HOGARTH, Paul Arthur Boyd Houghton, exh. cat., Victoria and Albert Museum, London 1975
LEWIS, M. J.F. Lewis 1805–76, 1978
MAAS, Jeremy Gambart, Prince of the Victorian Art World, 1975
NOAKES, Vivien Edward Lear 1812–88, exh. cat., Royal Academy, London 1885
NUNN, Pamela Gerrish Victorian Women Artists, 1967
WOOD, Christopher Victorian Panorama. Paintings of Victorian Life, 1976

CHAPTER SIX The Aesthetic Movement
BLUNT, Wilfred England's Michelangelo. G.F. Watts, 1975
CHRISTIAN, John Burne-Jones, exh. cat., Arts Council of Great Britain 1975
— The Last Romantics. The Romantic Tradition in British Art. Burne-Jones to Stanley Spencer, exh. cat., Barbican Art Gallery, London 1989
CURRY, David Park James McNeill Whistler at the Freer Gallery of Art, exh. cat., Washington, D.C. 1984
DANIELS, Jeffrey et al. Solomon, a Family of Painters, exh. cat., Geffrye Museum, London 1985
FITZGERALD, Penelope Edward Burne-Jones, a Biography, 1975
GREEN, Richard Albert Moore and his Contemporaries, exh. cat., Laing Art Gallery, Newcastle upon Tyne 1972
HARRISON, Martin and WATERS, Bill Burne-Jones, 1973
O'LOONEY, Betty Frederick Sandys 1829–1904, exh. cat., Brighton Museum and Art Gallery 1974
SPENCER, Robin The Aesthetic Movement. Theory and Practice, 1972
STALEY, Allen ed. From Realism to Symbolism. Whistler and his World, exh. cat., Wildenstein, New York and Philadelphia Museum of Art 1971
SUTTON, Denys Nocturne: The Art of James McNeill Whistler, 1963
YOUNG, Andrew McLaren, McDo-

NALD, Margaret, SPENCER, Robin and MILES, Hamish The Paintings of J.M. Whistler, 2 vols, 1980
G.F. Watts. The Hall of Fame, exh. cat., National Portrait Gallery, London 1975

CHAPTER SEVEN The Late Victorian Academy
ERRINGTON, Lindsay Master Class, Robert Scott Lauder and his Pupils, exh. cat., National Gallery of Scotland, Edinburgh 1983
FREE, Renée Victorian Olympians, exh. cat., Art Gallery of New South Wales 1975
HARDIE, William Sir William Quiller Orchardson RA, exh. cat., Scottish Arts Council 1972
HOBSON, Anthony The Art and Life of J.W. Waterhouse, 1980
LOMAX, James and ORMOND, Richard John Singer Sargent and the Edwardian Age, exh. cat., National Portrait Gallery, London and Lotherton Hall, Leeds 1979
MATYJASZKIEWICZ, Krystyna, ed. James Tissot, exh. cat., Barbican Art Gallery, London 1984
NEWALL, Christopher The Art of Lord Leighton, 1990
ORMOND, Leonée and Richard Lord Leighton, 1975
ORMOND, Richard John Singer Sargent, 1970
SWANSON, Vern G. Alma Tadema, the Painter of the Victorian Vision of the Ancient World, 1977
TREUHERZ, Julian Hard Times, Social Realism in Victorian Art, exh. cat., Manchester City Art Gallery 1987
USHERWOOD, Paul and SPENCER-SMITH, Jenny Lady Butler, Battle Artist 1846–1933, exh. cat., National Army Museum, London 1987
WENTWORTH, Michael James Tissot, 1984

CHAPTER EIGHT Late Victorian Landscape
BARON, Wendy Sickert, 1973
BILLCLIFFE, Roger The Glasgow Boys, 1985
BILLINGHAM, Rosalind George Heming Mason, exh. cat., Stoke-on-Trent Museum and Art Gallery 1982
DESLANDES, Gerald Arthur Melville 1855–1904, exh. cat., Dundee Museums and Art Galleries 1977–78
ERRINGTON, Lindsay William McTaggart 1835–1910, exh. cat., National Gallery of Scotland, Edinburgh 1989
FOX, Caroline and GREENACRE, Francis Painting in Newlyn 1880–1930, exh. cat., Barbican Art Gallery, London 1985
GRUETZNER, Anna, section on Great

Britain and Ireland in *Post-Impressionism*, exh. cat., Royal Academy, London 1980

HAMILTON, Vivien *Joseph Crawhall 1861–1913*, exh. cat., Glasgow Art Gallery and Museums 1990

HOOD, Nancy *William Teulon Blandford Fletcher 1858–1936, A Painter of Village Life*, 1986

IRWIN, Francina *Joseph Farquharson of Finzean*, exh. cat., Aberdeen Art Gallery 1985

LAUGHTON, Bruce *Philip Wilson Steer 1862–1942*, 1971

McCONKEY, Kenneth *A Painter's Harvest, Works by Henry Herbert La Thangue RA 1859–1929*, exh. cat., Oldham Art Gallery 1978

— *Sir George Clausen 1852–1944*, exh. cat., Bradford Art Gallery and Museum 1980

— *Sir John Lavery RA 1856–1941*, exh. cat., Ulster Museum, Belfast and Fine Art Society, London 1984–85

— *British Impressionism*, 1989

MUNRO, Jane *Philip Wilson Steer*, exh. cat., Fitzwilliam Museum, Cambridge 1986

NEWALL, Christopher *The Etruscans, Painters of the Italian Landscape*, exh. cat., Stoke-on-Trent Museum and Art Gallery 1989

ROBERTSON, Alexander *Atkinson Grimshaw*, 1988

ROBINS, Anna and FARMAR, Francis *The New English Art Club Centenary Exhibition*, exh. cat., Christie's, London 1986

SHEEHY, Jeanne *Walter Osborne*, exh. cat., National Gallery of Ireland, Dublin 1983

List of Illustrations

Garden-Pavilion in the Grounds of Buckingham Palace, 1846
31. SIR CHARLES LOCK EASTLAKE, *Christ Blessing Little Children*, 1839. Oil on canvas, 79 × 103.2 (31⅛ × 40⅝). © Manchester City Art Galleries
32. DANIEL MACLISE, *Trafalgar: the Death of Nelson*, 1863–65, (detail), finished study for House of Lords mural. Oil on canvas, 95.9 × 353.1 (37¾ × 139). The Board of Trustees of the National Museums & Galleries on Merseyside (Walker Art Gallery, Liverpool)
33. RICHARD DADD, *The Fairy Feller's Master-Stroke*, 1855–64. Oil on canvas, 54 × 39.4 (21¼ × 15½). Tate Gallery, London
34. SIR JOSEPH NOEL PATON, *The Reconciliation of Oberon and Titania*, 1847. Oil on canvas, 76.2 × 123.1 (30 × 48½). National Gallery of Scotland, Edinburgh
35. J.M.W. TURNER, *Slavers throwing overboard the Dead and Dying. Typhon coming on*, 1840. Oil on canvas, 91 × 122 (35⅝ × 48). Museum of Fine Arts, Boston, Henry Lillie Pierce Fund
36. JOHN MARTIN, *The Great Day of His Wrath*, 1851–53. Oil on canvas, 196.5 × 303 (77⅜ × 119⅜). Tate Gallery, London
37. SAMUEL PALMER, *The Lonely Tower*, 1864. Watercolour and bodycolour, 50.8 × 71.2 (20 × 28). Yale Center for British Art, New Haven, Paul Mellon Collection
38. FRANCIS DANBY, *The Evening Gun*, 1857. Oil on canvas, 50.8 × 76.1 (20 × 30). Private Collection
39. JOHN LINNELL, *The Last Load*, 1874–75. Oil on canvas, 131.5 × 169 (51¾ × 66½). The Board of Trustees of the National Museums & Galleries on Merseyside (Walker Art Gallery, Liverpool)
40. FREDERICK RICHARD LEE and THOMAS SIDNEY COOPER, *Cattle on the Banks of a River*, 1855. Oil on canvas, 152.4 × 111.8 (60 × 44). Tunbridge Wells Museum and Art Gallery
41. DAVID COX, *Rhyl Sands, c.* 1854. Oil on canvas, 45.8 × 63.5 (18 × 25). © Manchester City Art Galleries
42. SAMUEL PROUT, *The Palazzo Contarini-Fasan on the Grand Canal, Venice*, after 1841. Watercolour and bodycolour, 43.4 × 30.2 (17 × 12). By courtesy of the Board of Trustees of the Victoria & Albert Museum, London
43. THOMAS UWINS, *An Italian Mother Teaching her Child the Tarantella (The Lesson)*, 1842. Oil on panel, 43.5 × 55.9 (17⅛ × 22). By courtesy of the Board of Trustees of the Victoria & Albert Museum, London
44. DAVID ROBERTS, *The Temple of Karnak*, 1838. Pencil and watercolour,

48.5 × 32.5 (19¼ × 13). © Manchester City Art Galleries
45. W. CLARKSON STANFIELD, *The Day after the Wreck; A Dutch East Indiaman on shore in the Ooster Schelde – Ziericksee in the distance*, 1844. Oil on canvas, 153 × 232.4 (60¼ × 91½). Sheffield City Art Galleries
46. DANTE GABRIEL ROSSETTI, *The Girlhood of Mary Virgin*, 1848–49. Oil on canvas, 83.2 × 65.4 (32¾ × 25¾). Tate Gallery, London
47. GIOVANNI LASINIO, *The Miracles of St. Rainier, c.* 1832. Engraving after the fresco in the Campo Santo, Pisa. From Giovanni Lasinio, *Pitture a fresco del Camposanto di Pisa*, 1832
48. DANTE GABRIEL ROSSETTI, *Dante drawing an Angel on the First Anniversary of the Death of Beatrice*, 1849. Pen and ink, 39.4 × 32.6 (15¾ × 12⅞). Birmingham City Museums and Art Gallery
49. SIR JOHN EVERETT MILLAIS, *Isabella*, 1848–49. Oil on canvas, 102.9 × 142.9 (40½ × 56¼). The Board of Trustees of the National Museums & Galleries on Merseyside (Walker Art Gallery, Liverpool)
50. FORD MADOX BROWN, *The First Translation of the Bible into English: Wycliffe Reading his Translation of the Bible to John of Gaunt*, 1847–48. Oil on canvas, 119.5 × 153.3 (47 × 60½). Bradford City Art Gallery
51. SIR JOHN EVERETT MILLAIS, *Christ in the House of his Parents*, 1849–50. Oil on canvas, 86.4 × 139.7 (34 × 55). Tate Gallery, London
52. FORD MADOX BROWN, *James Leathart*, 1863. Oil on canvas, 34.3 × 27.9 (13½ × 11). Private Collection
53. WILLIAM BELL SCOTT, *Iron and Coal*, 1861. Oil on canvas, 186.6 × 187.9 (73½ × 74). Wallington Hall. Photo The National Trust Photographic Library
54. FORD MADOX BROWN, '*The Pretty Baa Lambs*', 1851. Oil on panel, 61 × 76.2 (24 × 30). Birmingham City Museums and Art Gallery
55. WILLIAM HOLMAN HUNT, *The Hireling Shepherd*, 1851–52 (detail). Oil on canvas, 76.4 × 109.5 (30⅛ × 43⅛). © Manchester City Art Galleries
56. WILLIAM HOLMAN HUNT, *The Awakening Conscience*, 1853–54. Oil on canvas, 76.2 × 55.9 (30 × 22). Tate Gallery, London
57. FORD MADOX BROWN, *Work*, 1852–65. Oil on canvas, 137 × 197.3 (54 × 78). © Manchester City Art Galleries
58. FORD MADOX BROWN, *An English Autumn Afternoon, Hampstead – Scenery in 1853*, 1852–55. Oil on canvas, 71.7 × 134.6 (28¼ × 53). Birmingham City Museums and Art Gallery

59. JOHN BRETT, *The Glacier of Rosenlaui*, 1856. Oil on canvas, 44.5 × 41.9 (17½ × 16½). Tate Gallery, London
60. JOHN RUSKIN, *Mer de Glace, Chamonix*, 1860. Watercolour, bodycolour, pen, ink and pencil, 42.1 × 33.1 (15⅜ × 12). The Whitworth Art Gallery, University of Manchester
61. GEORGE PRICE BOYCE, *At Binsey, near Oxford*, 1862. Watercolour, 31.7 × 53.7 (12½ × 21⅛). The Trustees, The Cecil Higgins Art Gallery, Bedford
62. SIR JOHN EVERETT MILLAIS, *John Ruskin*, 1853–54. Oil on canvas, 78.7 × 68 (31 × 26.4). Private Collection. Photo courtesy Tate Gallery, London
63. WILLIAM HENRY HUNT, *Primroses and Bird's Nest*. Watercolour on paper, 18.4 × 27.3 (7¼ × 10¾). Tate Gallery, London
64. DANIEL ALEXANDER WILLIAMSON, *Spring, Warton Crag*, 1863. Oil on canvas on panel, 27 × 40.6 (10⅝ × 16). The Board of Trustees of the National Museums & Galleries on Merseyside (Walker Art Gallery, Liverpool)
65. WILLIAM DYCE, *Pegwell Bay, Kent – a Recollection of October 5th 1858*, 1858–60. Oil on canvas, 63.5 × 88.9 (25 × 35). Tate Gallery, London
66. HENRY ALEXANDER BOWLER, *The Doubt: 'Can these Dry Bones Live?'*, 1854–55. Oil on canvas, 61 × 50.8 (24 × 20). Tate Gallery, London
67. WILLIAM HOLMAN HUNT, *The Scapegoat*, 1854. Oil on canvas, 87 × 139.8 (34½ × 55). The Board of Trustees of the National Museums & Galleries on Merseyside (Lady Lever Art Gallery, Port Sunlight)
68. WILLIAM HOLMAN HUNT, *The Light of the World*, 1853. Oil on canvas, 125.5 × 58.9 (49⅜ × 23⅛). By permission of the Warden and Fellows of Keble College, Oxford
69. SIR JOHN EVERETT MILLAIS, *Autumn Leaves*, 1855–56. Oil on canvas, 104.1 × 73.6 (41 × 29). © Manchester City Art Galleries
70. ARTHUR HUGHES, *The Long Engagement, c.* 1854–59. Oil on canvas, 105.4 × 52.1 (41½ × 20½). Birmingham City Museums and Art Gallery
71. JOHN DILLWYN LLEWELYN, *Lastrea Felix Mas, c.* 1854. Collodion, 20.6 × 15.4 (8⅛ × 6⅛). Richard Morris
72. HENRY PEACH ROBINSON, *A Holiday in the Wood*, 1860. Albumen print from 6 negatives, 50.3 × 60.4 (19¾ × 23¾). The International Museum of Photography at George Eastman House, Rochester, New York
73. DANTE GABRIEL ROSSETTI, *The Wedding of St George and the Princess Sabra*, 1857. Watercolour, 36.5 × 36.5

211

($14\frac{3}{8} \times 14\frac{3}{8}$). Tate Gallery, London

74. WILLIAM POWELL FRITH, *The Derby Day*, 1856–58 (detail). Oil on canvas, 101.6 × 223.6 (40 × 88). Tate Gallery, London

75. WILLIAM POWELL FRITH, *Life at the Seaside (Ramsgate Sands)*, 1854. Oil on canvas, 76.2 × 153.7 (30 × 60½). Royal Collection. St James's Palace. © Her Majesty the Queen

76. GEORGE ELGAR HICKS, *Dividend Day at the Bank of England*, 1859. Oil on panel, 24.8 × 37.5 ($9\frac{3}{4} \times 14\frac{3}{4}$). The Governor and Company of the Bank of England

77. WILLIAM MAW EGLEY, *Omnibus Life in London*, 1859. Oil on canvas, 44.8 × 41.9 ($17\frac{5}{8} \times 16\frac{1}{2}$). Tate Gallery, London

78. JOHN CALCOTT HORSLEY, *Showing a Preference*, 1860. Oil on canvas, 67.5 × 52.7 ($26\frac{5}{8} \times 20\frac{3}{4}$). Private Collection. Photo Courtauld Institute of Art, University of London

79. ALFRED RANKLEY, *Old Schoolfellows*, 1854. Oil on canvas, 93.3 × 71 ($36\frac{3}{4} \times 28$). Private Collection. Photo Courtauld Institute of Art, University of London

80. WILLIAM POWELL FRITH, *The Opera Box*, 1855. Oil on canvas, 34.9 × 45 ($13\frac{3}{4} \times 17\frac{3}{4}$). Reproduced by kind permission of the Harris Museum and Art Gallery, Preston, Richard Newsham Bequest, 1883

81–3. AUGUSTUS LEOPOLD EGG, *Past and Present*, 1858. Three oils on canvas, each 63.5 × 76.2 (25 × 30). Tate Gallery, London

84. GEORGE ELGAR HICKS, *Woman's Mission, Companion of Manhood*, 1863. Oil on canvas, 76.2 × 64.1 (30 × 25¼). Tate Gallery, London

85. HENRY NELSON O'NEIL, *Eastward Ho! August 1857*, 1857–58. Oil on canvas, 136 × 108 ($53\frac{1}{2} \times 42\frac{1}{2}$). Elton Hall Collection

86. SIR JOSEPH NOEL PATON, *In Memoriam*, 1858. Oil on panel, 123 × 96.5 ($48\frac{3}{8} \times 38$). Private Collection, England

87. PAUL FALCONER POOLE, *The Death of Cordelia*, 1858. Oil on canvas 144.2 × 187.4 ($56\frac{3}{4} \times 73\frac{3}{4}$). By courtesy of the Board of Trustees of the Victoria & Albert Museum, London

88. MYLES BIRKET FOSTER, *The Hayrick*, c.1862. Watercolour, 77.7 × 68 ($30\frac{5}{8} \times 26\frac{3}{4}$). Yale Center for British Art, New Haven, Paul Mellon Collection

89. JAMES CLARKE HOOK, *'Welcome Bonny Boat!'*, 1856. Oil on canvas, 63 × 94.7 ($24\frac{3}{4} \times 37\frac{1}{4}$). Reproduced by kind permission of Harris Museum and Art Gallery, Preston, Richard Newsham Bequest, 1883

90. EDWARD LEAR, *Quarries of Syracuse*,

1847. Ink and watercolour, 35.4 × 50.3 ($13\frac{7}{8} \times 19\frac{7}{8}$). The Board of Trustees of the National Museums & Galleries on Merseyside (Walker Art Gallery, Liverpool)

91. JOHN PHILLIP, *La Gloria*, 1864. Oil on canvas, 146 × 219.7 ($57\frac{1}{2} \times 86\frac{1}{2}$). National Gallery of Scotland, Edinburgh

92. JOHN FREDERICK LEWIS, *The Siesta*, 1876. Oil on canvas, 88.6 × 111.1 ($34\frac{7}{8} \times 43\frac{3}{4}$). Tate Gallery, London

93. THOMAS WEBSTER, *Roast Pig*, 1862. Oil on canvas, 76.8 × 121.9 (30¼ × 48). Sheffield City Art Galleries

94. JAMES SANT, *Speak Lord, for thy servant heareth (The Infant Samuel)*, 1853. Oil on canvas, 73.7 × 61 (29 × 24). Bury Art Gallery

95. WILLIAM MACDUFF, *Shaftesbury, or Lost and Found*, 1862. Oil on canvas, 47 × 40.6 ($18\frac{1}{2} \times 16$). Private Collection

96. GEORGE BERNARD O'NEILL, *Public Opinion*, 1863. Oil on canvas, 53.4 × 78.7 (21 × 31). Leeds City Art Galleries

97. EMILY MARY OSBORN, *Nameless and Friendless*, 1857. Oil on canvas, 82.5 × 104.2 ($32\frac{1}{2} \times 41$). Private Collection. Photo Courtauld Institute of Art, University of London

98. JAMES ABBOT McNEILL WHISTLER, *The White Girl (later renamed Symphony in White No. 1)*, 1861–62. Oil on canvas, 214.6 × 108 ($84\frac{1}{2} \times 42\frac{1}{2}$). National Gallery of Art, Washington, Harris Whittemore Collection, 1943

99. DANTE GABRIEL ROSSETTI, *Monna Vanna*, 1866. Oil on canvas, 88.9 × 86.4 (35 × 34). Tate Gallery, London

100. SIR EDWARD COLEY BURNE-JONES, *Le Chant d'Amour*, 1869–77. Oil on canvas, 112 × 152.5 (44 × 60). Metropolitan Museum of Art, New York (Alfred N. Punnett Endowment Fund 1947)

101. JAMES ABBOT McNEILL WHISTLER, *Symphony in White No. 3*, 1865–67. Oil on canvas, 51.1 × 76.8 ($20\frac{1}{8} \times 30\frac{1}{4}$). The Barber Institute of Fine Arts, The University of Birmingham

102. FREDERIC, LORD LEIGHTON, *Golden Hours*, 1864. Oil on canvas, 91.5 × 122 (36 × 48). Glyndebourne, on loan from the Tapeley 1978 Chattels Trust

103. ALBERT JOSEPH MOORE, *A Venus*, 1861. Oil on canvas, 160 × 76.2 (63 × 30). York City Art Gallery

104. JAMES ABBOT McNEILL WHISTLER, *Arrangement in Grey and Black No. I: the Artist's Mother*, 1872. Oil on canvas, 145 × 164 (57 × 64½). Musée d'Orsay, Paris

105. Reconstruction of The Peacock Room, designed by Thomas Jekyll and James Abbot McNeill Whistler, 1876. Oil and gold on leather and wood, 425.8 × 1010.9 × 608.3 ($167\frac{5}{8} \times 398 \times$

239½). Courtesy of the Freer Gallery of Art, Smithsonian Institution, Washington, D.C. 04.61

106. ALBERT JOSEPH MOORE, *Dreamers*, 1882. Oil on canvas, 68.5 × 119.4 (27 × 47). Birmingham City Museums and Art Gallery

107. DANTE GABRIEL ROSSETTI, *Dante's Dream at the Time of the Death of Beatrice*, 1870–71. Oil on canvas, 216 × 312.4 (84 × 123). The Board of Trustees of the National Museums & Galleries on Merseyside (Walker Art Gallery, Liverpool)

108. DANTE GABRIEL ROSSETTI, *Proserpine*, 1877. Oil on canvas, 119.5 × 57.8 (42 × 22). Private Collection

109. SIR EDWARD COLEY BURNE-JONES, *The Annunciation (The Flower of God)*, 1863. Gouache, 60.3 × 52.7 ($23\frac{3}{4} \times 20\frac{3}{4}$). Private Collection. Photo Christie's, London

110. FREDERICK SANDYS, *Medea*, 1868. Oil on panel 62.2 × 46.3 ($24\frac{1}{2} \times 18\frac{1}{4}$). Birmingham City Museums and Art Gallery

111. SIMEON SOLOMON, *Carrying the Scrolls of the Law*, 1867. Watercolour and bodycolour 35.7 × 25.5 (14 × 10). The Whitworth Art Gallery, University of Manchester

112. ARTHUR HUGHES, *The Knight of the Sun*, 1860. Oil on canvas, 101.5 × 132.5 (40 × 52½). Private Collection. Photo Christie's, London

113. SIR EDWARD COLEY BURNE-JONES, *The Beguiling of Merlin*, 1873–77. Oil on canvas, 186 × 111 ($73\frac{1}{4} \times 43\frac{3}{4}$). The Board of Trustees of the National Museums & Galleries on Merseyside (Lady Lever Art Gallery, Port Sunlight)

114. SIR EDWARD COLEY BURNE-JONES, *The Sleep of Arthur in Avalon*, 1881–98. Oil on canvas, 111 × 254 ($43\frac{3}{4} \times 101$). Museo de Arte de Ponce, Inc., The Luis A. Ferre Foundation, Inc., Puerto Rico

115. JAMES ABBOT McNEILL WHISTLER, *Nocturne in Black and Gold: the Falling Rocket*, c. 1874. Oil on panel, 60.3 × 46.6 ($23\frac{3}{4} \times 18\frac{3}{8}$). © The Detroit Institute of Arts (Gift of Dexter M. Ferry Jr)

116. FORD MADOX BROWN, *The Opening of the Bridgewater Canal AD 1639*, 1881–83. Gambier Parry method of spirit fresco, 143.3 × 317.5 (58 × 125). Manchester Town Hall. Photo Manchester City Council

117. J.M. STRUDWICK, *Isabella*, 1879. Tempera with gold paint on canvas, 99 × 58.5 (39 × 23). The Trustees of the De Morgan Foundation

118. JOHN BYAM LISTON SHAW, *Boer War 1900*, 1900. Oil on canvas, 100 × 75 ($39\frac{3}{8} \times 29\frac{1}{2}$). Birmingham City Museums and Art Gallery

119. JULIA MARGARET CAMERON, *The Kiss of Peace*, 1869. Albumen print, 35.6 × 27.9 (14 × 11). Gernsheim Collection, Harry Ransom Humanities Research Center, The University of Texas at Austin
120. GEORGE FREDERIC WATTS, *Tennyson*, 1863–64. Oil on canvas, 61.3 × 51.4 (24⅛ × 20¼). National Portrait Gallery, London
121. GEORGE FREDERIC WATTS, *Hope*, 1886. Oil on canvas, 142.2 × 111.8 (56 × 44). Tate Gallery, London
122. GEORGE FREDERIC WATTS, *The Sower of the Systems*, 1902–3. Oil on canvas, 122.6 × 91.4 (48½ × 36). Art Gallery of Ontario, Toronto. Gift of Mr and Mrs J.M. Tanenbaum, 1971. Donated by the Ontario Heritage Foundation, 1988
123. WILLIAM POWELL FRITH, *The Private View of the Royal Academy in 1881*, 1881–82. Oil on canvas, 102.9 × 195.6 (40½ × 77). A. Pope Family Trust
124. The studio, Leighton House, London. Photograph by Bedford Lemere, 1895. Royal Commission on the Historical Monuments of England
125. BRITON RIVIERE, *Sympathy*, 1877. Oil on canvas, 122 × 101.6 (48 × 40). Royal Holloway and Bedford New College, London
126. WALTER DENDY SADLER, *Thursday*, 1880. Oil on canvas, 86.4 × 141 (34 × 55½). Tate Gallery, London
127. SIR JOHN EVERETT MILLAIS, *My First Sermon*, 1863. Oil on canvas, 92.1 × 76.8 (36¼ × 30¼). Guildhall Art Gallery, Corporation of London
128. SIR JOHN EVERETT MILLAIS, *Mrs Bischoffsheim*, 1873. Oil on canvas, 130.8 × 90.2 (51½ × 35½). Tate Gallery, London
129. SIR JOHN EVERETT MILLAIS, *Chill October*, 1870. Oil on canvas, 141 × 186.7 (55½ × 73½). Private Collection, England
130. WILLIAM FREDERICK YEAMES, '*And When did you last see your father?*', 1878. Oil on canvas, 122 × 249 (48 × 98). The Board of Trustees of the National Museums & Galleries on Merseyside (Walker Art Gallery, Liverpool)
131. HENRY STACY MARKS, *A Select Committee*, 1891. Oil on canvas, 111.7 × 86.7 (44 × 34⅛). The Board of Trustees of the National Museums & Galleries on Merseyside (Walker Art Gallery, Liverpool)
132. JOHN PETTIE, *Scene from 'Peveril of the 'Peak'*, 1887. Oil on canvas, 88.9 × 121.9 (35 × 48). Dundee Art Galleries and Museums
133. WILLIAM QUILLER ORCHARDSON, *Mariage de Convenance*, 1884. Oil on canvas, 104.8 × 153.4 (41¼ × 60⅜). Glas-

gow Museums: Art Gallery & Museum, Kelvingrove
134. JAMES TISSOT, *The Ball on Shipboard*, 1874. Oil on canvas, 84.1 × 129.5 (33⅛ × 51). Tate Gallery, London
135. MARCUS STONE, *Two's Company, Three's None*, 1892. Oil on canvas, 91.4 × 152.4 (36 × 60). Blackburn Museum and Art Gallery
136. SIR LAWRENCE ALMA TADEMA, *Unconscious Rivals*, 1893. Oil on canvas, 45.7 × 63.6 (18 × 25). City of Bristol Museum and Art Gallery
137. SIR LAWRENCE ALMA TADEMA, *A Picture Gallery in Rome in the time of Augustus*, 1874. Oil on canvas, 218.4 × 166 (86 × 65½). Towneley Hall Art Gallery & Museums, Burnley Borough Council
138. FREDERIC, LORD LEIGHTON, *Elijah in the Wilderness*, 1878. Oil on canvas, 234.3 × 210.2 (92¼ × 82¾). The Board of Trustees of the National Museums & Galleries on Merseyside (Walker Art Gallery, Liverpool)
139. FREDERIC, LORD LEIGHTON, *Captive Andromache*, 1888. Oil on canvas, 197 × 407 (77½ × 160¼). © Manchester City Art Galleries
140. FREDERIC, LORD LEIGHTON, *The Garden of the Hesperides*, 1892. Oil on canvas, diameter 169 (66½). The Board of Trustees of National Museums & Galleries on Merseyside (Lady Lever Art Gallery, Port Sunlight)
141. SIR EDWARD POYNTER, *The Catapult*, 1868. Oil on canvas, 155 × 183.5 (61 × 72¼). Laing Art Gallery, Newcastle upon Tyne
142. JOHN WILLIAM WATERHOUSE, *Hylas and the Nymphs*, 1897. Oil on canvas, 98.2 × 163.3 (38⅝ × 64¼). © Manchester City Art Galleries
143. EDWARD J. GREGORY, *Boulter's Lock – Sunday Afternoon*, 1897. Oil on canvas, 214.5 × 143 (84½ × 56¼). The Board of Trustees of the National Museums & Galleries on Merseyside (Lady Lever Art Gallery, Port Sunlight)
144. EDITH HAYLLAR, *A Summer Shower*, 1883. Oil on millboard, 53.3 × 43.2 (21 × 17). The Forbes Magazine Collection, New York
145. ELIZABETH THOMPSON, later LADY BUTLER, *The Roll Call*, 1874. Oil on canvas, 91 × 182.9 (35½ × 72). Royal Collection. St James's Palace. © Her Majesty the Queen
146. SIR (SAMUEL) LUKE FILDES, *Applicants for Admission to a Casual Ward*, 1874. Oil on canvas, 137.1 × 243.7 (54 × 96). Royal Holloway and Bedford New College, London
147. SIR HUBERT VON HERKOMER, *Hard Times 1885*, 1885. Oil on canvas, 144.7 × 214.6 (57 × 84½). © Manches-

ter City Art Galleries
148. FRANK HOLL, *Her Firstborn*, 1876. Oil on canvas, 109.2 × 155.6 (43 × 61¼). Dundee Art Galleries and Museums
149. SIR (SAMUEL) LUKE FILDES, *An Al Fresco Toilette*, 1889. Oil on canvas, 170.2 × 105.4 (67 × 41½). The Board of Trustees of the National Museums & Galleries on Merseyside (Lady Lever Art Gallery, Port Sunlight)
150. JOHN SINGER SARGENT, *Ena and Betty, Daughters of Asher and Mrs Wertheimer*, 1901. Oil on canvas, 185.4 × 130.8 (73 × 51½). Tate Gallery, London
151. GEORGE HEMING MASON, *The Gander*, 1865. Oil on canvas, 48.2 × 83.9 (19 × 33). The Board of Trustees of the National Museums & Galleries on Merseyside (Lady Lever Art Gallery, Port Sunlight)
152. FREDERICK WALKER, *The Harbour of Refuge*, 1872. Oil on canvas, 116.8 × 197.5 (46 × 77¾). Tate Gallery, London
153. JOHN WILLIAM NORTH, *Halsway Court*, 1865. Watercolour and bodycolour, 33 × 44.5 (13 × 17½). Private Collection
154. HELEN ALLINGHAM, *The Orchard*, 1887. Watercolour, 28.5 × 37.4 (11¼ × 14¾). The Board of Trustees of the National Museums & Galleries on Merseyside (Walker Art Gallery, Liverpool)
155. CECIL GORDON LAWSON, *The Minister's Garden*, 1878. Oil on canvas, 184.2 × 275 (72½ × 108¼). © Manchester City Art Galleries
156. MATTHEW RIDLEY CORBET, *Val d'Arno: Evening*, 1901. Oil on canvas, 90.8 × 208.9 (35 ¾ × 82¼). Tate Gallery, London
157. BENJAMIN WILLIAMS LEADER, *February Fill Dyke*, 1881. Oil on canvas, 119.4 × 181.6 (47 × 71½). Birmingham Museums and Art Gallery
158. ATKINSON GRIMSHAW, *Liverpool Quay by Moonlight*, 1887. Oil on canvas, 61 × 91.4 (24 × 36). Tate Gallery, London
159. HENRY MOORE, *Mount's Bay: Early Morning-Summer*, 1886. Oil on canvas, 122.2 × 213.5 (48⅛ × 84⅛). © Manchester City Art Galleries
160. WILLIAM McTAGGART, *The Storm*, 1890. Oil on canvas, 121.9 × 183 (48 × 72). National Gallery of Scotland, Edinburgh
161. JULES BASTIEN-LEPAGE, *Pauvre Fauvette*, 1881. Oil on canvas, 162.5 × 125.7 (64½ × 49½). Glasgow Museums: Art Gallery & Museum, Kelvingrove
162. STANHOPE FORBES, *A Street in Brittany*, 1881. Oil on canvas, 104.2 × 75.8 (41¼ × 29¾). The Board of Trustees

213

of the National Museums & Galleries on Merseyside (Walker Art Gallery, Liverpool)
163. SIR GEORGE CLAUSEN, *The Stone Pickers*, 1887. Oil on canvas, 106.5 × 79 (42 × 31). Laing Art Gallery, Newcastle upon Tyne
164. WILLIAM TEULON BLANDFORD FLETCHER, *The Farm Garden*, 1888. Oil on canvas, 61 × 50.8 (24 × 20). Ashmolean Museum, Oxford
165. FRANK BRAMLEY, *A Hopeless Dawn*, 1885. Oil on canvas, 122.6 × 167.6 (48¼ × 66). Tate Gallery, London
166. JOHN SINGER SARGENT, *Carnation, Lily, Lily, Rose*, 1885–86. Oil on canvas, 174 × 153.7 (68½ × 60½). Tate Gallery, London
167. HENRY HERBERT LA THANGUE, *The Ploughboy*, 1900. Oil on canvas, 156.2 × 118.2 (61 × 38½). City of Aberdeen Art Gallery & Museums Collections
168. SIR GEORGE CLAUSEN, *The*

Mowers, 1897. Oil on canvas, 97.2 × 76.2 (40 × 34). Usher Art Gallery, Lincoln
169. WALTER OSBORNE, *Life in the Streets, Musicians*, 1893. Oil on canvas, 59.7 × 80 (23½ × 31½). Hugh Lane Municipal Gallery of Modern Art, Dublin
170. JAMES ABBOT MCNEILL WHISTLER, *Chelsea Shops*, early 1880s. Oil on panel, 13.5 × 23.4 (5¼ × 9¼). Courtesy of the Freer Gallery of Art, Smithsonian Institution, Washington, D.C. 02.149
171. PHILIP WILSON STEER, *Knucklebones*, 1888–89. Oil on canvas, 61 × 76.2 (24 × 30). Ipswich Museums & Art Galleries
172. WALTER RICHARD SICKERT, *The Gallery of the Old Bedford (The Boy I Love is up in the Gallery)*, 1895. Oil on canvas, 76.2 × 59.7 (30 × 23½). The Board of Trustees of the National Museums & Galleries on Merseyside (Walker Art Gallery, Liverpool)

173. JAMES GUTHRIE, *Hard at it*, 1883. Oil on canvas, 31.1 × 46 (12 × 18¼). Glasgow Museums: Art Gallery & Museum, Kelvingrove
174. JOSEPH CRAWHALL, *The Flower Shop*, 1894–1900. Gouache on linen, 28.2 × 35.2 (11⅛ × 13⅞). Glasgow Museums: The Burrell Collection, Glasgow
175. JOHN LAVERY, *The Tennis Party*, 1886. Oil on canvas, 77 × 183.5 (30¼ × 72¼). City of Aberdeen Art Gallery & Museums Collections
176. ARTHUR MELVILLE, *The Little Bullfight. Bravo Toro!*, 1899. Watercolour, 55.9 × 77.5 (22 × 30½). By courtesy of the Board of Trustees of the Victoria & Albert Museum, London
177. GEORGE HENRY and EDWARD ATKINSON HORNEL, *The Druids: Bringing in the Mistletoe*, 1890. Oil on canvas, 152 × 152 (58⅞ × 58⅞). Glasgow Museums: Art Gallery & Museum, Kelvingrove

Index

216